HOW TO DRAW
ANIMALS

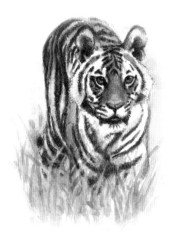

SADAO NAITŌ

TUTTLE Publishing

Tokyo | Rutland, Vermont | Singapore

Contents

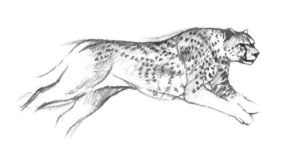

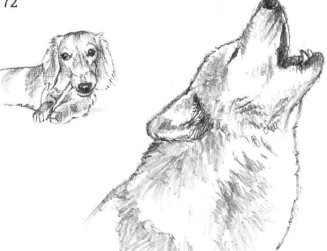

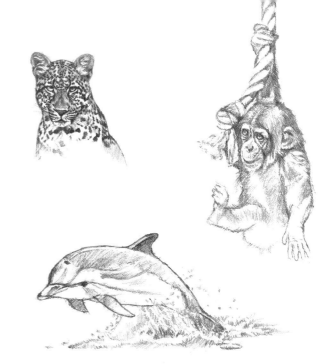

PART TWO
Coloring Your Drawings

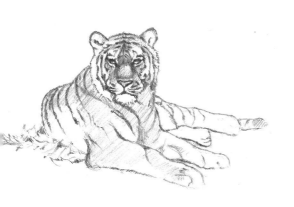

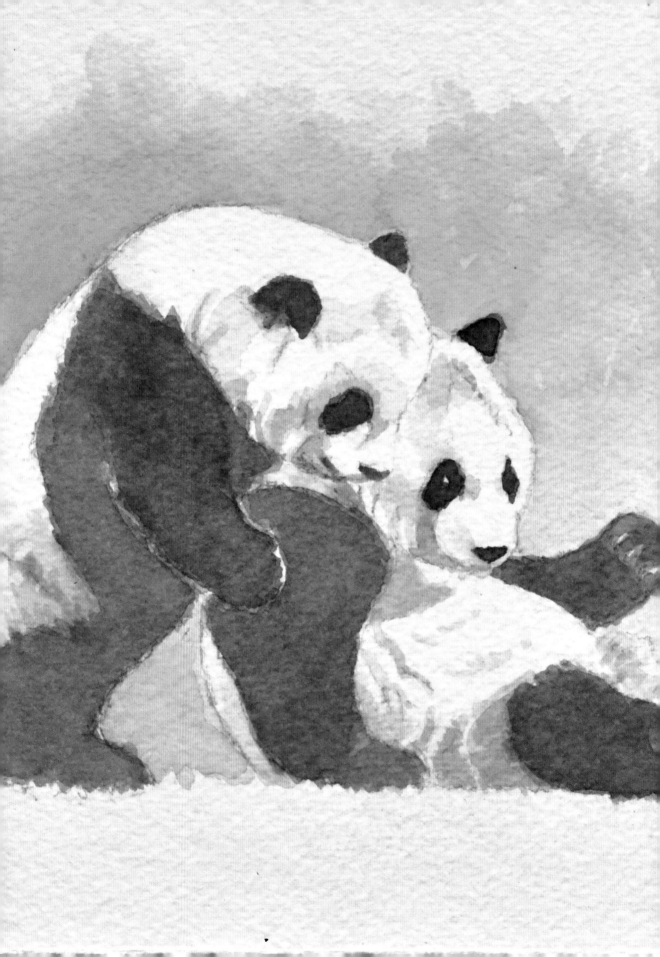

Why I Wrote this Book

Recently, after a long career involved in painting wildlife, mainly in color, I turned my hand to sketching animals.

With just a few pencil lines and some shading, it was fascinating to discover the varied poses and expressions of different creatures. Once again, I felt how much fun it was to simply sketch and draw in monochrome.

At home, I drew my cats. I also went out to dog parks to sketch dogs. For other animals, I made a number of trips to the zoo.

Besides that, I made use of photographs and sketches from past expeditions to Alaska, Africa and other places.

If you love drawing and animals, or are just curious about wildlife, I hope you will find this book useful.

— Sadao Naitō

A Gallery of the Animals Featured in This Book

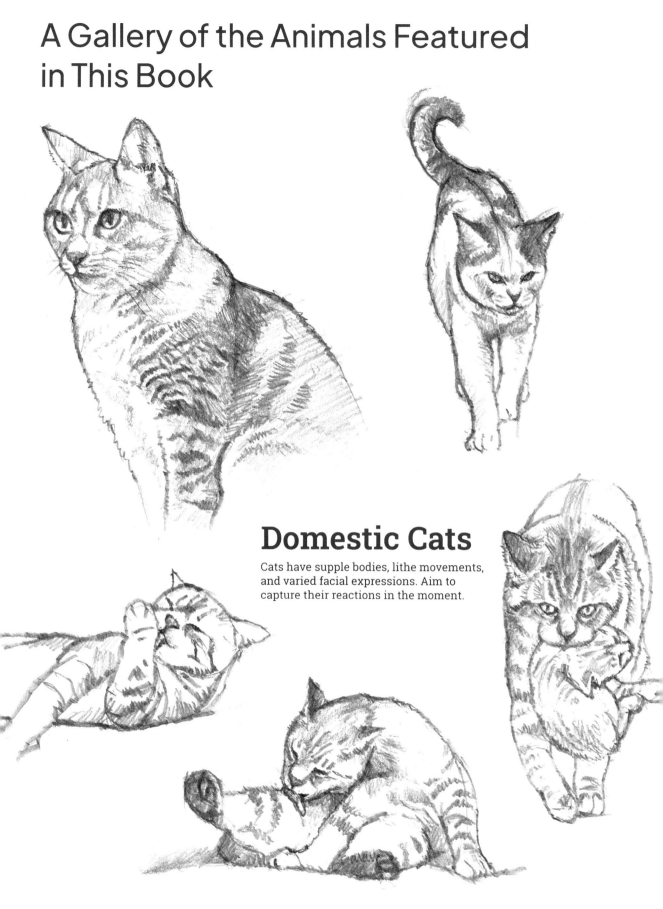

Domestic Cats

Cats have supple bodies, lithe movements, and varied facial expressions. Aim to capture their reactions in the moment.

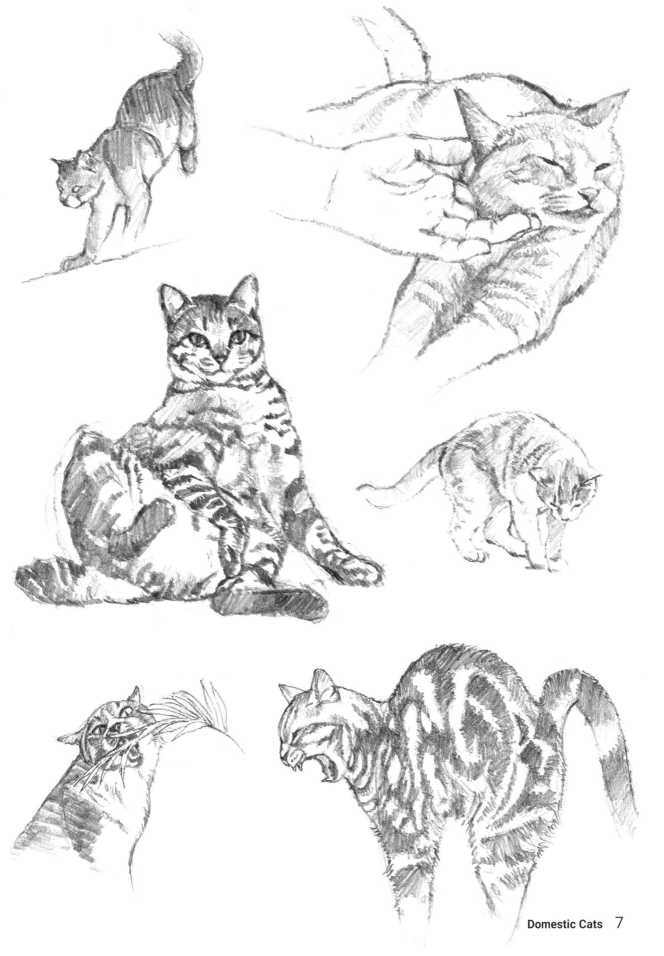

Other Felines

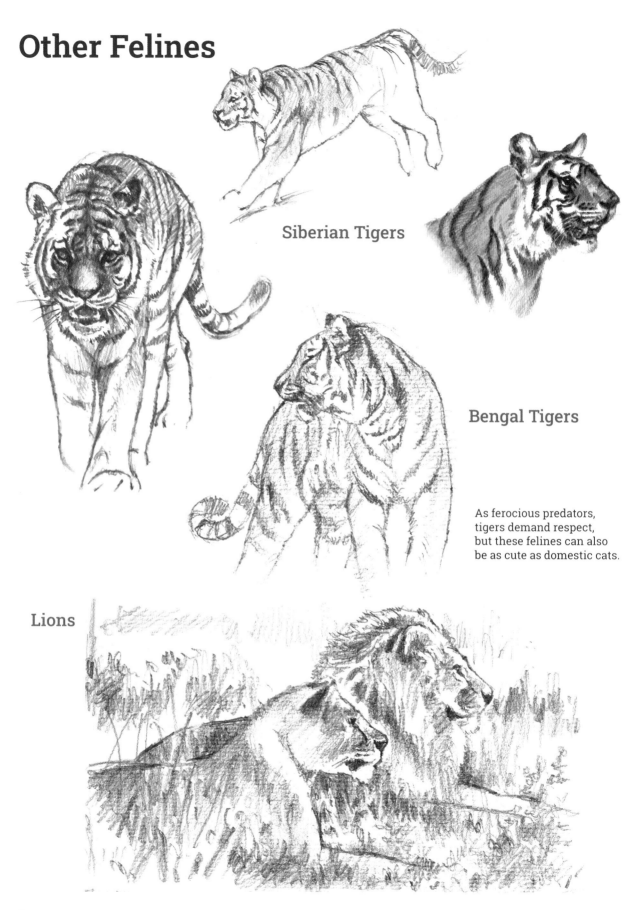

Siberian Tigers

Bengal Tigers

As ferocious predators, tigers demand respect, but these felines can also be as cute as domestic cats.

Lions

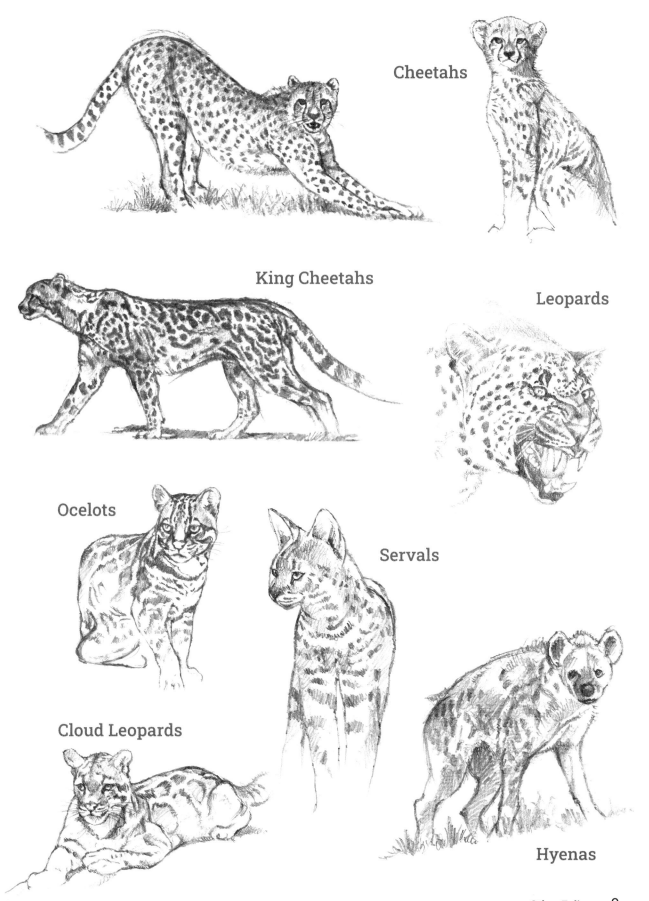

Cheetahs

King Cheetahs

Leopards

Ocelots

Servals

Cloud Leopards

Hyenas

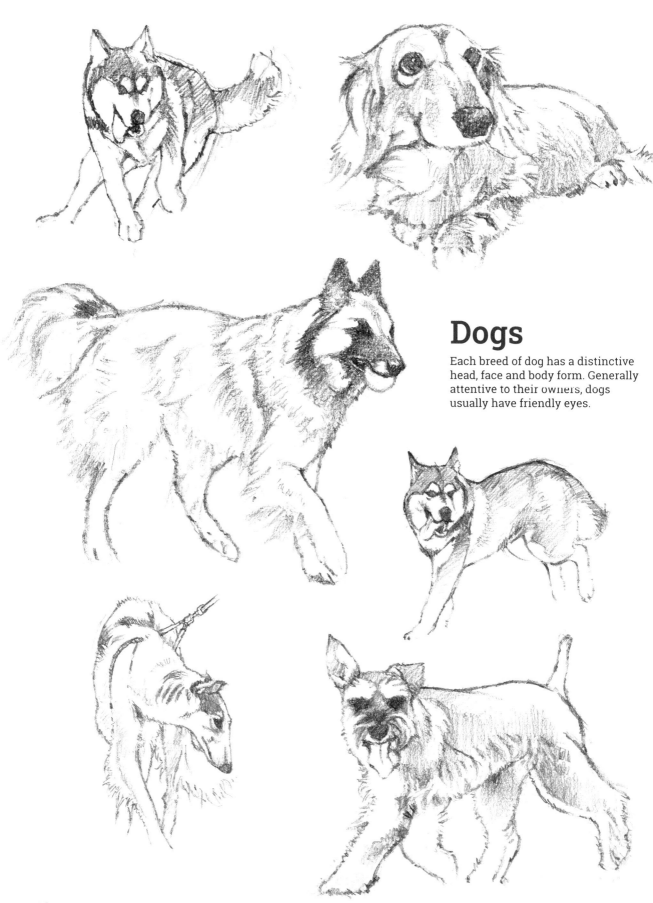

Dogs

Each breed of dog has a distinctive head, face and body form. Generally attentive to their owners, dogs usually have friendly eyes.

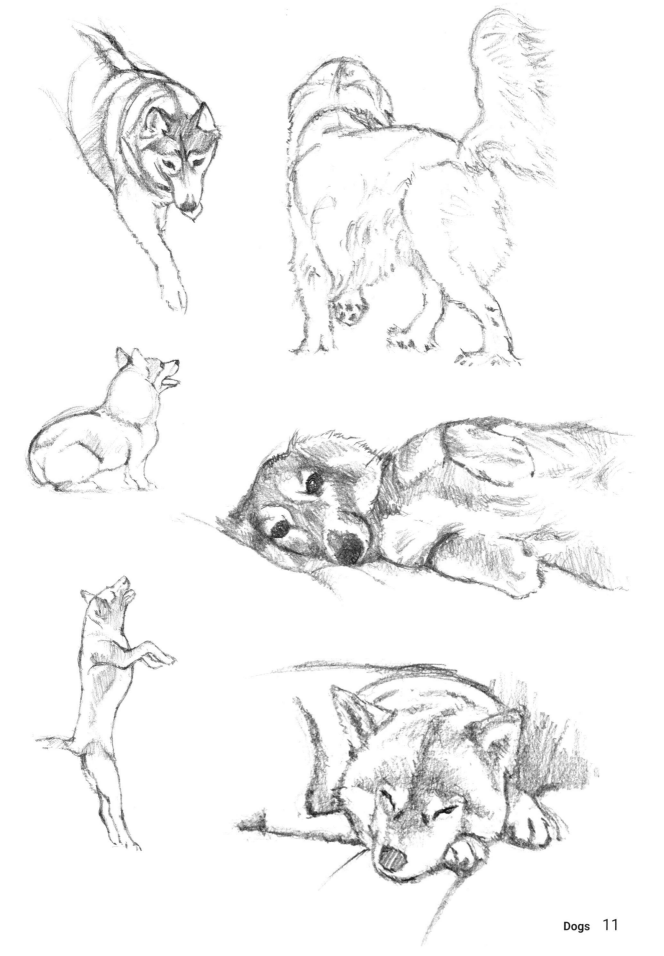

Other Canines

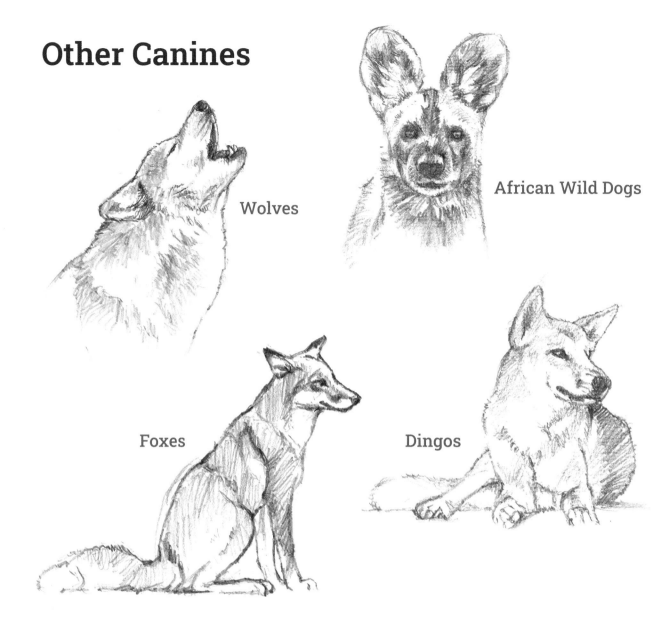

Wolves

African Wild Dogs

Foxes

Dingos

Other Mammals

Mammals vary widely in body form, movement, face and coat length. Closely observe the size, shape and movement of various animals. Discover things that you fail to notice when looking at them casually.

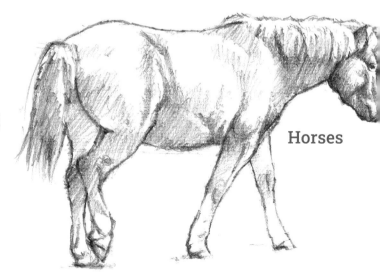

Horses

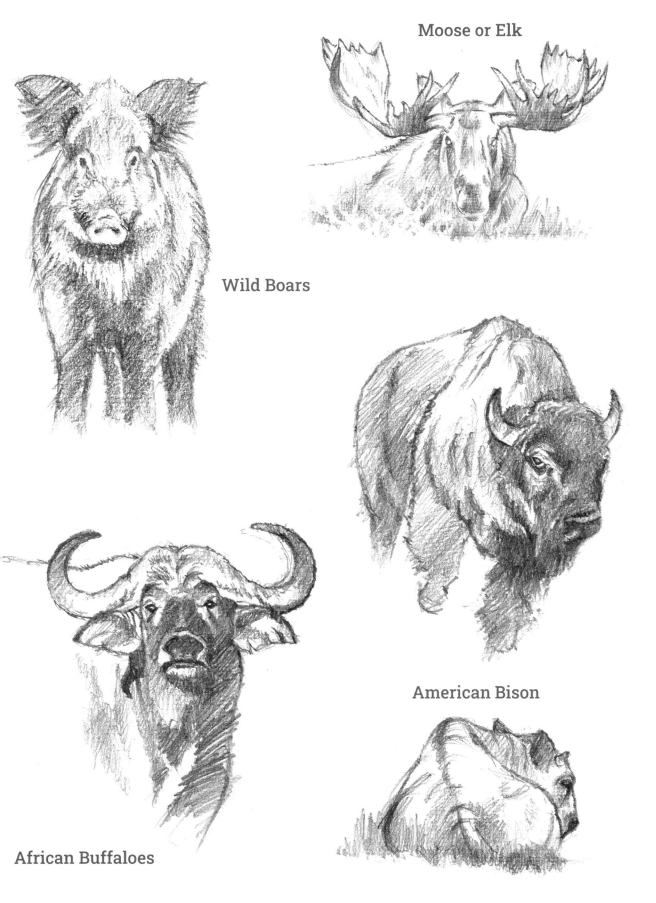

Moose or Elk

Wild Boars

American Bison

African Buffaloes

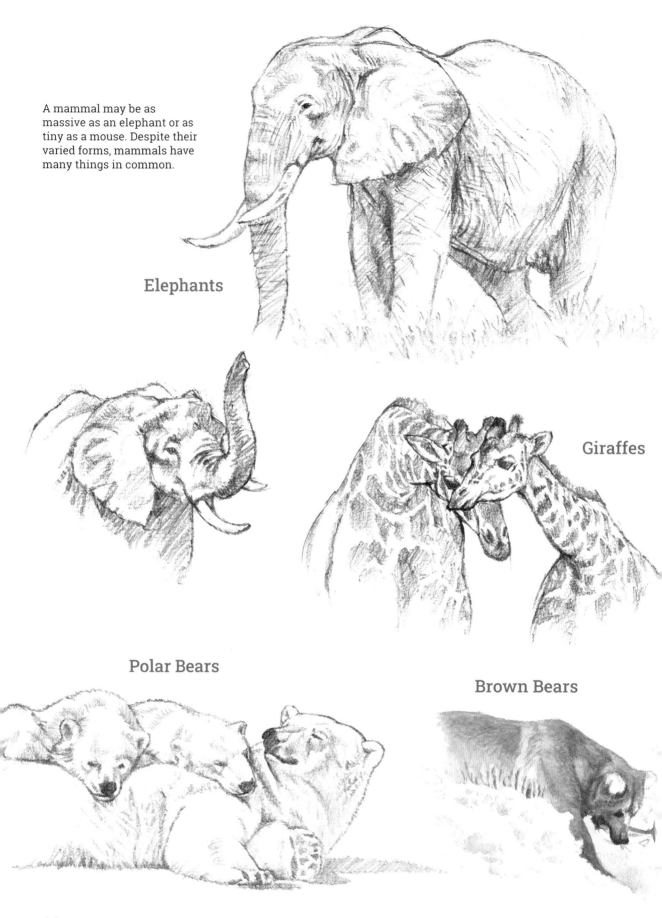

A mammal may be as massive as an elephant or as tiny as a mouse. Despite their varied forms, mammals have many things in common.

Elephants

Giraffes

Polar Bears

Brown Bears

A Gallery of the Animals Featured in This Book

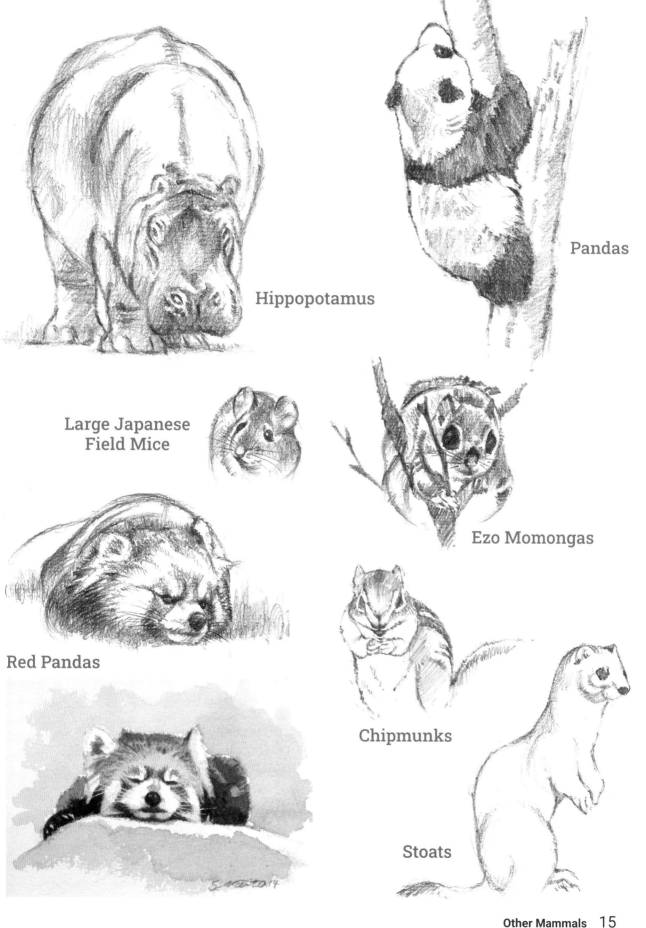

Pandas

Hippopotamus

Large Japanese
Field Mice

Ezo Momongas

Red Pandas

Chipmunks

Stoats

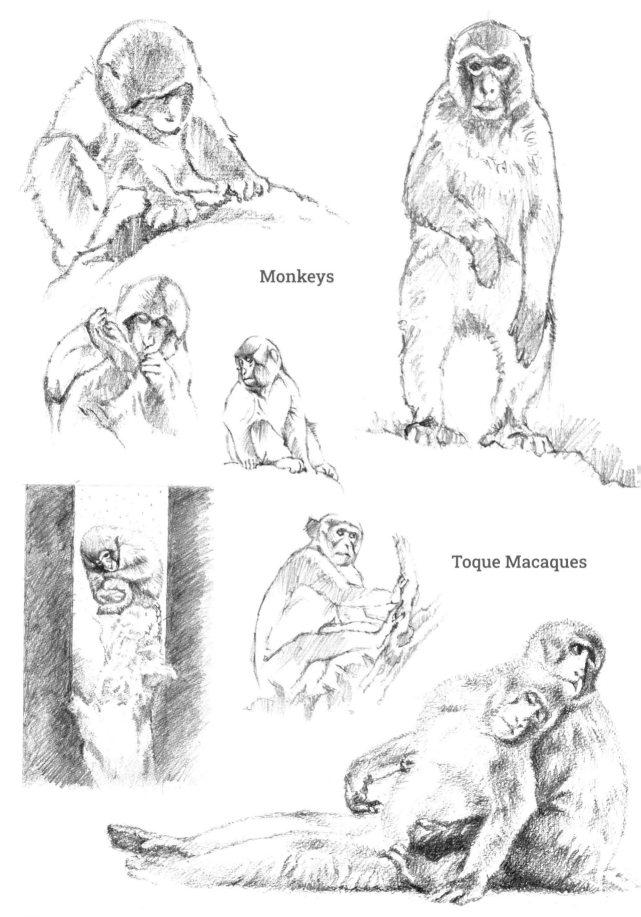

Monkeys

Toque Macaques

A Gallery of the Animals Featured in This Book

Aquatic Mammals

Humpback Whales

With streamlined bodies, some mammals freely swim in water. Aquatic mammals contrast with terrestrial mammals in interesting ways.

Dolphins

Killer Whales

Amphibians

Iguanas

Japanese Common Toads

Reptiles

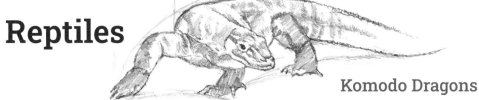

Komodo Dragons

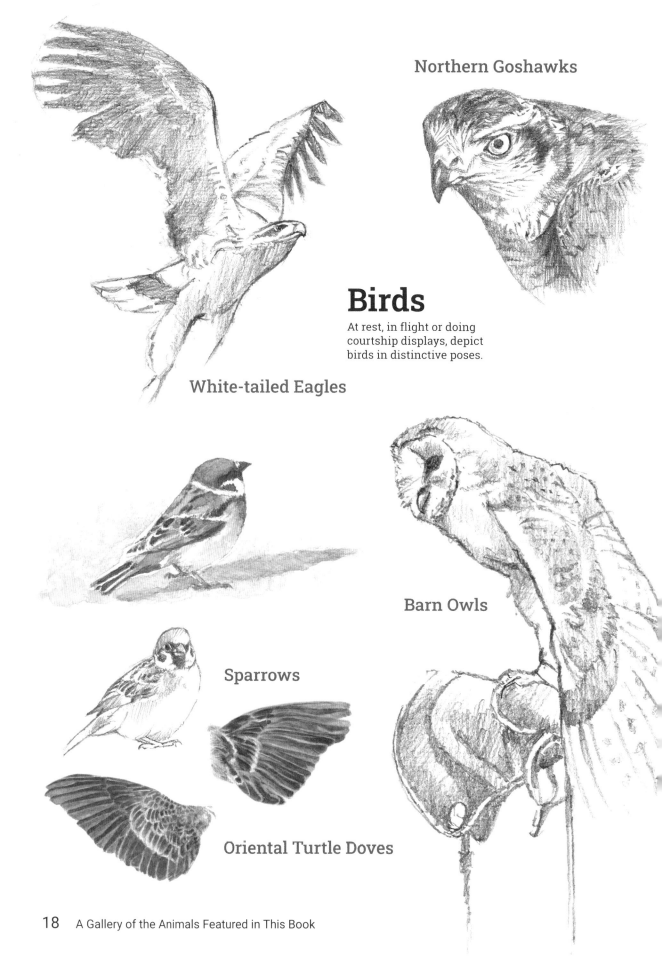

Northern Goshawks

Birds

At rest, in flight or doing courtship displays, depict birds in distinctive poses.

White-tailed Eagles

Barn Owls

Sparrows

Oriental Turtle Doves

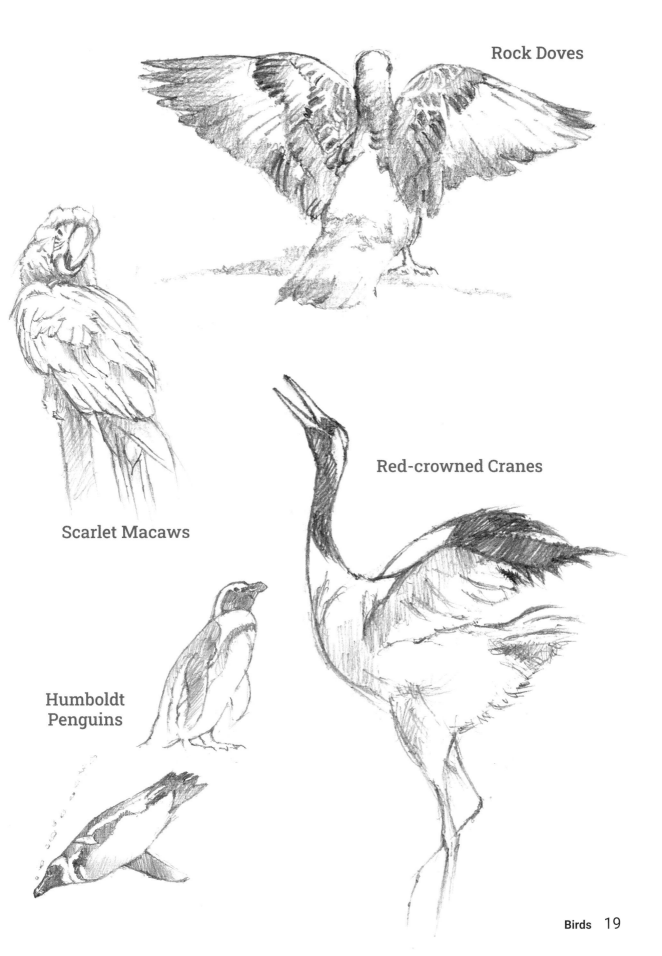

Rock Doves

Scarlet Macaws

Red-crowned Cranes

Humboldt
Penguins

Five Things to Keep in Mind When Drawing Animals

Whatever the animal, the principles of drawing them are the same. Think about these five things:

❶ The face is critical, so start with the centerline and the eye position.

The face makes or breaks an animal picture. Once you have sketched the outline, clearly mark a vertical centerline and auxiliary horizontal lines above and below the eyes.

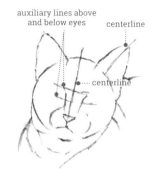

auxiliary lines above and below eyes
centerline
centerline

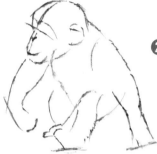

❷ Outline the overall form.

Is the head round, long or square? Think about the body shape in the same way. Draw details only after you have done the outline.

❸ Hair flows outward from between the eyes.

Look closely at the face of a furry animal. Notice how their hair usually flows upward or downward and to the right and left from between the eyes. It then flows onto the body and finally converges at the tail. Pay attention to hair flow.

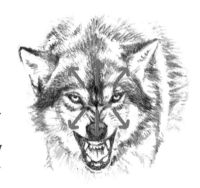

muscle line

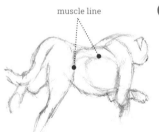

❹ Bear in mind the movement of bones and muscles.

Drawing is easier if you bear in mind the movement of bones and muscles. Even if you are unsure of anatomical details, for a more complete drawing, imagine the general skeletal structure.

❺ Start with lighter colors.

When coloring, start with a light base. Work on details while shading. Then, apply layers of lighter color. To minimize mistakes, use black and other dark colors at the end.

Basic Sketching Techniques

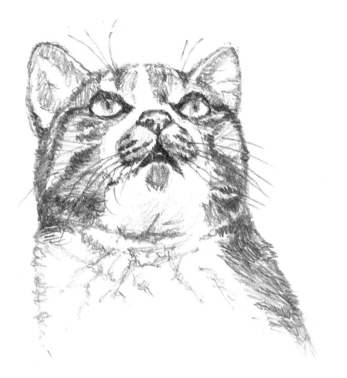

Cats

Drawing Fundamentals

Cats in general suggest plumpness and soft curves. Compared to their heads, their bodies seem long. Cats also have supple tails.

❶ Sketch the outline. ➡

❷ Draw the face, legs, and feet. ➡

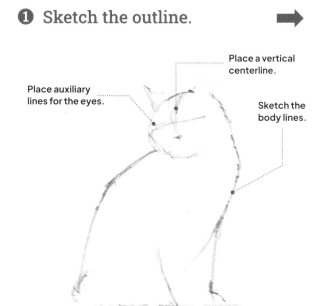

Place a vertical centerline.

Place auxiliary lines for the eyes.

Sketch the body lines.

Get a sense of the patterning.

Draw the forelegs with the shoulders in mind.

Outline the face in a circle and the body in an oval.

Draw the face with eyes positioned, legs with paws together, and curled tail. Start defining the body and hindlegs.

Physical Characteristics

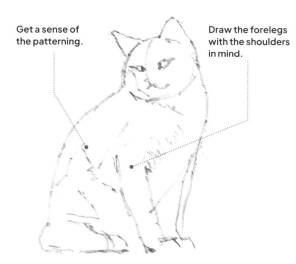

Nose length varies by breed.

Cat bodies are more sinewy than dogs' bodies.

The tail moves freely in any direction.

The upper leg is located behind the neck.

Each foot contacts the ground on tiptoe. Heels float when walking.

Thighs attach along the hips.

❸ **Sketch and start pattern shading.**

❹ **Add fur and facial expression details.**

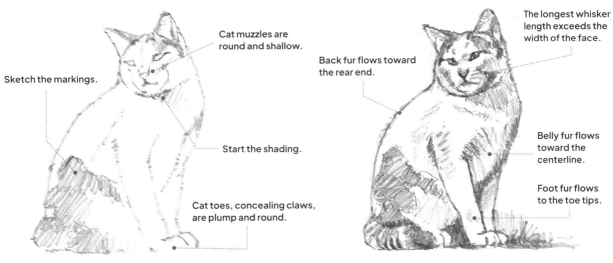

Sketch the markings.

Cat muzzles are round and shallow.

Start the shading.

Cat toes, concealing claws, are plump and round.

Create volume with light and shade. Aim for a round, plump look. Paws are also round.

Back fur flows toward the rear end.

The longest whisker length exceeds the width of the face.

Belly fur flows toward the centerline.

Foot fur flows to the toe tips.

Draw eyes to give expression to the face. Draw the pattern and finish with shading.

Skeletal Features

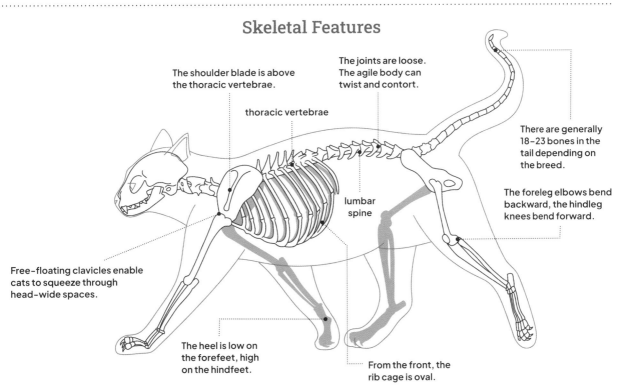

The shoulder blade is above the thoracic vertebrae.

The joints are loose. The agile body can twist and contort.

thoracic vertebrae

lumbar spine

There are generally 18–23 bones in the tail depending on the breed.

The foreleg elbows bend backward, the hindleg knees bend forward.

Free-floating clavicles enable cats to squeeze through head-wide spaces.

The heel is low on the forefeet, high on the hindfeet.

From the front, the rib cage is oval.

❶ Cat Poses

Sitting, walking, sleeping and other poses. Can you capture the poses of cats in their various daily routines?

① Sitting

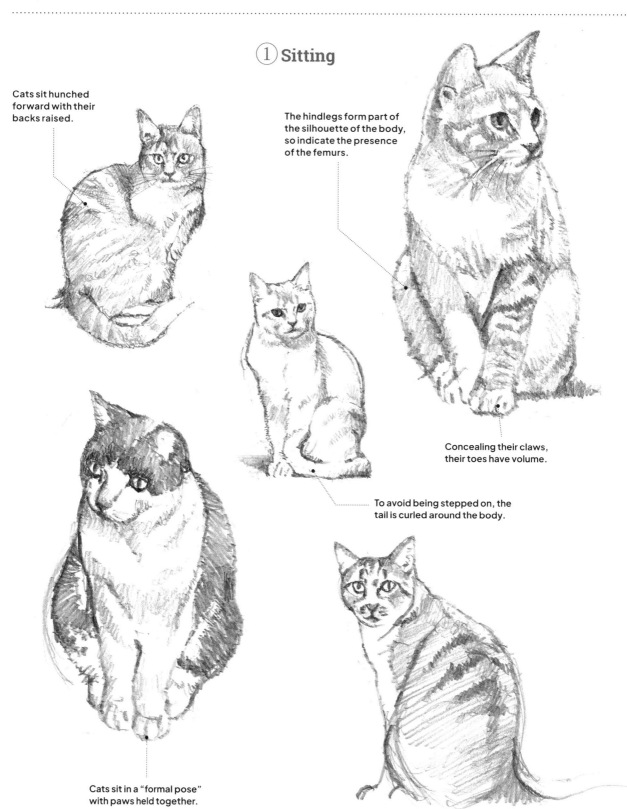

Cats sit hunched forward with their backs raised.

The hindlegs form part of the silhouette of the body, so indicate the presence of the femurs.

Concealing their claws, their toes have volume.

To avoid being stepped on, the tail is curled around the body.

Cats sit in a "formal pose" with paws held together.

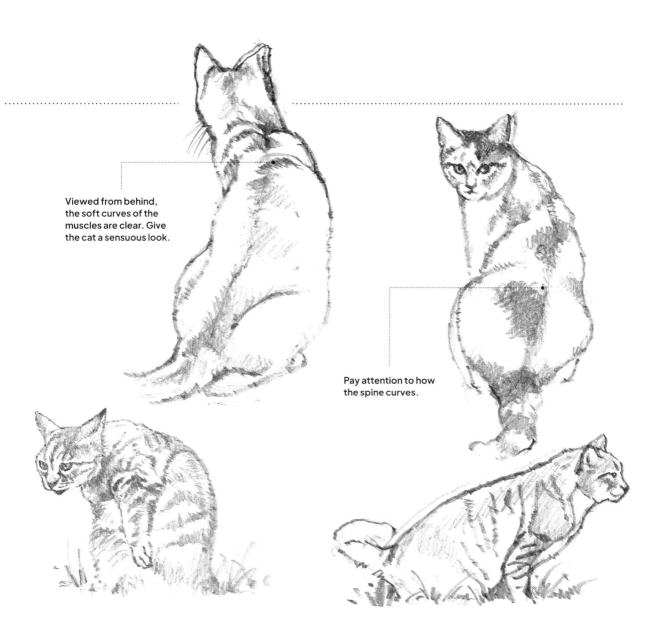

Viewed from behind, the soft curves of the muscles are clear. Give the cat a sensuous look.

Pay attention to how the spine curves.

TRY IT! Draw a crouching cat.

※ Cat above eye-level

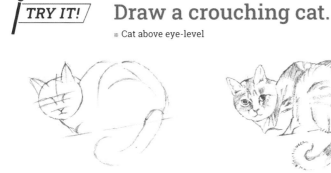

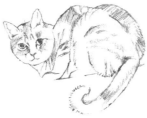

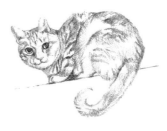

① The face fits a round outline. Rough out the body with contoured muscles. Slightly exaggerate the roundness.

② Draw the face, then rough out the fur pattern. Make the fur look fluffy while paying attention to the direction of the light.

③ Create volume by shading. Finish by checking the overall balance.

(See coloring sample on page 142)

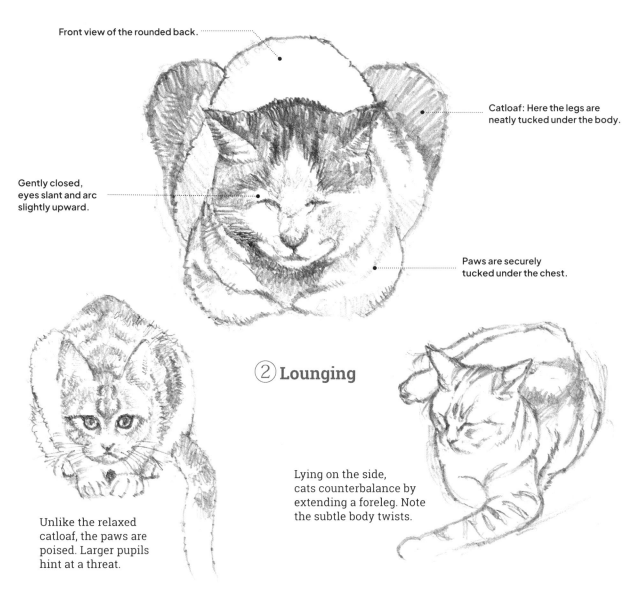

Front view of the rounded back.

Catloaf: Here the legs are neatly tucked under the body.

Gently closed, eyes slant and arc slightly upward.

Paws are securely tucked under the chest.

② **Lounging**

Unlike the relaxed catloaf, the paws are poised. Larger pupils hint at a threat.

Lying on the side, cats counterbalance by extending a foreleg. Note the subtle body twists.

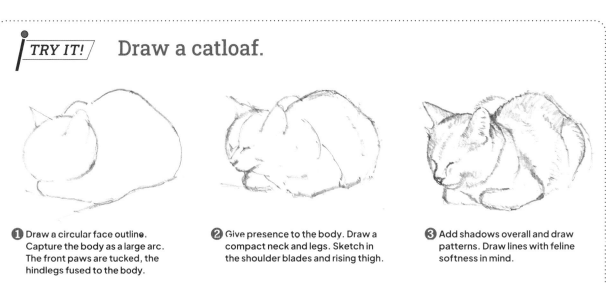

TRY IT! Draw a catloaf.

❶ Draw a circular face outline. Capture the body as a large arc. The front paws are tucked, the hindlegs fused to the body.

❷ Give presence to the body. Draw a compact neck and legs. Sketch in the shoulder blades and rising thigh.

❸ Add shadows overall and draw patterns. Draw lines with feline softness in mind.

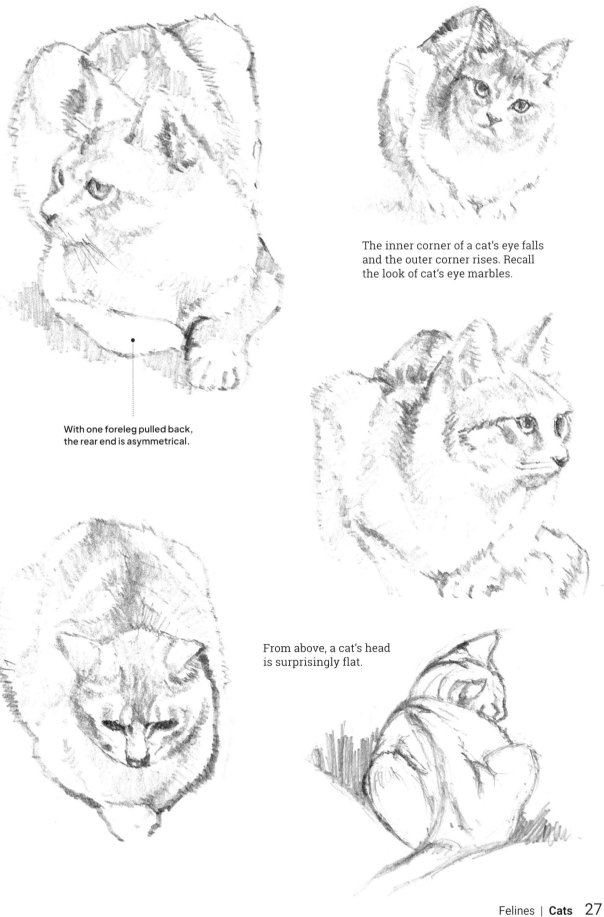

The inner corner of a cat's eye falls and the outer corner rises. Recall the look of cat's eye marbles.

With one foreleg pulled back, the rear end is asymmetrical.

From above, a cat's head is surprisingly flat.

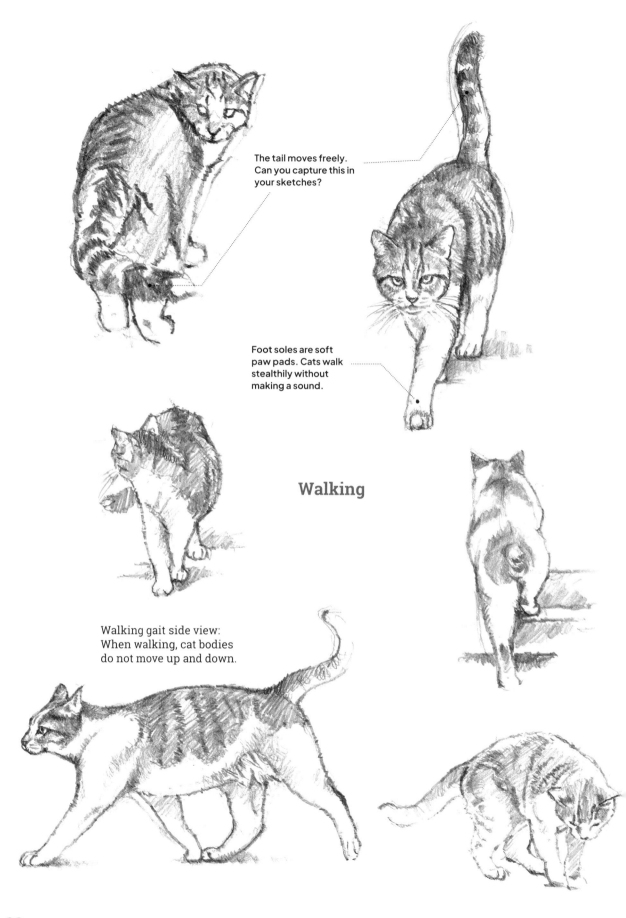

The tail moves freely. Can you capture this in your sketches?

Foot soles are soft paw pads. Cats walk stealthily without making a sound.

Walking

Walking gait side view: When walking, cat bodies do not move up and down.

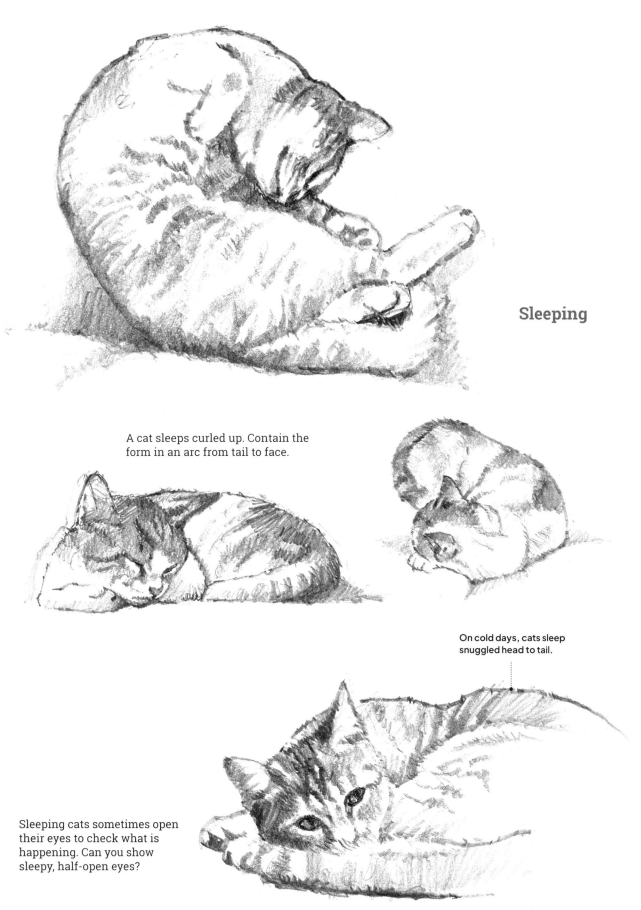

Sleeping

A cat sleeps curled up. Contain the form in an arc from tail to face.

On cold days, cats sleep snuggled head to tail.

Sleeping cats sometimes open their eyes to check what is happening. Can you show sleepy, half-open eyes?

❷ Cat Expressions

Eyes, whiskers, tails and behavior show how cats are feeling. When sketching, look out for the emotional state of the cat.

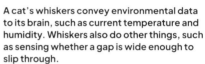

With eyes closed, a cat's face is round like a dumpling.

A cat's whiskers convey environmental data to its brain, such as current temperature and humidity. Whiskers also do other things, such as sensing whether a gap is wide enough to slip through.

Cats have about a dozen whiskers on either side of their nose. Long whiskers extend more than 3 inches (7–9 cm). Short whiskers are found on their eyebrows, the sides of their face, and on their chin. On a relaxed cat, the long whiskers arc downward.

TRY IT! Draw a front view of a cat's face.

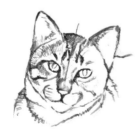

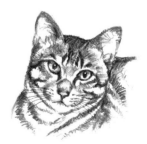

❶ Outline the face in a circle. Add ears, and then draw the centerline and lines to position the eyes.

❷ Draw the cat's eyes, nose lines and round muzzle. Start shading, remaining aware of the direction of the light.

❸ Detail the patterns and make the fur look fuller and more lively. Give life to the eyes with highlights.

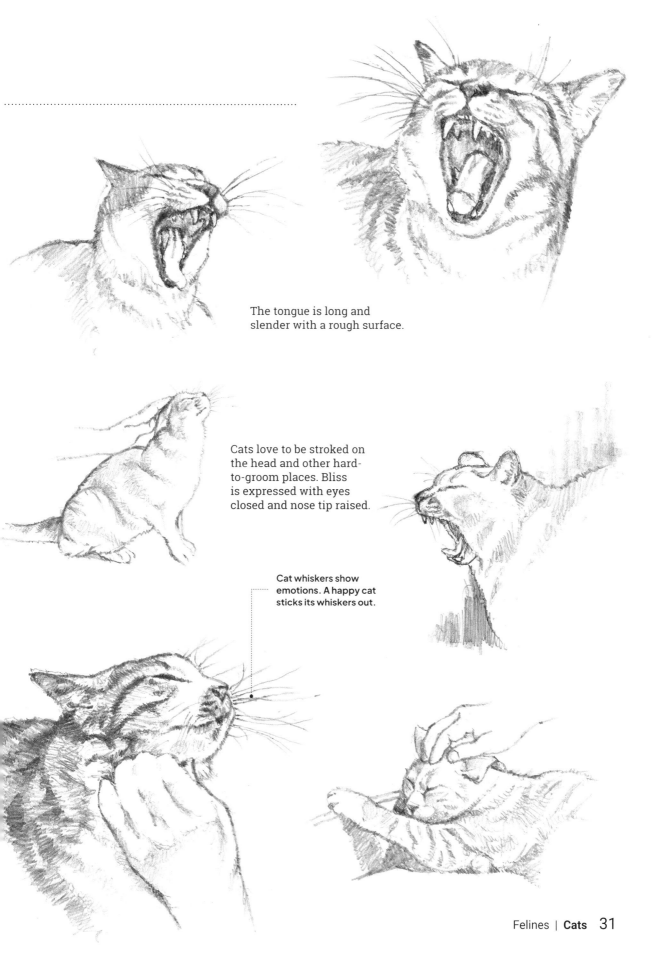

The tongue is long and slender with a rough surface.

Cats love to be stroked on the head and other hard-to-groom places. Bliss is expressed with eyes closed and nose tip raised.

Cat whiskers show emotions. A happy cat sticks its whiskers out.

❸ Cats in Motion

Active cats curl and stretch. They have the agility of gymnasts.

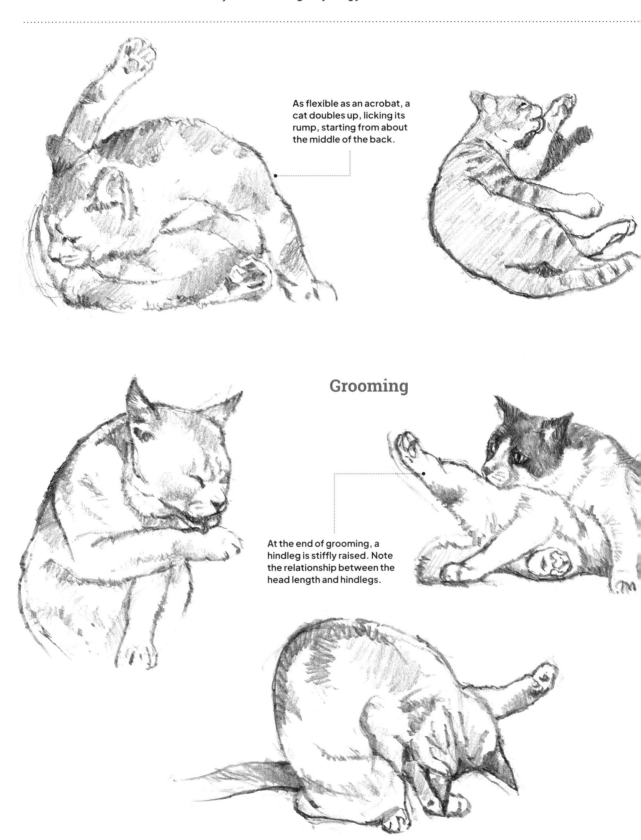

As flexible as an acrobat, a cat doubles up, licking its rump, starting from about the middle of the back.

Grooming

At the end of grooming, a hindleg is stiffly raised. Note the relationship between the head length and hindlegs.

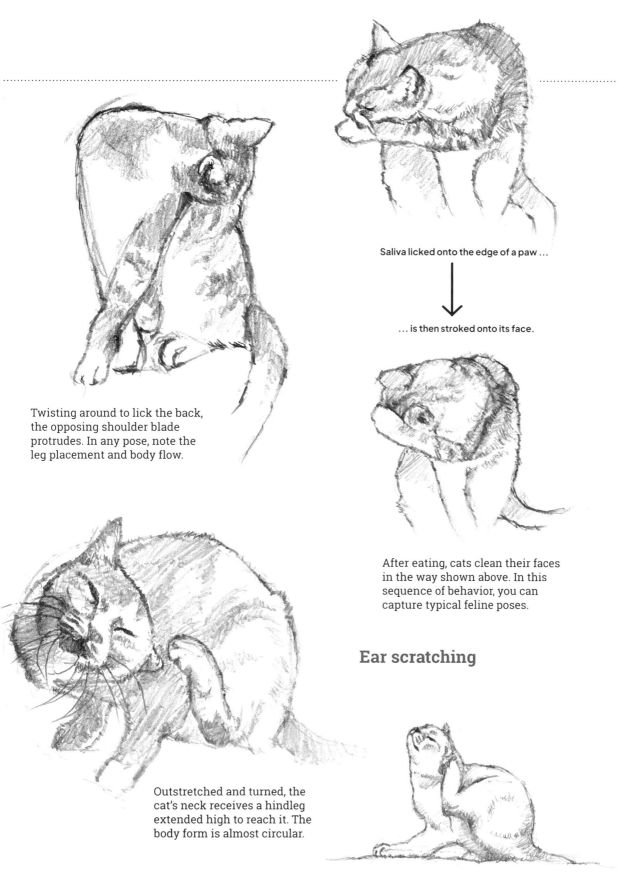

Saliva licked onto the edge of a paw …

… is then stroked onto its face.

Twisting around to lick the back, the opposing shoulder blade protrudes. In any pose, note the leg placement and body flow.

After eating, cats clean their faces in the way shown above. In this sequence of behavior, you can capture typical feline poses.

Ear scratching

Outstretched and turned, the cat's neck receives a hindleg extended high to reach it. The body form is almost circular.

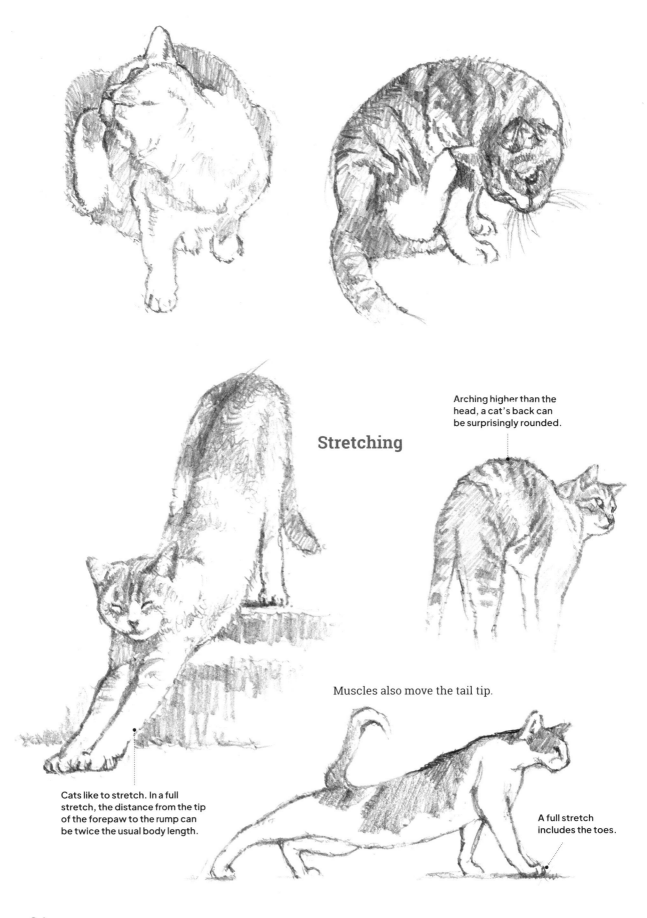

Stretching

Arching higher than the head, a cat's back can be surprisingly rounded.

Muscles also move the tail tip.

Cats like to stretch. In a full stretch, the distance from the tip of the forepaw to the rump can be twice the usual body length.

A full stretch includes the toes.

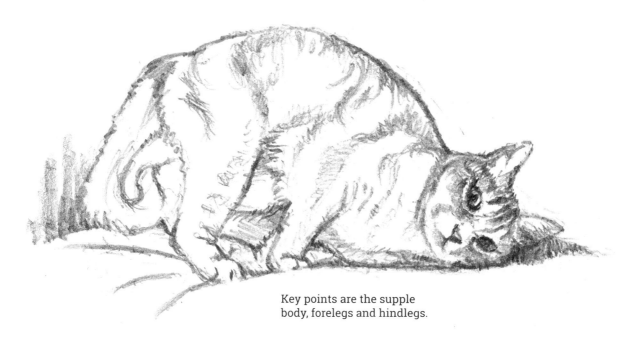

Key points are the supple
body, forelegs and hindlegs.

Relaxing

When you draw a relaxed cat, can you capture
its expression of complete contentment?

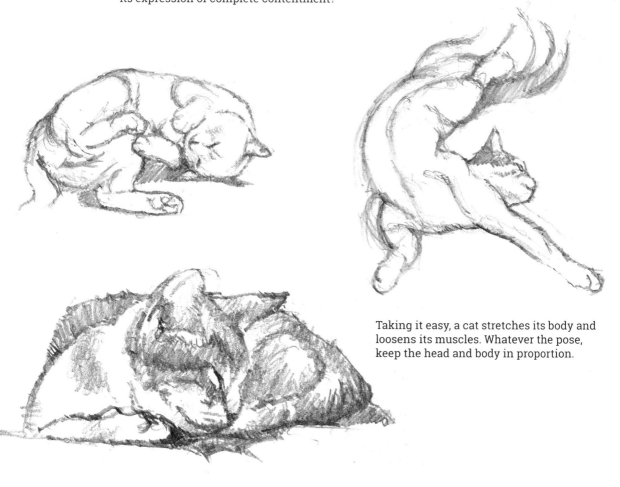

Taking it easy, a cat stretches its body and
loosens its muscles. Whatever the pose,
keep the head and body in proportion.

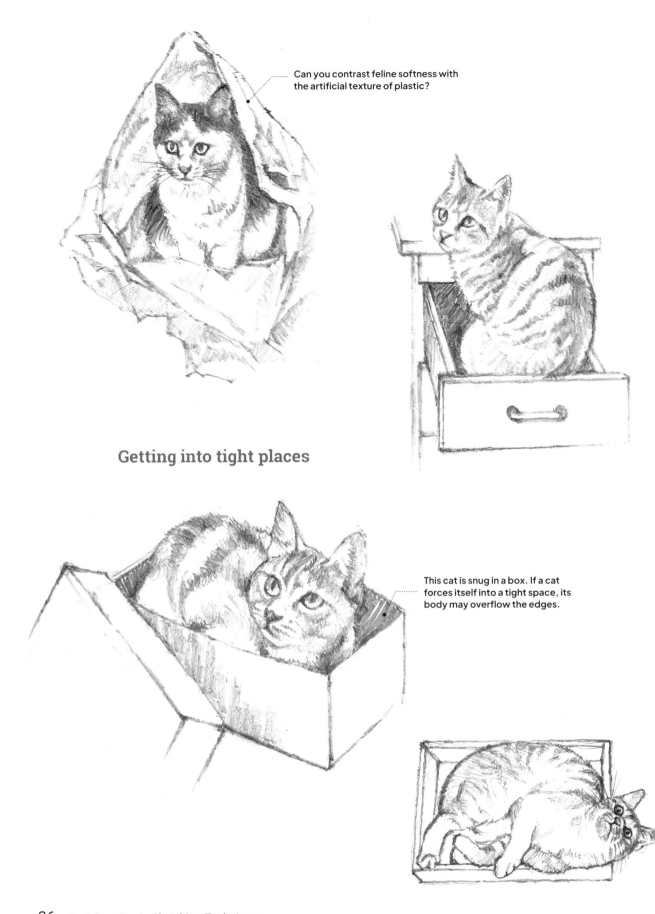

Can you contrast feline softness with the artificial texture of plastic?

Getting into tight places

This cat is snug in a box. If a cat forces itself into a tight space, its body may overflow the edges.

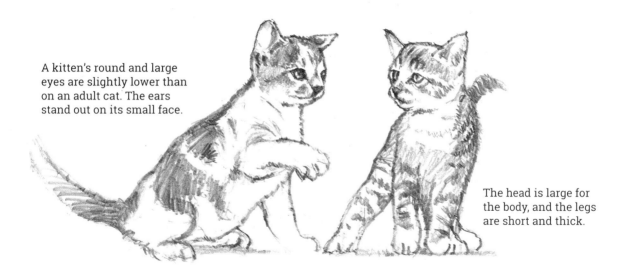

A kitten's round and large eyes are slightly lower than on an adult cat. The ears stand out on its small face.

The head is large for the body, and the legs are short and thick.

Playful kittens

Through play, kittens practice movements they need for hunting.

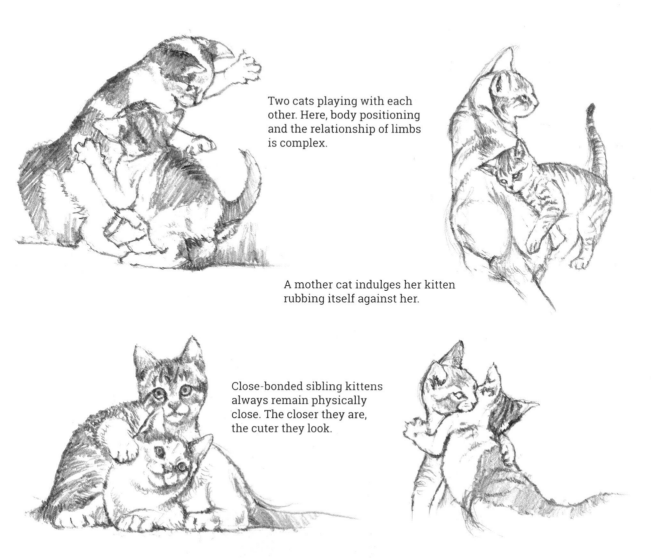

Two cats playing with each other. Here, body positioning and the relationship of limbs is complex.

A mother cat indulges her kitten rubbing itself against her.

Close-bonded sibling kittens always remain physically close. The closer they are, the cuter they look.

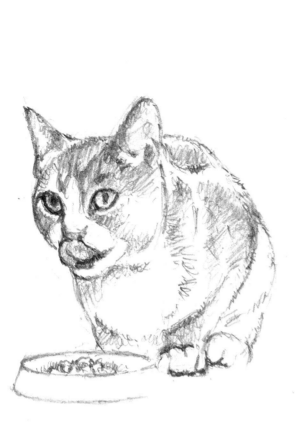

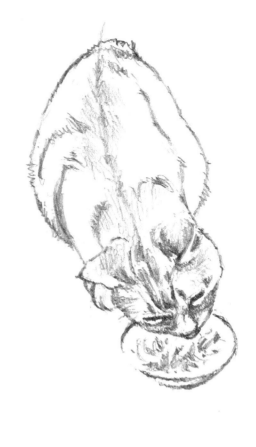

Feeding

Cats are exclusively carnivorous. They express enjoyment while eating. When I notice fleeting looks and gestures, I want to draw them.

Cats sometimes eat cat grass. This stimulates the stomach to regurgitate indigestible furballs. That determined look is also typical of cats.

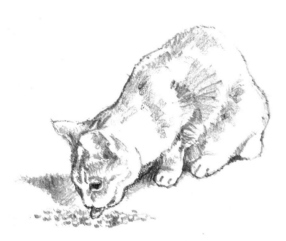

A cat's long, slender tongue ably scoops up food.

Claw sharpening

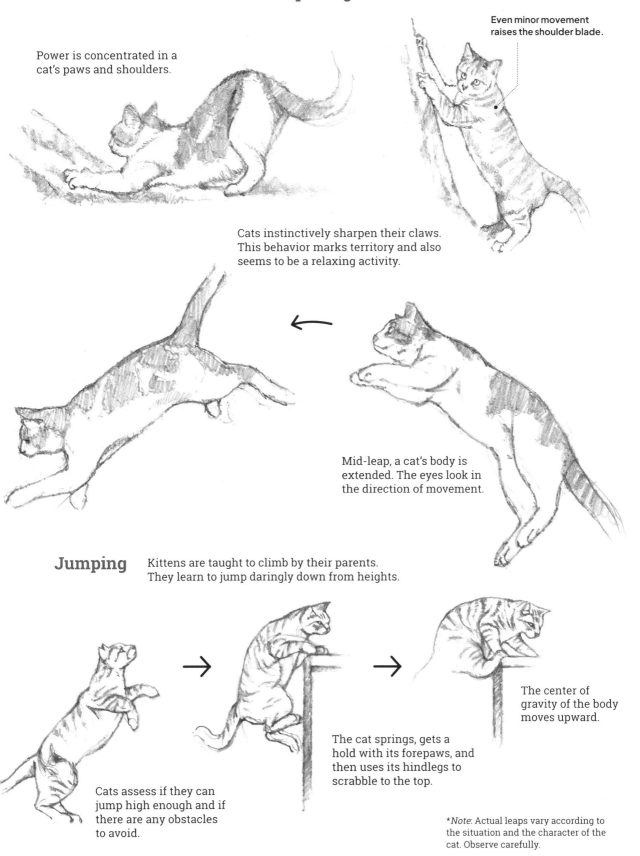

Power is concentrated in a cat's paws and shoulders.

Even minor movement raises the shoulder blade.

Cats instinctively sharpen their claws. This behavior marks territory and also seems to be a relaxing activity.

Mid-leap, a cat's body is extended. The eyes look in the direction of movement.

Jumping

Kittens are taught to climb by their parents. They learn to jump daringly down from heights.

Cats assess if they can jump high enough and if there are any obstacles to avoid.

The cat springs, gets a hold with its forepaws, and then uses its hindlegs to scrabble to the top.

The center of gravity of the body moves upward.

*Note: Actual leaps vary according to the situation and the character of the cat. Observe carefully.

❹ Cat Breeds

There are many breeds of cat in the world. The face, body form, and the length and color of the fur are the main distinguishing features. Below are sketches of some of the breeds.

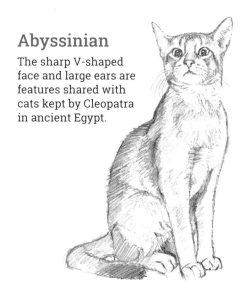

Abyssinian

The sharp V-shaped face and large ears are features shared with cats kept by Cleopatra in ancient Egypt.

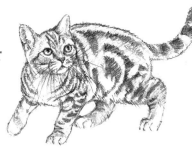

American Shorthair

These are descended from rat catchers accompanying settlers in the seventeenth century. Many have swirly patterns on their fur.

Scottish Fold

Bred by crossing a cat with a mutant gene and a British Shorthair, the cat's distinctive lop-ear caused a sensation in the cat world.

Munchkin

Walking on short legs, these cats are adorable. But they are surprising athletic, and like other cats leap and climb trees.

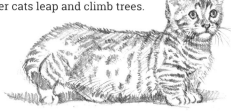

Somali

A long, fluffy tail gives a graceful appearance to this long-haired Abyssinian. Its distinctive tiptoe gait gives it the name "ballet cat."

Russian Blue

Associated with Russian aristocrats, one feature of this cat is its upturned mouth that always seems to be smiling.

American Curl

Bred from cats with a mutation that caused the ears to curl back, this gentle and curious cat has adorable large, expressive eyes and a long tail.

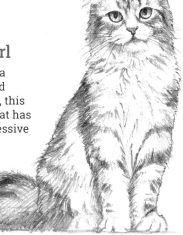

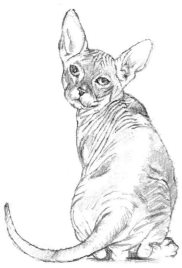

Sphynx

The alien in the movie *E.T.* is said to be based on this hairless cat. The bare skin and wrinkled expression project a mysterious charm.

Persian

The first long-hair breed most people think of, its demeanor is naturally elegant. Docile and friendly to humans, it gave rise to a number of other breeds.

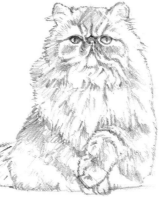

Bengal

Bred from hybrids with wild leopard cats, Bengals are gentle and friendly although they look wild. The spot patterning of the fur is beautiful.

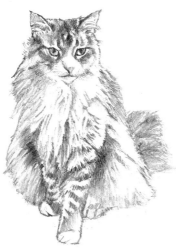

Norwegian Forest Cat

Descended from natives of northern forests, this graceful cat has long fluffy fur that protects against cold and rain. Its eyes are well defined.

TRY IT!

Draw a Maine Coon.

Note: The Maine Coon refers its US state of origin and the resemblance of its progenitors to the raccoon. The large muscular body has long silky fur.

1 The fur of this long-haired breed conceals body contours. Outline the face with its squarish mouth in a slightly flattened oval.

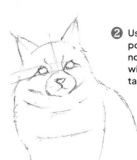

2 Using auxiliary lines, position the eyes and nose. Add large ears, wide at the base, tapering to points.

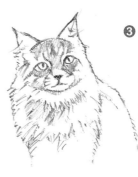

3 Depict the fur while keeping the hidden body contours in mind. The fur is short on the face but increases in length along the body. Shade to make the face 3D.

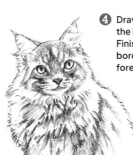

4 Draw overlapping fur and the layered shadows. Finish by clarifying the borders where the head, forelegs and body meet.

Lions

Drawing Fundamentals

The male lion, called the "king of the beasts," has a prominent thick mane and a stout, burly body. Female lions are slimmer and more supple.

❶ Sketch the outline. ➡ **❷ Draw the face and mane.** ➡

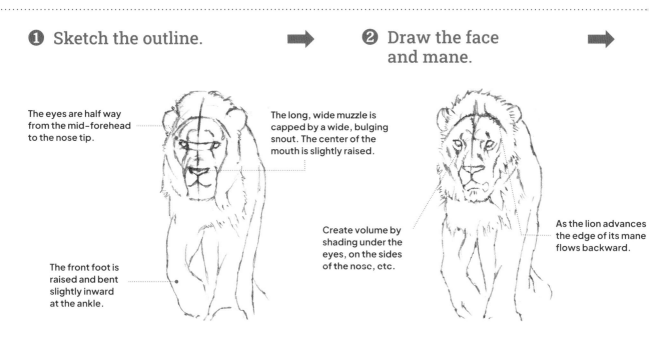

The eyes are half way from the mid-forehead to the nose tip.

The long, wide muzzle is capped by a wide, bulging snout. The center of the mouth is slightly raised.

Create volume by shading under the eyes, on the sides of the nose, etc.

As the lion advances the edge of its mane flows backward.

The front foot is raised and bent slightly inward at the ankle.

Sketch the face, mane and body. Outline the whole lion to fit into a rectangle. Position the eyes, nose and mouth.

While sketching the face and mane, think about the effect of lighting from the right. Make the legs thick.

Physical Features

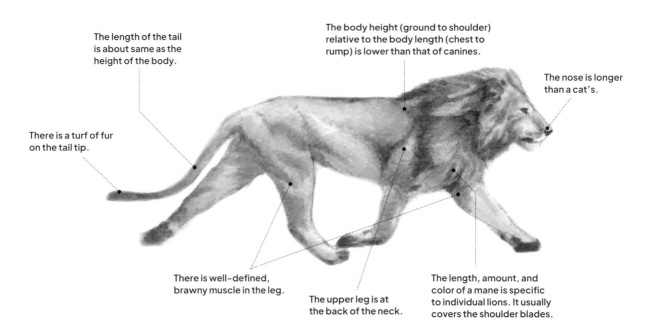

The length of the tail is about same as the height of the body.

The body height (ground to shoulder) relative to the body length (chest to rump) is lower than that of canines.

The nose is longer than a cat's.

There is a turf of fur on the tail tip.

There is well-defined, brawny muscle in the leg.

The upper leg is at the back of the neck.

The length, amount, and color of a mane is specific to individual lions. It usually covers the shoulder blades.

❸ Draw details and add expression.

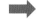

❹ Detail the fur and facial expression.

The eyes of a carnivore look more intense, with a strong outline and white rim below.

The nose and lips are black.

Between the eyes there is an up–down fur-flow border.

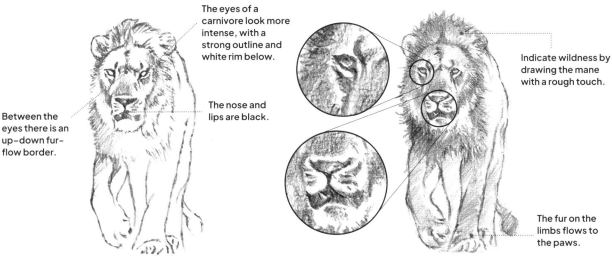

Indicate wildness by drawing the mane with a rough touch.

The fur on the limbs flows to the paws.

Draw the eyes, nose and mouth. Shade and give expression to the face. With an eye to hair flow, draw the mane roughly.

Modulate the shading to create volume. Finish by detailing the eyes.

(See coloring sample on page 45)

Skeletal Features

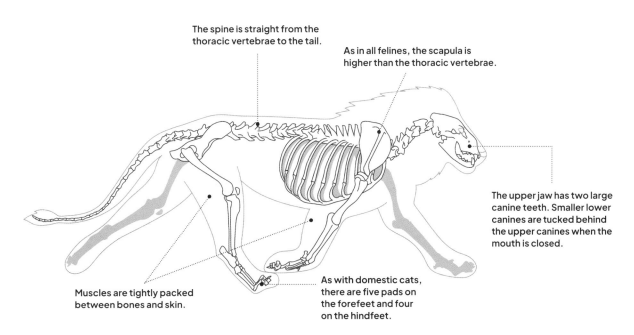

The spine is straight from the thoracic vertebrae to the tail.

As in all felines, the scapula is higher than the thoracic vertebrae.

The upper jaw has two large canine teeth. Smaller lower canines are tucked behind the upper canines when the mouth is closed.

Muscles are tightly packed between bones and skin.

As with domestic cats, there are five pads on the forefeet and four on the hindfeet.

Family: Felidae; Genus: *Panthera*
Lions live in Africa and India. After the tiger, the lion is the second largest cat.
Social lions live in groups called prides.

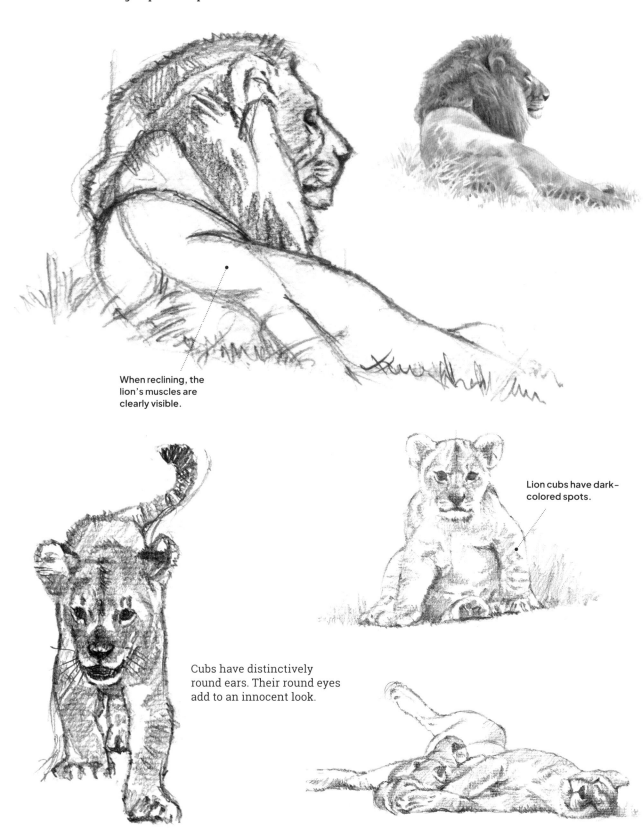

When reclining, the lion's muscles are clearly visible.

Lion cubs have dark-colored spots.

Cubs have distinctively round ears. Their round eyes add to an innocent look.

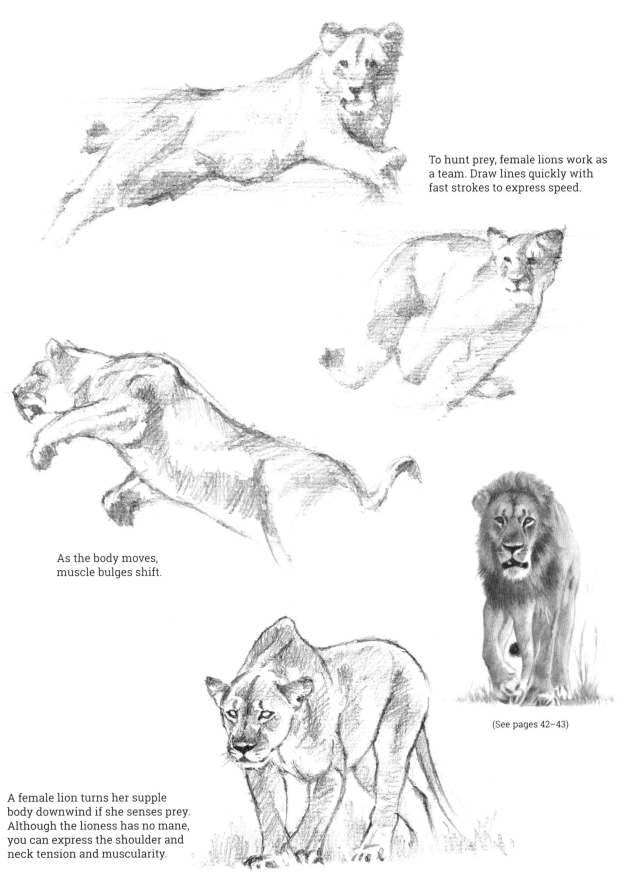

To hunt prey, female lions work as a team. Draw lines quickly with fast strokes to express speed.

As the body moves, muscle bulges shift.

(See pages 42–43)

A female lion turns her supple body downwind if she senses prey. Although the lioness has no mane, you can express the shoulder and neck tension and muscularity.

Tigers

Siberian Tiger

Family: Felidae; Genus: *Panthera*
The distribution of the Siberian Tiger is limited to Russian far east coastal regions and the Amur and Ussuri river basins. Largest among all cats, male Amur tigers may reach nearly 10 feet (3 meters) long and weigh more than 770 pounds (350 kg).

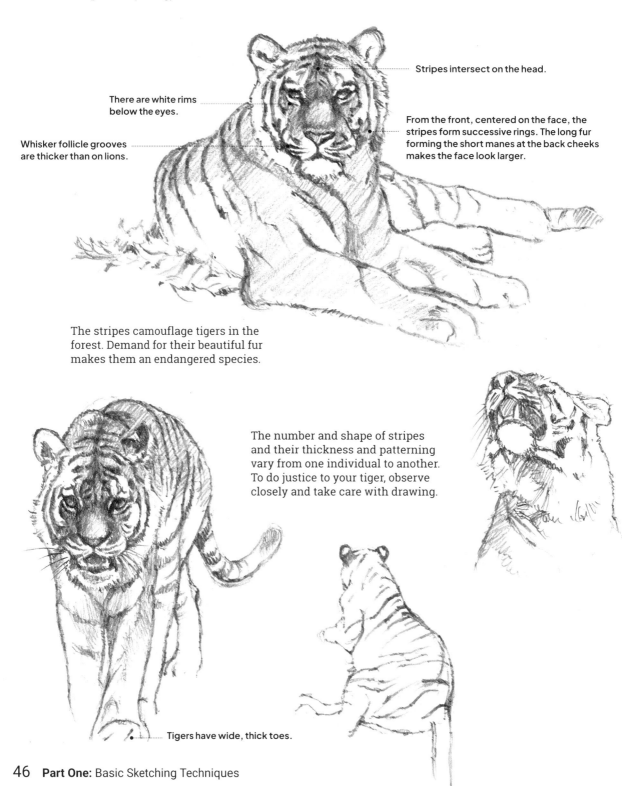

Stripes intersect on the head.

There are white rims below the eyes.

From the front, centered on the face, the stripes form successive rings. The long fur forming the short manes at the back cheeks makes the face look larger.

Whisker follicle grooves are thicker than on lions.

The stripes camouflage tigers in the forest. Demand for their beautiful fur makes them an endangered species.

The number and shape of stripes and their thickness and patterning vary from one individual to another. To do justice to your tiger, observe closely and take care with drawing.

Tigers have wide, thick toes.

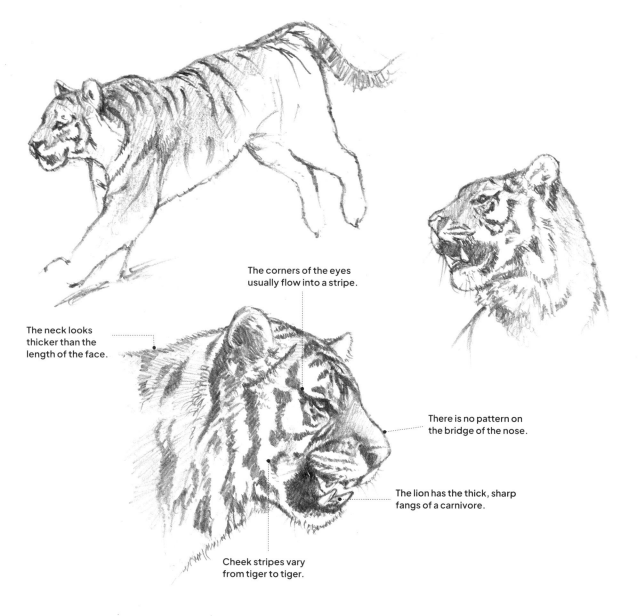

The corners of the eyes usually flow into a stripe.

The neck looks thicker than the length of the face.

There is no pattern on the bridge of the nose.

The lion has the thick, sharp fangs of a carnivore.

Cheek stripes vary from tiger to tiger.

TRY IT! Draw a front view of a resting tiger.

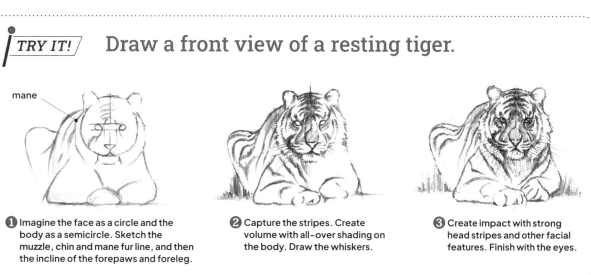

mane

❶ Imagine the face as a circle and the body as a semicircle. Sketch the muzzle, chin and mane fur line, and then the incline of the forepaws and foreleg.

❷ Capture the stripes. Create volume with all-over shading on the body. Draw the whiskers.

❸ Create impact with strong head stripes and other facial features. Finish with the eyes.

Bengal Tiger

Family: Felidae; **Genus:** *Panthera*
The Bengal Tiger lives in India, Nepal, Bhutan and Bangladesh. It has relatively few stripes, especially on the shoulders and chest.

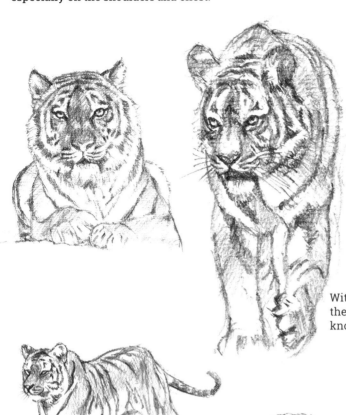

Viewed from above, the stripes, centered on the spine, flow to left and right.

With a single blow, the hefty forepaw can knock down prey.

This skeleton shows gaping jaws. The upper and lower canines are well developed in its large mouth.

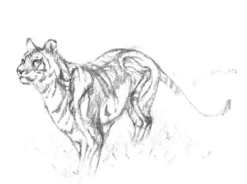

As with other cats, tigers run and walk on tiptoe.

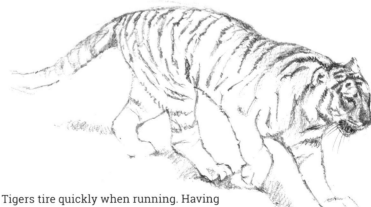

I imagined the skeleton and drew it fleshed out.

Tigers tire quickly when running. Having paws similar to domestic cats, they creep stealthily to pounce on prey.

Leopards

Family: Felidae; Genus: *Panthera*
Known for its spots, the leopard is widely distributed across the African continent, the Arabian Peninsula and Southeast Asia. Its legs are relatively short.

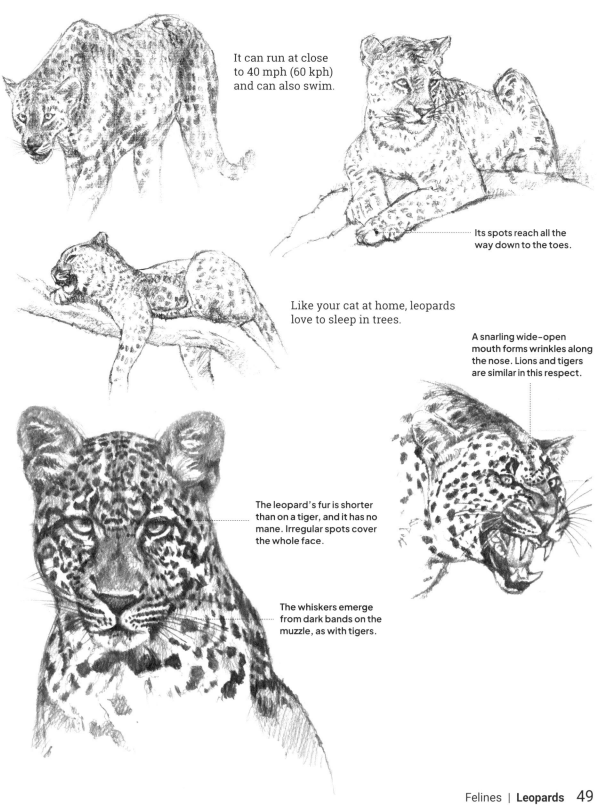

It can run at close to 40 mph (60 kph) and can also swim.

Its spots reach all the way down to the toes.

Like your cat at home, leopards love to sleep in trees.

A snarling wide-open mouth forms wrinkles along the nose. Lions and tigers are similar in this respect.

The leopard's fur is shorter than on a tiger, and it has no mane. Irregular spots cover the whole face.

The whiskers emerge from dark bands on the muzzle, as with tigers.

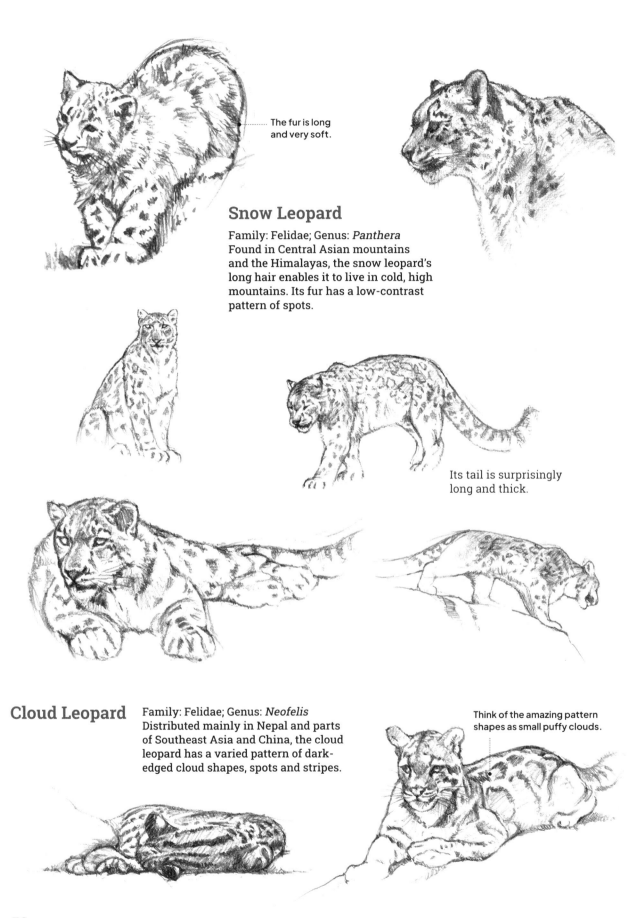

The fur is long and very soft.

Snow Leopard

Family: Felidae; Genus: *Panthera*
Found in Central Asian mountains and the Himalayas, the snow leopard's long hair enables it to live in cold, high mountains. Its fur has a low-contrast pattern of spots.

Its tail is surprisingly long and thick.

Cloud Leopard

Family: Felidae; Genus: *Neofelis*
Distributed mainly in Nepal and parts of Southeast Asia and China, the cloud leopard has a varied pattern of dark-edged cloud shapes, spots and stripes.

Think of the amazing pattern shapes as small puffy clouds.

Cheetahs

Family: Felidae; Genus: *Panthera*
Found in Africa and Iran, the cheetah's fur is gray or brown with spots. Petite and slender, some cheetahs are nearly as long as 5 feet (1.5 m) and can weigh up to 160 pounds (72 kg).

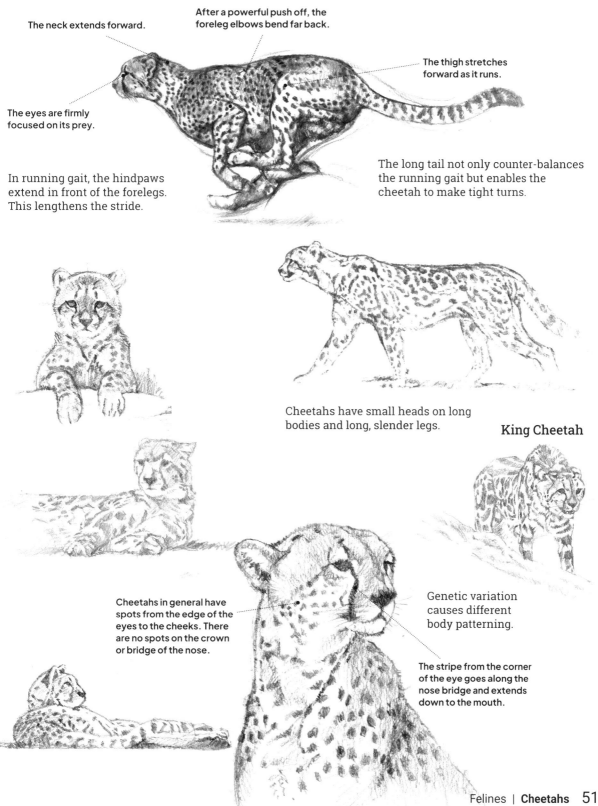

The neck extends forward.

After a powerful push off, the foreleg elbows bend far back.

The thigh stretches forward as it runs.

The eyes are firmly focused on its prey.

The long tail not only counter-balances the running gait but enables the cheetah to make tight turns.

In running gait, the hindpaws extend in front of the forelegs. This lengthens the stride.

Cheetahs have small heads on long bodies and long, slender legs.

King Cheetah

Cheetahs in general have spots from the edge of the eyes to the cheeks. There are no spots on the crown or bridge of the nose.

Genetic variation causes different body patterning.

The stripe from the corner of the eye goes along the nose bridge and extends down to the mouth.

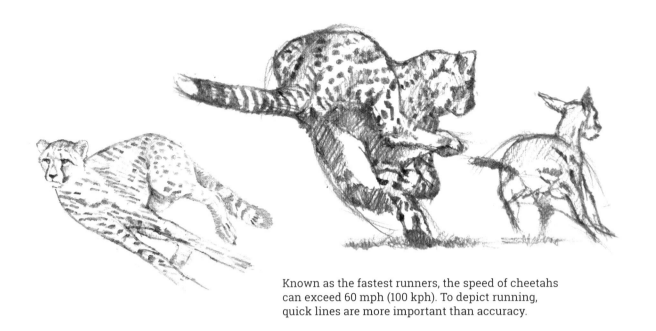

Known as the fastest runners, the speed of cheetahs can exceed 60 mph (100 kph). To depict running, quick lines are more important than accuracy.

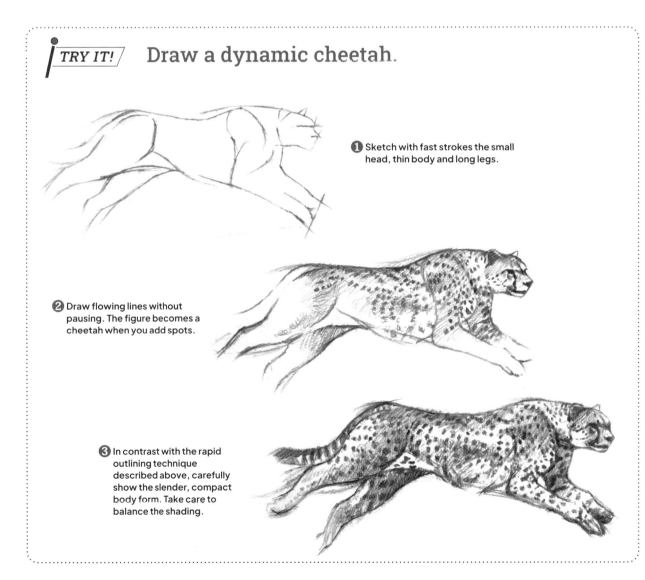

TRY IT! ## Draw a dynamic cheetah.

❶ Sketch with fast strokes the small head, thin body and long legs.

❷ Draw flowing lines without pausing. The figure becomes a cheetah when you add spots.

❸ In contrast with the rapid outlining technique described above, carefully show the slender, compact body form. Take care to balance the shading.

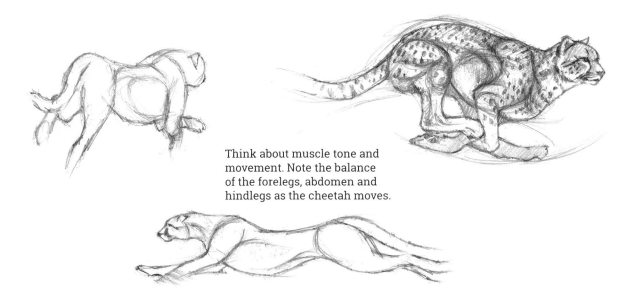

Think about muscle tone and movement. Note the balance of the forelegs, abdomen and hindlegs as the cheetah moves.

Hyenas and Tsushima Leopard Cats

Hyena

Family: Hyaenidae
Related to the family Viverridae, the most primitive of cat-like carnivores, hyenas are found in Africa, India and the Middle East. They have powerful jaws and teeth that can chomp through animal bones.

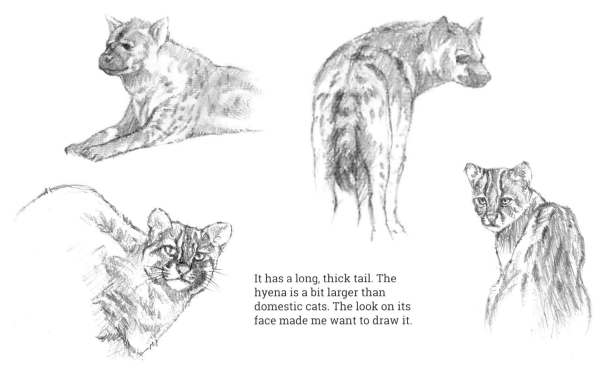

It has a long, thick tail. The hyena is a bit larger than domestic cats. The look on its face made me want to draw it.

Tsushima Leopard Cat

Living wild on the Japanese island of Tsushima, this is a distinct subspecies of leopard cat. It is marked by white spots on the backs of its ears.

Eurasian Lynxes, Bobcats and Other Felines

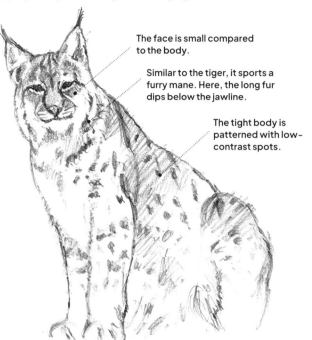

The face is small compared to the body.

Similar to the tiger, it sports a furry mane. Here, the long fur dips below the jawline.

The tight body is patterned with low-contrast spots.

As with other cats, it has a prominent scapula.

The short tail is black at the tip.

There are black tufts of hair on the ear tips.

Eurasian Lynx

Family: Felidae; Genus: *Lynx*
Widely distributed over cold regions of Eurasia, the Eurasian lynx is known to travel 25 miles (40 km) in a night, hunting over large territories. Adults weigh about 48 pounds (22 kg). The tail is short.

Slender, long legs are noticeable when standing. Excellent jumpers, caracals are able to spring up to catch birds in flight.

Caracal

Family: Felidae; Genus: *Caracal*
Indigenous to Africa, Afghanistan, Iran and Northwest India, their signature feature is the long black tufts of hair on the tips of their large ears.

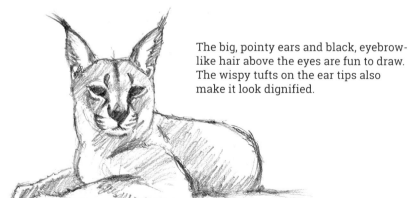

The big, pointy ears and black, eyebrow-like hair above the eyes are fun to draw. The wispy tufts on the ear tips also make it look dignified.

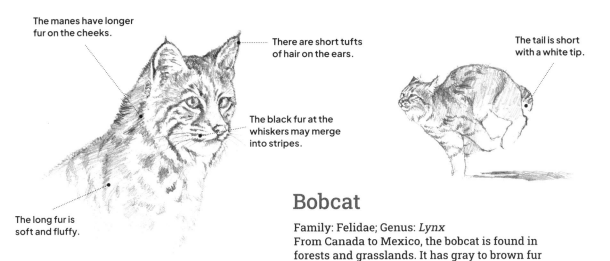

The manes have longer fur on the cheeks.

There are short tufts of hair on the ears.

The black fur at the whiskers may merge into stripes.

The long fur is soft and fluffy.

The tail is short with a white tip.

Bobcat

Family: Felidae; Genus: *Lynx*
From Canada to Mexico, the bobcat is found in forests and grasslands. It has gray to brown fur and cheek manes.

Serval

Family: Felidae; Genus: *Leptailurus*
Found on Sub-Saharan African savannahs, the serval has a small head with large ears rising to rounded tips, a long, slender body and elegantly long limbs. Its yellowish-brown fur is patterned with black spots.

The serval is interesting for its large ears and small face that tightly tapers to the tip of its nose. It has black spots and a striped tail. Capture the ear proportions and fur patterns.

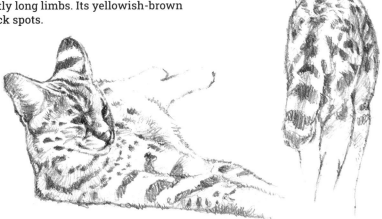

Ocelot

Family: Felidae; Genus: *Leopardus*
Primarily an inhabitant of the tropical rainforests of South and Central America, the ocelot has irregularly patterned short fur in pale gray, yellow and dark brown.

Its face has two horizontal stripes on the forehead with flecks in between. Horizontal stripes occur at the upper corners of the eyes and across the cheeks.

Two to three times bigger than domestic cats, ocelots have short, soft fur with brown patches formed into chain–like patterns. Can you depict these patterns?

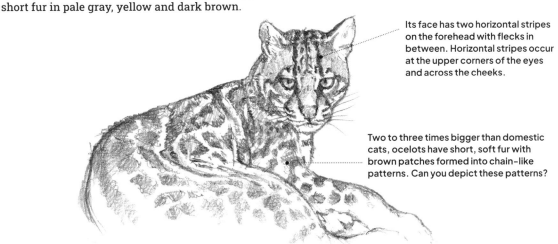

How to Draw Cats and Other Felines

If you understand the structure of the underlying skeleton of an animal, you will be able to successfully draw its form. Let us take a look at a cat and a lion.

Draw with the skeleton in mind: Key points

1 │ Rather than trying to memorize the bone structure of each animal, first visualize the location and balance of the protrusions and axes, and the distance from the skin surface to the bone. Below, you can see this principle applied to reveal skeletal outlines of the domestic cat and the lion.

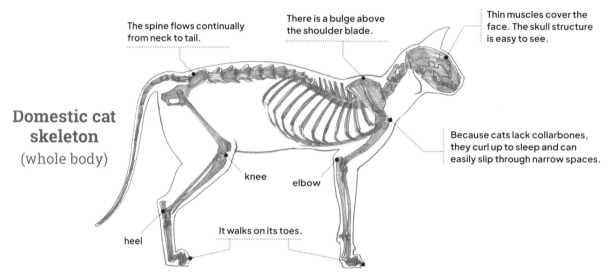

The spine flows continually from neck to tail.

There is a bulge above the shoulder blade.

Thin muscles cover the face. The skull structure is easy to see.

Domestic cat skeleton
(whole body)

Because cats lack collarbones, they curl up to sleep and can easily slip through narrow spaces.

knee

elbow

It walks on its toes.

heel

(*Source:* Gottfried Bammes, *Grosse Tieranatomie*, Ravensburger, 1991)

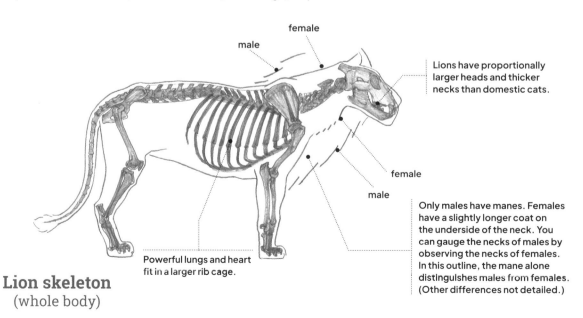

female

male

Lions have proportionally larger heads and thicker necks than domestic cats.

female

male

Only males have manes. Females have a slightly longer coat on the underside of the neck. You can gauge the necks of males by observing the necks of females. In this outline, the mane alone distinguishes males from females. (Other differences not detailed.)

Powerful lungs and heart fit in a larger rib cage.

Lion skeleton
(whole body)

2 | The big difference between large felines such as lions and small domestic cats is the nose length. Muscles around the nose have grown larger to power larger canine teeth and incisors. Eye sockets and eyes are relatively smaller than in cats, and the nose bridge curves less than in dogs.

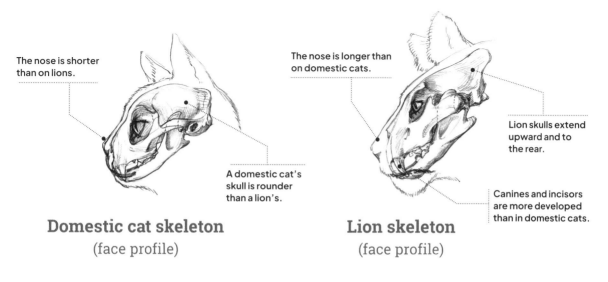

The nose is shorter than on lions.

A domestic cat's skull is rounder than a lion's.

Domestic cat skeleton
(face profile)

The nose is longer than on domestic cats.

Lion skulls extend upward and to the rear.

Canines and incisors are more developed than in domestic cats.

Lion skeleton
(face profile)

Domestic cats: Typical facial expressions

To show different facial expressions of cats, shape the eyelids and pupils.

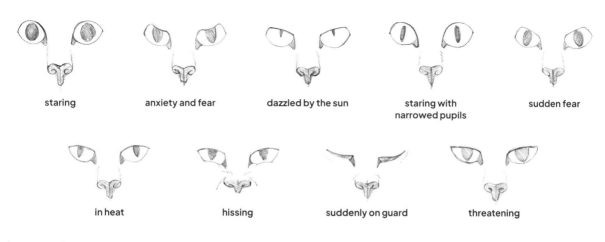

staring

anxiety and fear

dazzled by the sun

staring with narrowed pupils

sudden fear

in heat

hissing

suddenly on guard

threatening

(*Source*: Gottfried Bammes, *Grosse Tieranatomie*, Ravensburger, 1991.)

Dogs

Drawing Fundamentals

Worldwide, more than 300 distinct breeds of dog are recognized. They differ in body size, head shape, ear type, coat length and other features.

1 Sketch in the eyes, nose and body form.

2 Draw the eyes, nose and flow of hair in the coat.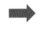

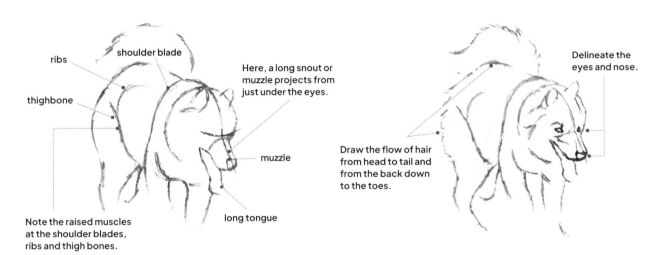

ribs

shoulder blade

thighbone

Here, a long snout or muzzle projects from just under the eyes.

muzzle

long tongue

Note the raised muscles at the shoulder blades, ribs and thigh bones.

Delineate the eyes and nose.

Draw the flow of hair from head to tail and from the back down to the toes.

Outline the face and body and position the eyes. When drawing the body, visualize muscles.

Outline the eyes and nose. When drawing the body, observe the hair length. Include the tail.

Physical Features

Tails can be long and thin or, whether short or long, thick with hair. Spitz tails are curled.

Dog coats can be long or short or, as with terriers, wiry—densely covered with coarse hair.

The ears of some dogs are erect. Others have drooping ears. Size and shape vary.

Dog heads have basically three forms: round, long or square.

Breeds descended from hunting dogs have long snouts. Those originally bred for fighting tend to have short muzzles and square jaws.

In general, the higher the withers height (foot-ground contact to top of shoulder), the longer the leg.

❸ Shade in and draw the coat as well.

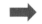

❹ Finish by drawing details.

For long-haired species, pay attention to the flow and overlap of the coat.

Draw the shaded areas.

Draw the shaggy swaying tail of a running dog.

Draw hair in the shadowed area of the coat.

Leave a hint of highlight in the eyes.

Add realism by giving some form to the ground.

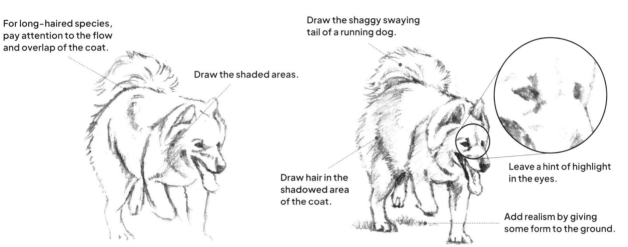

Add shadows to create three-dimensionality. Render the coat with more detail. Draw the legs.

Shade to bring out more details. Keep checking how the parts balance.

Skeletal Features

The shoulder blade moves freely in coordination with the foreleg.

In the absence of collarbones, muscles attach shoulder blades at either side of the skeleton.

As with most other mammals, there are seven cervical vertebrae.

Depending on the breed, the tail has 6–24 vertebrae.

The ribs form an ellipse. Narrow-shouldered hunting dogs are relatively elongated. The ribs of breeds such as pugs and bulldogs are more like circles.

Dogs walk on tiptoe. This enables agile movement.

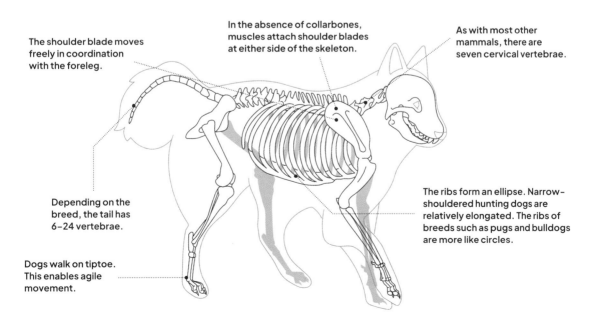

❶ Dog Poses

Faithful and attentive to their owners, dogs show a wide variety of forms. These drawings were made from dog park impressions.

Sitting

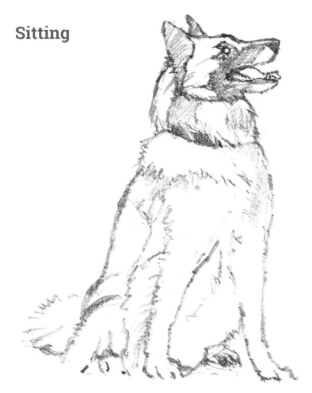

In a proper sitting position, the forelegs are extended and the hindlegs are bent. The back remains upright.

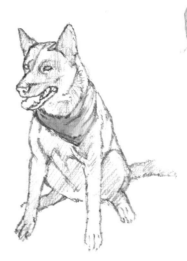

Waiting for a signal, the dog keeps an eye on its owner.

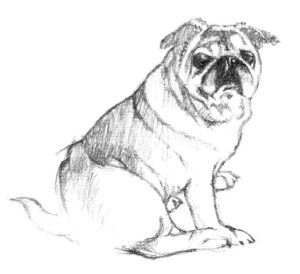

A puppy looks anxiously for its owner. The slightly awkward sitting position and the expression in the eyes are key to showing character.

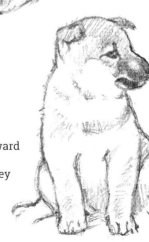

Lying down, a dachshund enjoys a treat.

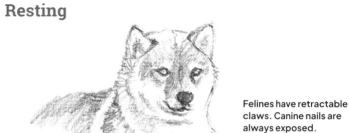

Here, front legs poised, the dog may leap up at any time.

Resting

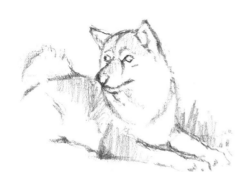

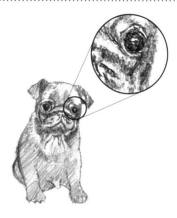

Felines have retractable claws. Canine nails are always exposed.

This dog waits patiently for a signal. I was attracted by its expression. The direction of the gaze must be apparent.

TRY IT! ## Draw a sitting pug.

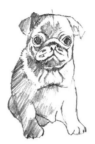

❶ Outline the pug's face in a square. Locate the skin folds, and then sketch in the eyes and nose and outline the body.

❷ Draw the face. The nose is more than halfway up. The eyes are round and large. Clearly show the skin folds. Draw the feet and start shading.

❸ Create unevenness by grading shadows. Do not completely fill in the eyes. Leave highlights.

❷ Capturing Them in Motion

Can you depict the whole-body involvement of dogs playing and running?

Playing

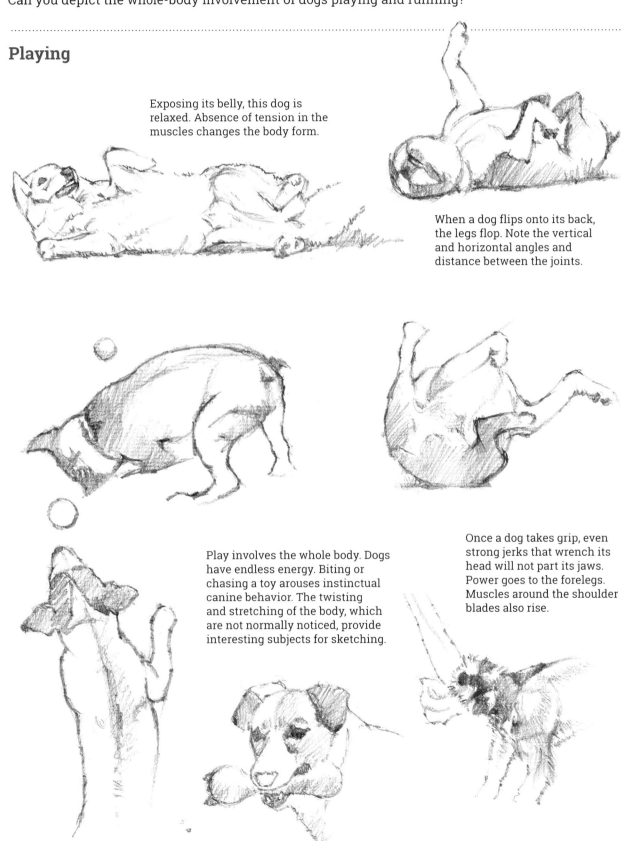

Exposing its belly, this dog is relaxed. Absence of tension in the muscles changes the body form.

When a dog flips onto its back, the legs flop. Note the vertical and horizontal angles and distance between the joints.

Play involves the whole body. Dogs have endless energy. Biting or chasing a toy arouses instinctual canine behavior. The twisting and stretching of the body, which are not normally noticed, provide interesting subjects for sketching.

Once a dog takes grip, even strong jerks that wrench its head will not part its jaws. Power goes to the forelegs. Muscles around the shoulder blades also rise.

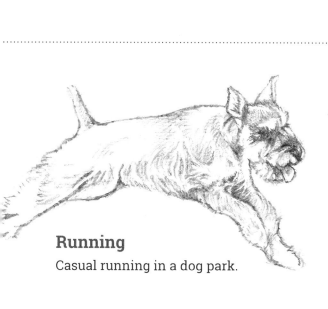

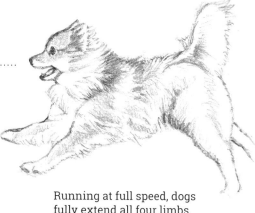

Running at full speed, dogs fully extend all four limbs.

Running

Casual running in a dog park.

This dog is just starting to run. When its hindlegs are pulled in, power transfers to its forelegs. As its hindlegs push off, its forelegs extend.

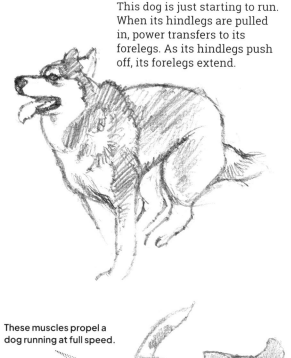

These muscles propel a dog running at full speed.

TRY IT!

Draw a running Shiba Inu.

❶ Outline the round face. Sketch the short snout and triangular ears. Sketch the body. Think about how weight shifts between the front and rear legs of running dogs. Here, the forelimbs are poised for landing.

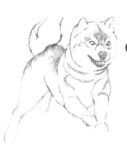

❷ Draw the face. Dynamism is conveyed when the foreleg muscles are well drawn.

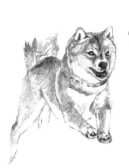

❸ Modulate the shading of the coat. While the body hair is short, the tail is fluffy. Clearly depict the eyes and nose. To give life to the eyes, leave some highlights.

(See coloring sample on page 144)

❸ Dog Breeds

Each dog has its own character, friendly expressions and disposition.
Keep these differences in mind when you draw any dog.

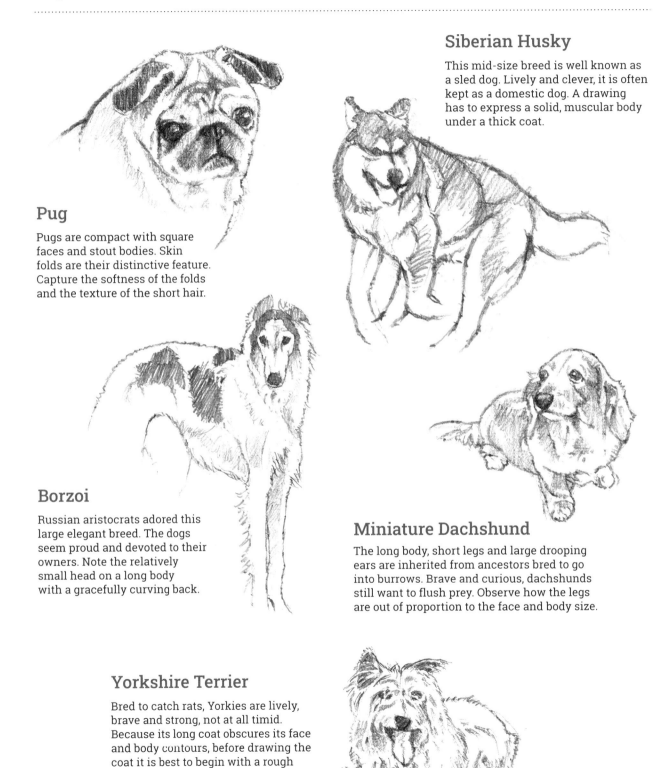

Siberian Husky

This mid-size breed is well known as a sled dog. Lively and clever, it is often kept as a domestic dog. A drawing has to express a solid, muscular body under a thick coat.

Pug

Pugs are compact with square faces and stout bodies. Skin folds are their distinctive feature. Capture the softness of the folds and the texture of the short hair.

Borzoi

Russian aristocrats adored this large elegant breed. The dogs seem proud and devoted to their owners. Note the relatively small head on a long body with a gracefully curving back.

Miniature Dachshund

The long body, short legs and large drooping ears are inherited from ancestors bred to go into burrows. Brave and curious, dachshunds still want to flush prey. Observe how the legs are out of proportion to the face and body size.

Yorkshire Terrier

Bred to catch rats, Yorkies are lively, brave and strong, not at all timid. Because its long coat obscures its face and body contours, before drawing the coat it is best to begin with a rough sketch of the general form.

Pembroke Welsh Corgi

Short-legged and long-bodied, this is the smaller of two breeds of corgi derived from herding lineages in Wales. They have a charming curiosity. Note the short legs and muscular neck and body.

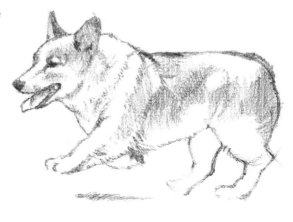

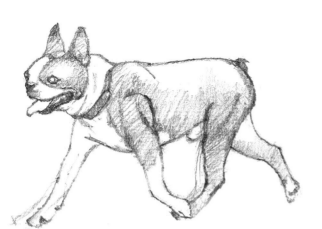

Boston Terrier

As working dogs, Boston terriers used to herd cattle. They are slim with short tails and large ears held erect. Contrasting patterning of the coat on the body and face give it a strong appeal.

Shiba Inu

This signature Japanese breed is the most widely kept dog in Japan. Active and faithful to their owners, many still are used for hunting and as guard dogs. Features include a wide forehead, well-shaped oval eyes, a pointed muzzle and triangular ears that tilt slightly forward.

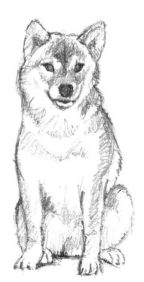

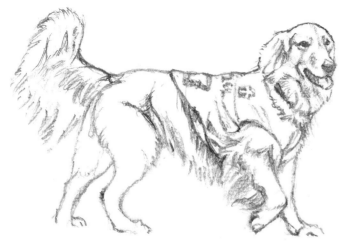

Irish Setter

This cheerful, gentle breed has a luxuriant coat that extends from where the ears droop along the body to the tip of the tail. Because of their color, they are also called "red setters." Before drawing, closely observe the flow of the long, glossy coat.

Wolves

Drawing Fundamentals

The wolf and the domestic dog share similar skeletons. Wolves, however, are wild.
Convey this wildness in your drawings.

❶ Outline the face and limbs.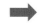

❷ Draw the face and sketch the patterning.

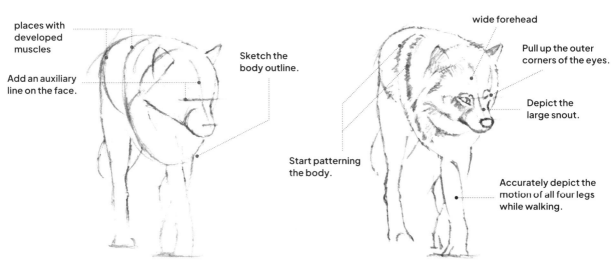

places with developed muscles

Add an auxiliary line on the face.

Sketch the body outline.

wide forehead

Pull up the outer corners of the eyes.

Depict the large snout.

Start patterning the body.

Accurately depict the motion of all four legs while walking.

The oval face has a large snout. The body also fits into an oval outline. Boldly sketch the legs with volume in the thigh muscles.

Draw the eyes, nose, and body patterns. Compared with dogs, wolf eyes are sharper and more angled, and snouts are larger.

Physical Features

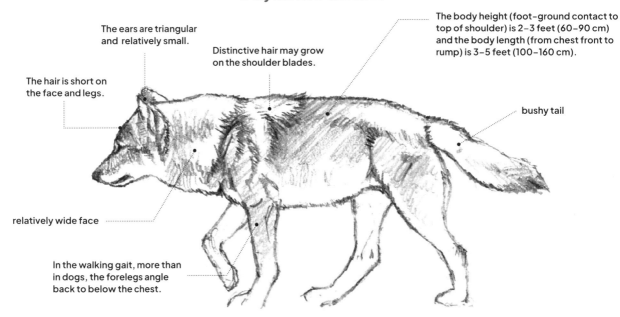

The ears are triangular and relatively small.

Distinctive hair may grow on the shoulder blades.

The body height (foot-ground contact to top of shoulder) is 2–3 feet (60–90 cm) and the body length (from chest front to rump) is 3–5 feet (100–160 cm).

The hair is short on the face and legs.

bushy tail

relatively wide face

In the walking gait, more than in dogs, the forelegs angle back to below the chest.

❸ Detail the coat and add shading.

❹ Color the drawing.

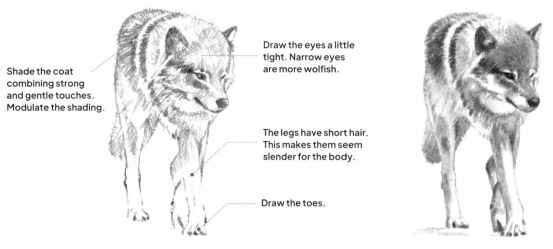

Shade the coat combining strong and gentle touches. Modulate the shading.

Draw the eyes a little tight. Narrow eyes are more wolfish.

The legs have short hair. This makes them seem slender for the body.

Draw the toes.

Shade to create three-dimensionality. Add detail to the coat, too. Clearly draw the feet, including the nails.

Color with watercolors on top of the drawing. Pencil shading is quite effective.
(See coloring sample on page 146)

Skeletal Features

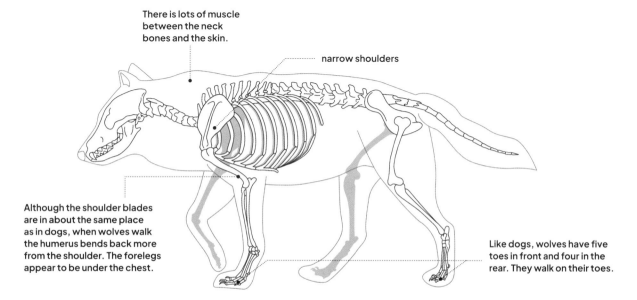

There is lots of muscle between the neck bones and the skin.

narrow shoulders

Although the shoulder blades are in about the same place as in dogs, when wolves walk the humerus bends back more from the shoulder. The forelegs appear to be under the chest.

Like dogs, wolves have five toes in front and four in the rear. They walk on their toes.

Dingos and Other Canines

Wolves

Canis lupus

Wolves live mostly in the northern hemisphere. They are the largest of the existing canids (dog-like carnivores). Their body color is mainly grayish brown, with some white and black. Although wolves generally live in packs, lone wolves driven from the group also exist.

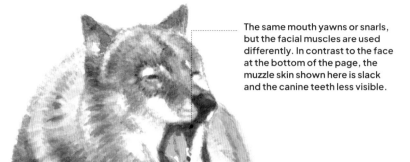

The same mouth yawns or snarls, but the facial muscles are used differently. In contrast to the face at the bottom of the page, the muzzle skin shown here is slack and the canine teeth less visible.

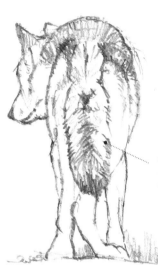

North American wolves survive in packs by hunting elk and reindeer. Generally lean, they have sharp teeth. Their tails are bushy.

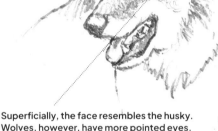

The tail angles down naturally while walking. When running, the tail straightens to line up horizontally with the back. Tails help when making tight turns.

Superficially, the face resembles the husky. Wolves, however, have more pointed eyes. For a wild look, darkly shade around the eyes.

TRY IT! ## Draw a menacing wolf face from the front.

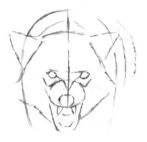

1 The face outline is pentagonal and the body is oval. Eyes closer to the centerline convey threat. Sketch the skin creased by the snarl.

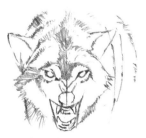

2 Draw the mouth and fangs. With shading in mind, draw the coat. Make sure the open mouth is balanced in the face.

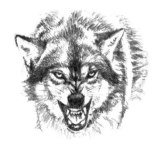

3 Modulate the shading and finish. Take care not to shade too much, as the drawing may become too dark.

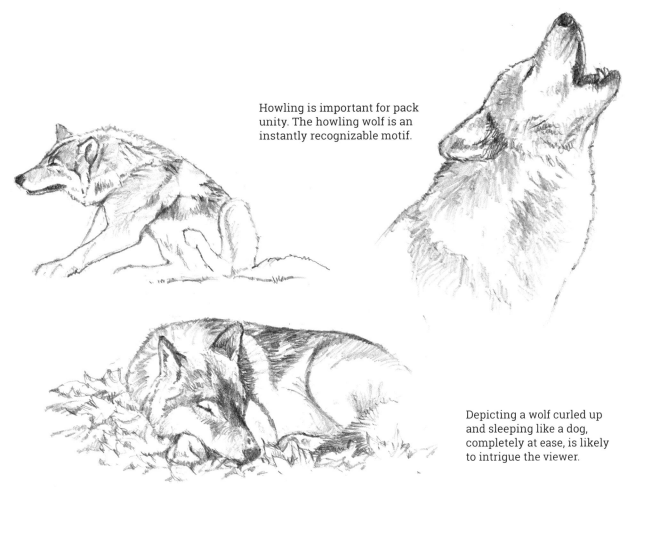

Howling is important for pack unity. The howling wolf is an instantly recognizable motif.

Depicting a wolf curled up and sleeping like a dog, completely at ease, is likely to intrigue the viewer.

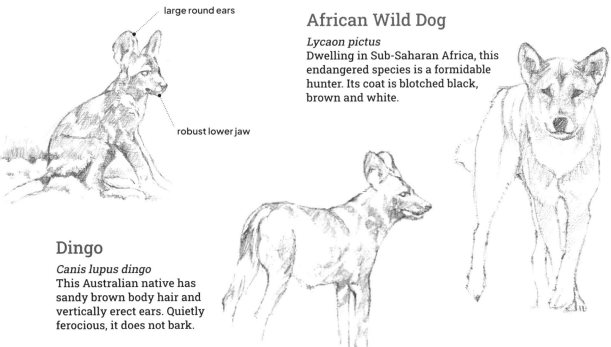

large round ears

robust lower jaw

African Wild Dog

Lycaon pictus
Dwelling in Sub-Saharan Africa, this endangered species is a formidable hunter. Its coat is blotched black, brown and white.

Dingo

Canis lupus dingo
This Australian native has sandy brown body hair and vertically erect ears. Quietly ferocious, it does not bark.

Foxes and Jackals

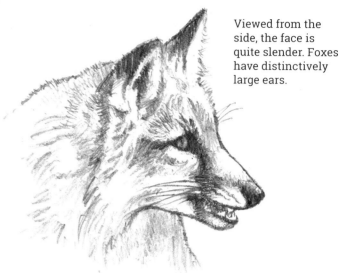

Viewed from the side, the face is quite slender. Foxes have distinctively large ears.

Kitsune Fox

Vulpes vulpes japonica
Found all over the world, foxes eat meat by preference but can also eat other things and adapt to many environments. They are small canines with large ears and fluffy tails.

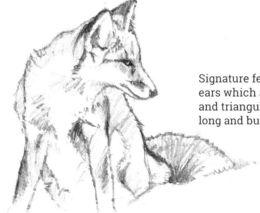

Foxes resemble some mid-sized dogs. As in cats, fox pupils are vertical slits.

Signature features are the ears which are large, erect and triangular. The tail is long and bushy.

For the body size, the fluffy tail is large.

slender legs and petite toes

Black-backed Jackal

Canis mesomelas
Living in eastern and southern Africa, the jackal has a slim body and large ears. The coat is marked by salt-and-pepper stippling at the back and neck.

The name derives from patterning that extends from the neck and along the back. The tail is black.

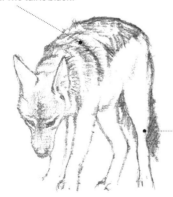

It has slender ears, longer than those of the fox.

The long legs are even more slender than those of the fox.

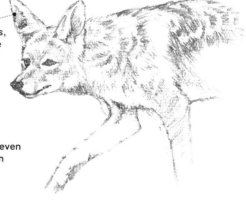

The tanuki often features in Japanese folk tales. Encountered in Japan in managed woodland on mountain slopes near farming villages, it looks portly.

Despite the pointy face, the tanuki looks plump.

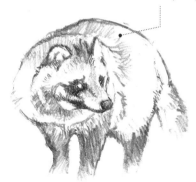

Tanuki

Originally found only in East Asia, tanuki have ranged across Asia into northern and western Europe. The tanuki looks stocky, but its legs and tail are surprisingly long.

Randomly occurring white to dark brown fur covers the body. The fur from the eyes and cheeks to the chin is dark brown.

Its ears are on the small side.

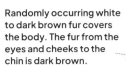

Fur from the back to the forelegs and on the hindlegs may often be dark brown.

▌*TRY IT!* Draw the tanuki at an angle from the front.

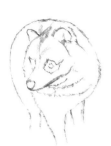

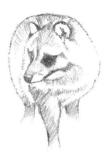

❶ Outlined in a widened rhomboid, the face has a slender projecting snout. Sketch the rounded body and draw the surprisingly long legs.

❷ Draw in the black fur around the eyes and add shading to the boundary between the neck and body.

❸ Make it look like a tanuki by accenting the black around the eyes and nose and the edge of the ears.

How to Draw Dogs and Canines

The skeletal structure of dogs and cats (both mammals) is the same.
Below, for comparison, a human skeleton is also shown.

Draw with the skeleton in mind: Key points

1 Here, side-by-side, are the skeletons of a human on all fours and a canine. The positioning of the joints, spine and ribs is quite similar. While the bones vary in length, curvature and number, the skeletal structure is basically the same.

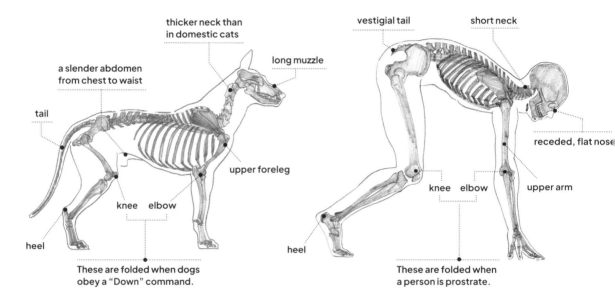

a slender abdomen from chest to waist

thicker neck than in domestic cats

long muzzle

tail

upper foreleg

knee elbow

heel

These are folded when dogs obey a "Down" command.

Great Dane skeleton
(whole body)

vestigial tail

short neck

receded, flat nose

knee elbow upper arm

heel

These are folded when a person is prostrate.

Human skeleton
(whole body)

Dachshund skeleton
(whole body)

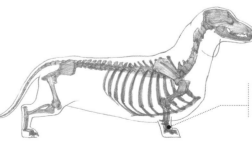

The head and body are similar to mid-size dogs. However, the legs of dachshunds are very short.

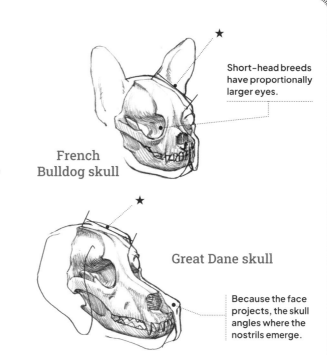

French
Bulldog skull

Short-head breeds
have proportionally
larger eyes.

Great Dane skull

Because the face
projects, the skull
angles where the
nostrils emerge.

2 Dogs have three main head forms. Going by length from nose to skull top (★), short-head breeds (French bulldog, pug, etc.) have short noses; long-head breeds (Great Dane, collie, husky, etc.) have long muzzles; and, in between, the noses of medium-head breeds (pomeranian, Labrador retriever, corgi, etc.) are neither long nor short.

Mammalian feet and hand configurations

Mammalian extremities can be classified according to the number of digits: humans, cats, dogs and bears have five; deer, goats and cattle have two; and horses have a single digit. Deer and horse feet have vestigial digit bones.

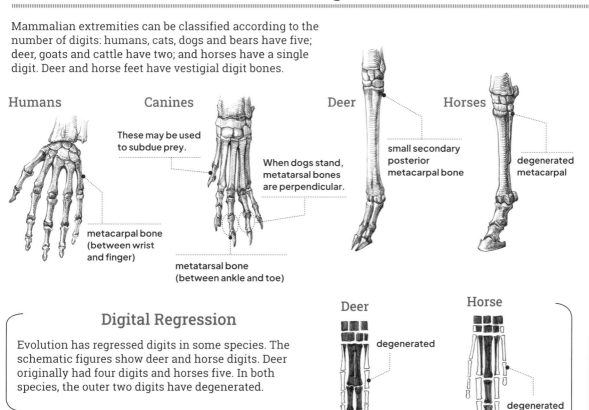

Humans

Canines

These may be used to subdue prey.

When dogs stand, metatarsal bones are perpendicular.

metacarpal bone (between wrist and finger)

metatarsal bone (between ankle and toe)

Deer

small secondary posterior metacarpal bone

Horses

degenerated metacarpal

Digital Regression

Evolution has regressed digits in some species. The schematic figures show deer and horse digits. Deer originally had four digits and horses five. In both species, the outer two digits have degenerated.

Deer

degenerated

Horse

degenerated

(*Source*: Gottfried Bammes, *Grosse Tieranatomie*, Ravensburger, 1991.)

Horses

Drawing Fundamentals

You can readily see the working of equine muscles. Horses are excellent subjects for sketching, but they require careful observation.

❶ Contour sketching Sketch the contours of the face and body. Look closely and draw the rise and fall of the muscles.

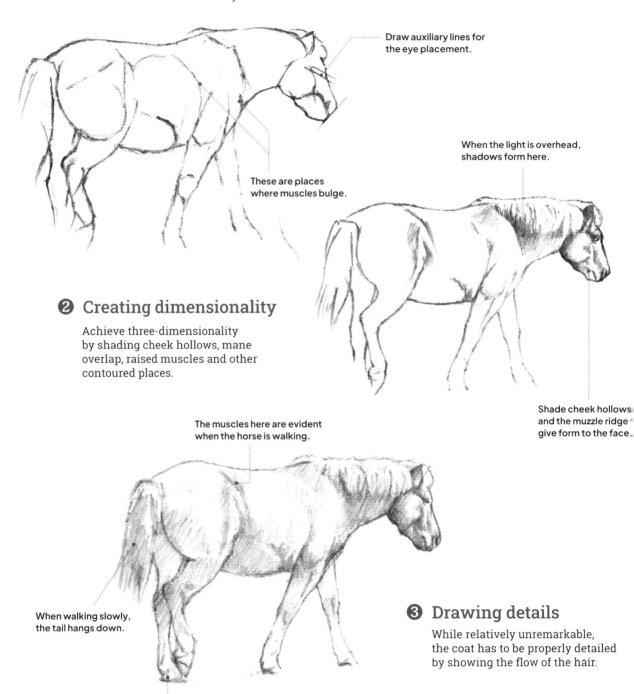

Draw auxiliary lines for the eye placement.

These are places where muscles bulge.

When the light is overhead, shadows form here.

❷ Creating dimensionality

Achieve three-dimensionality by shading cheek hollows, mane overlap, raised muscles and other contoured places.

Shade cheek hollows and the muzzle ridge give form to the face.

The muscles here are evident when the horse is walking.

When walking slowly, the tail hangs down.

❸ Drawing details

While relatively unremarkable, the coat has to be properly detailed by showing the flow of the hair.

Draw the hooves as well.

Physical Features

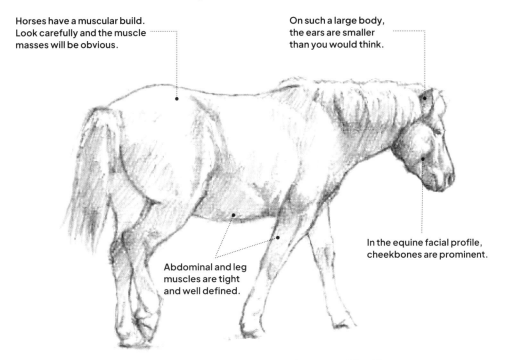

Horses have a muscular build. Look carefully and the muscle masses will be obvious.

On such a large body, the ears are smaller than you would think.

Abdominal and leg muscles are tight and well defined.

In the equine facial profile, cheekbones are prominent.

The Dosanko or Hokkaidō Horse

According to body size, horses may be classed as heavy, intermediate, light or pony. This Japanese breed is heavy. In contrast, racing thoroughbreds are light.

Skeletal Features

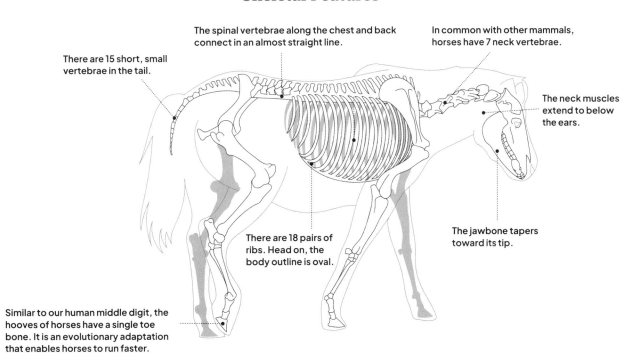

There are 15 short, small vertebrae in the tail.

The spinal vertebrae along the chest and back connect in an almost straight line.

In common with other mammals, horses have 7 neck vertebrae.

The neck muscles extend to below the ears.

There are 18 pairs of ribs. Head on, the body outline is oval.

The jawbone tapers toward its tip.

Similar to our human middle digit, the hooves of horses have a single toe bone. It is an evolutionary adaptation that enables horses to run faster.

Horses and Zebras

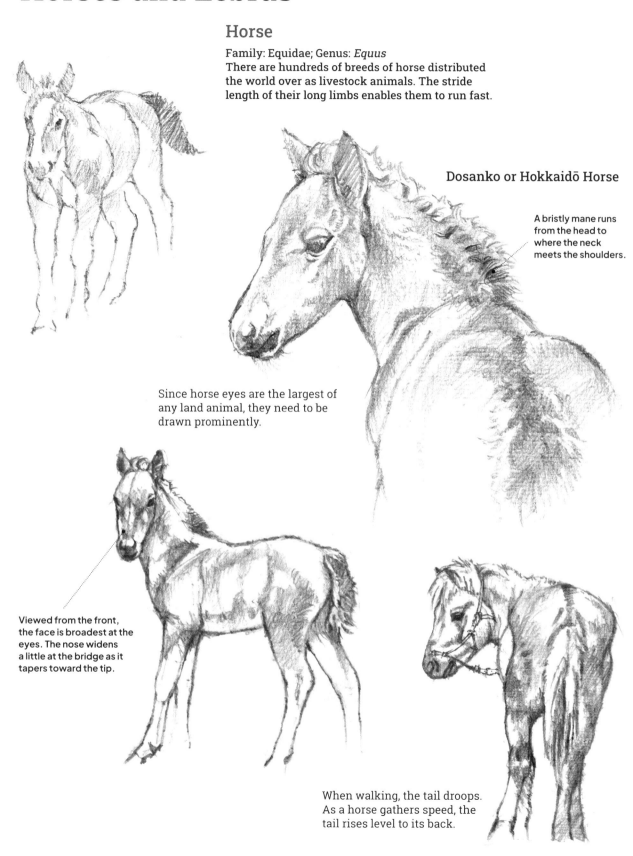

Horse

Family: Equidae; Genus: *Equus*
There are hundreds of breeds of horse distributed the world over as livestock animals. The stride length of their long limbs enables them to run fast.

Dosanko or Hokkaidō Horse

A bristly mane runs from the head to where the neck meets the shoulders.

Since horse eyes are the largest of any land animal, they need to be drawn prominently.

Viewed from the front, the face is broadest at the eyes. The nose widens a little at the bridge as it tapers toward the tip.

When walking, the tail droops. As a horse gathers speed, the tail rises level to its back.

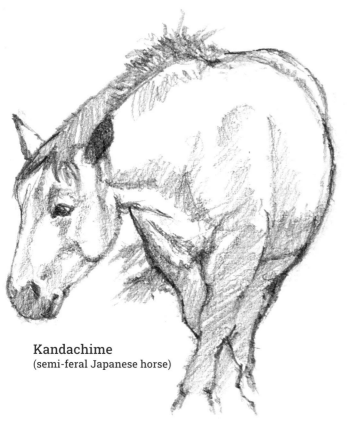

Look closely at the body of this horse and you can clearly see areas of light and shade that vary each time a horse moves. This interplay of muscle and bone inspires you to draw horses.

Kandachime
(semi-feral Japanese horse)

Zebra Family: Equidae; Genus: *Equus*

Indigenous to Africa, the zebra is noted for its black-and-white full-body stripe patterning, large ears and brushy tail tip. Zebras violently resist attempts to tame them.

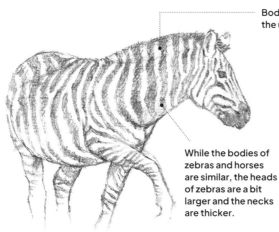

Body stripes continue into the upright bristly mane.

While the bodies of zebras and horses are similar, the heads of zebras are a bit larger and the necks are thicker.

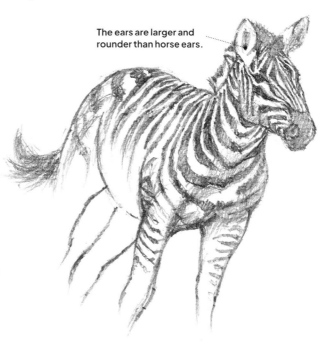

The ears are larger and rounder than horse ears.

Each zebra has a different pattern. Generally, a thin vertical stripe runs down the middle of the face. Stripes change direction at the cheek and shoulder, becoming thicker toward the rump.

Deer, Moose and Reindeer

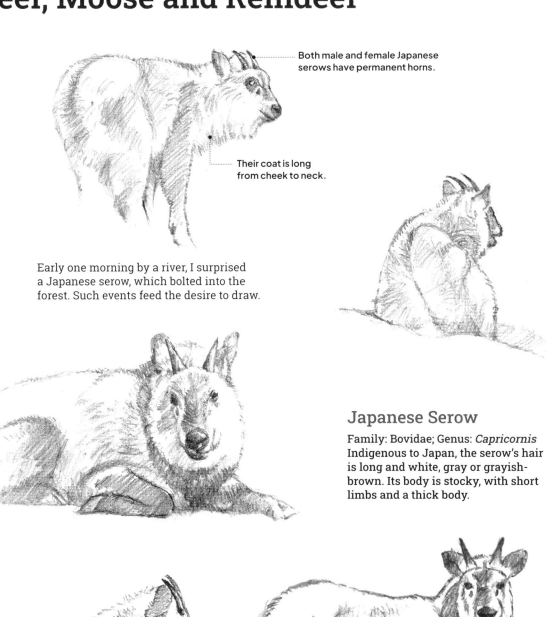

Both male and female Japanese serows have permanent horns.

Their coat is long from cheek to neck.

Early one morning by a river, I surprised a Japanese serow, which bolted into the forest. Such events feed the desire to draw.

Japanese Serow

Family: Bovidae; Genus: *Capricornis*
Indigenous to Japan, the serow's hair is long and white, gray or grayish-brown. Its body is stocky, with short limbs and a thick body.

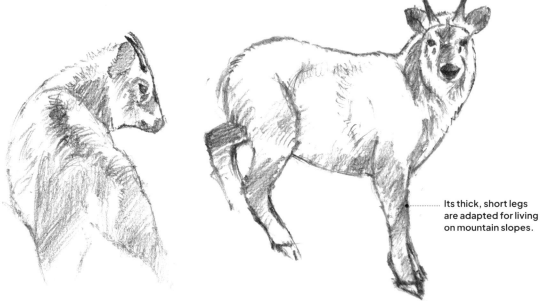

Its thick, short legs are adapted for living on mountain slopes.

Moose or Elk

Family: Cervidae; Genus: *Alces*

This largest member of the deer family ranges across northern Europe, Russia and northern North America. The shoulder height and antler span are about the same (6 feet 6 inches or 2 meters). Despite its size, it can run fast and is also a good swimmer.

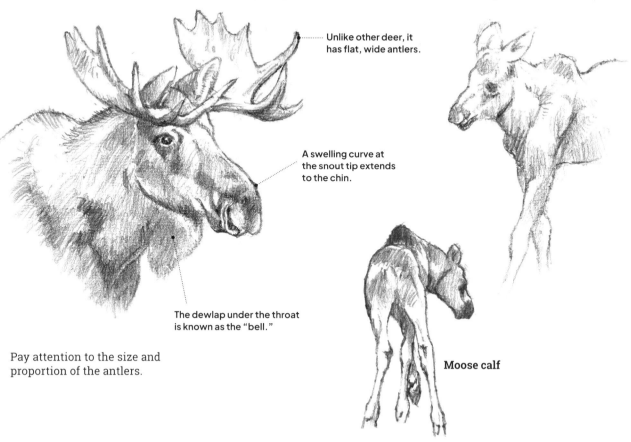

Unlike other deer, it has flat, wide antlers.

A swelling curve at the snout tip extends to the chin.

The dewlap under the throat is known as the "bell."

Pay attention to the size and proportion of the antlers.

Moose calf

Reindeer

Family: Cervidae; Genus: *Rangifer*

Living mainly around the Arctic Circle, reindeer have thick fur and wide hooves for walking on snow. Unlike other deer, both males and females have antlers.

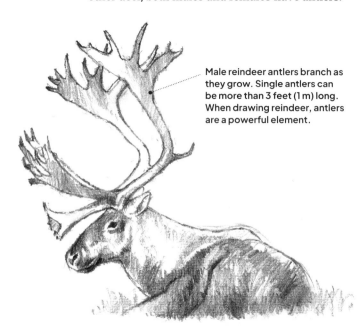

Male reindeer antlers branch as they grow. Single antlers can be more than 3 feet (1 m) long. When drawing reindeer, antlers are a powerful element.

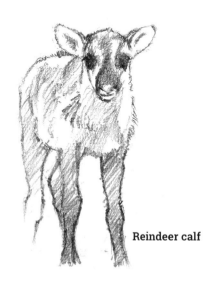

Reindeer calf

Without antlers, young reindeer are hard to identify. They are best depicted with an adult.

Hokkaidō Sika Deer

Family: Cervidae; Genus: *Cervus*
The coat of this large deer is brown in summer and grayish brown in winter. The rump hair is always white.

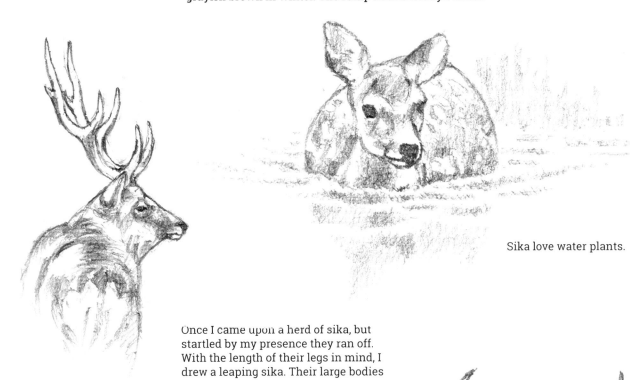

Sika love water plants.

Once I came upon a herd of sika, but startled by my presence they ran off. With the length of their legs in mind, I drew a leaping sika. Their large bodies aid survival in a cold climate.

Thick at first, antlers become thinner toward their tips.

Japanese Deer

Family: Cervidae; Genus: *Cervus*
Their brown coats have white spots in summer but none in winter. The rumps are always white. In early spring, males shed their antlers and start growing new ones.

If the whole antler is shown, the face looks smaller.

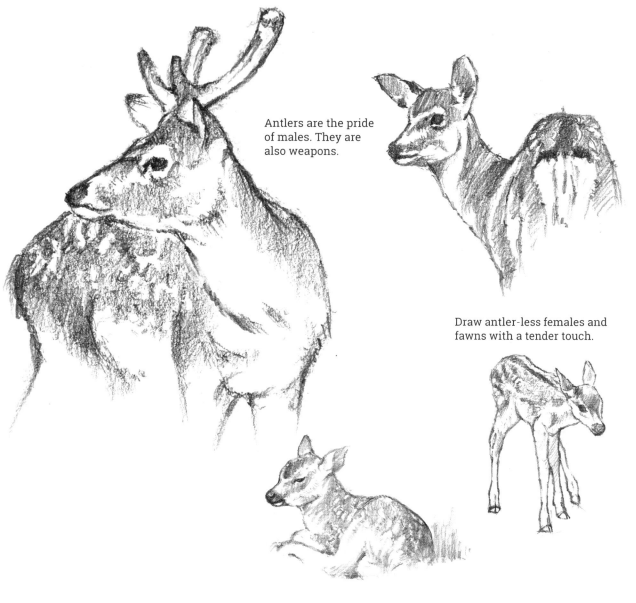

Antlers are the pride of males. They are also weapons.

Draw antler-less females and fawns with a tender touch.

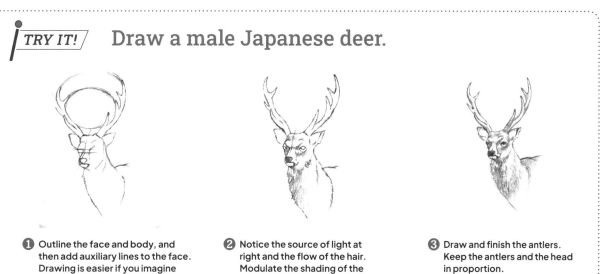

TRY IT! Draw a male Japanese deer.

1 Outline the face and body, and then add auxiliary lines to the face. Drawing is easier if you imagine an oval between the antlers.

2 Notice the source of light at right and the flow of the hair. Modulate the shading of the coat as you draw.

3 Draw and finish the antlers. Keep the antlers and the head in proportion.

Bison and Buffalo

American Bison

Family: Bovidae; Genus: *Bison*
These North American beasts are stocky. Both males and females have curved horns and shaggy hair from the head and shoulders to the forehooves.

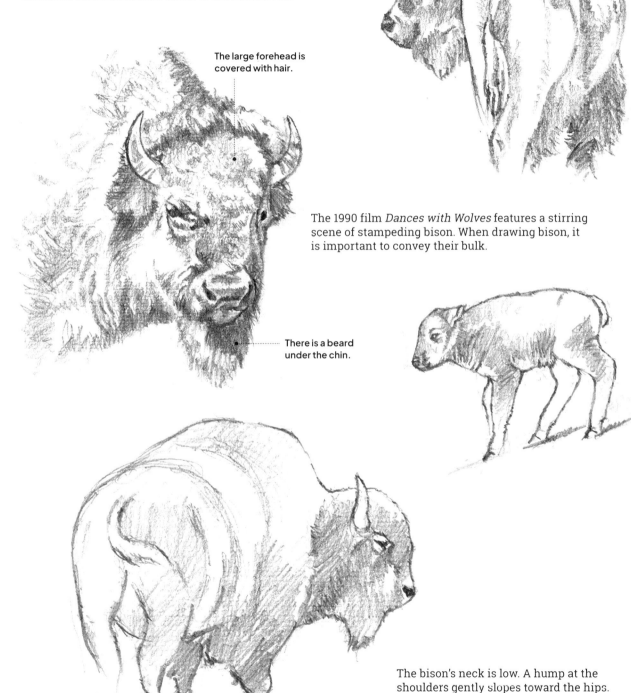

The large forehead is covered with hair.

There is a beard under the chin.

The 1990 film *Dances with Wolves* features a stirring scene of stampeding bison. When drawing bison, it is important to convey their bulk.

The bison's neck is low. A hump at the shoulders gently slopes toward the hips. The body form is very distinctive. Note how the coat-hair length and texture vary.

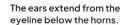
The ears extend from the eyeline below the horns.

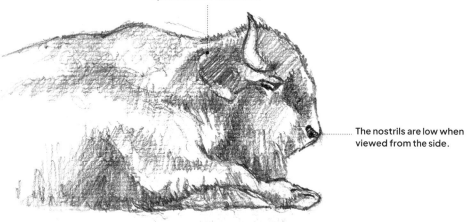
The nostrils are low when viewed from the side.

African Buffalo

Family: Bovidae; Genus: *Syncerus*
Indigenous to Sub-Saharan Africa, buffalo have coats of short black or brown hair. Curved horns perch on the heads of both males and females.

Take the width of the face as 1. From the centerline to the outer edge of each horn, both left and right, the width is 1.5. Using these proportions, draw confidently.

The large ears next to the cheeks are fringed with hair.

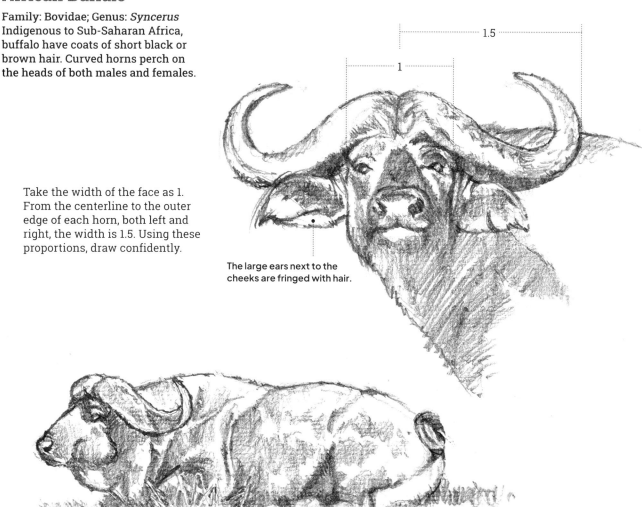

At Amboseli National Park in Kenya, I saw this African buffalo wallowing in mud. Draw the horns as faithfully as you can.

Wild Boar

Family: Suidae; Genus: *Sus*

Once limited to Asia and Europe, wild boar have spread
to the United States and Australia. Alert and intelligent,
boars may charge you with a surprising burst of speed.

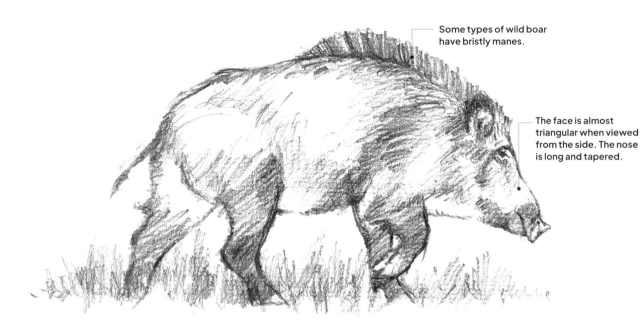

Some types of wild boar
have bristly manes.

The face is almost
triangular when viewed
from the side. The nose
is long and tapered.

Using their tough snouts like a shovel,
wild boars can dig up roots and other food.
Note how the back curves to the head.

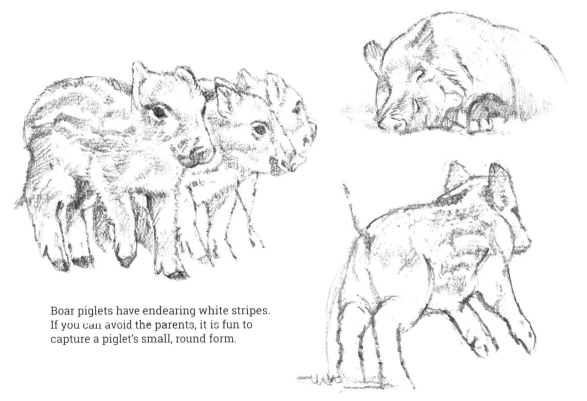

Boar piglets have endearing white stripes.
If you can avoid the parents, it is fun to
capture a piglet's small, round form.

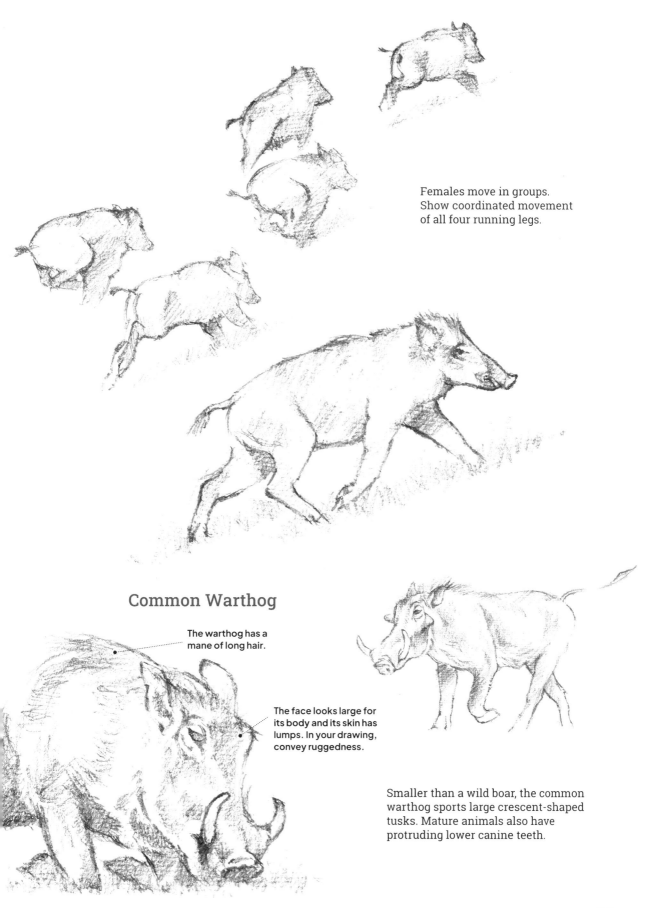

Females move in groups.
Show coordinated movement
of all four running legs.

Common Warthog

The warthog has a
mane of long hair.

The face looks large for
its body and its skin has
lumps. In your drawing,
convey ruggedness.

Smaller than a wild boar, the common
warthog sports large crescent-shaped
tusks. Mature animals also have
protruding lower canine teeth.

African Elephants

Family: Elephantidae; Genus: *Loxodonta*
The world's largest terrestrial animal is native to the savannahs and forests of Africa. Each has large ears and a prehensile trunk that handles as much as 300 pounds (140 kg) of food a day.

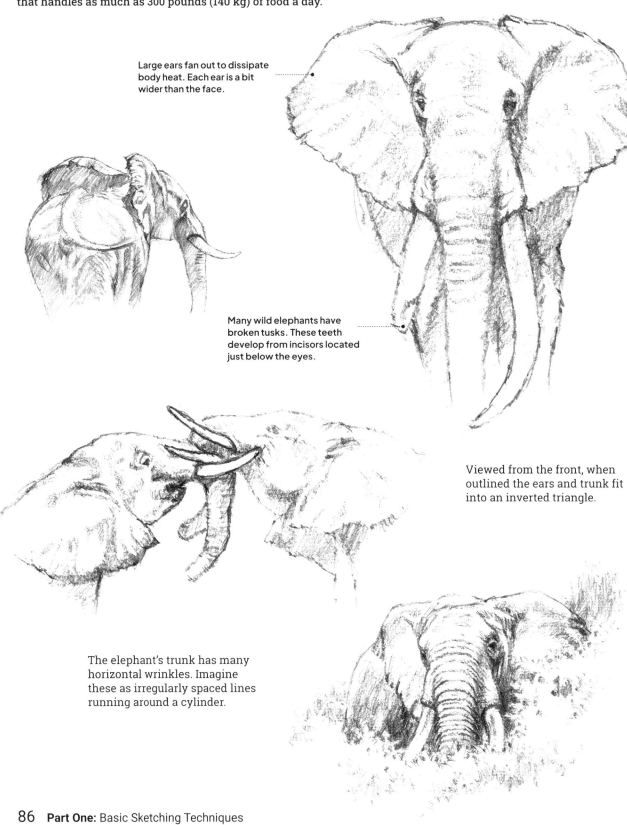

Large ears fan out to dissipate body heat. Each ear is a bit wider than the face.

Many wild elephants have broken tusks. These teeth develop from incisors located just below the eyes.

Viewed from the front, when outlined the ears and trunk fit into an inverted triangle.

The elephant's trunk has many horizontal wrinkles. Imagine these as irregularly spaced lines running around a cylinder.

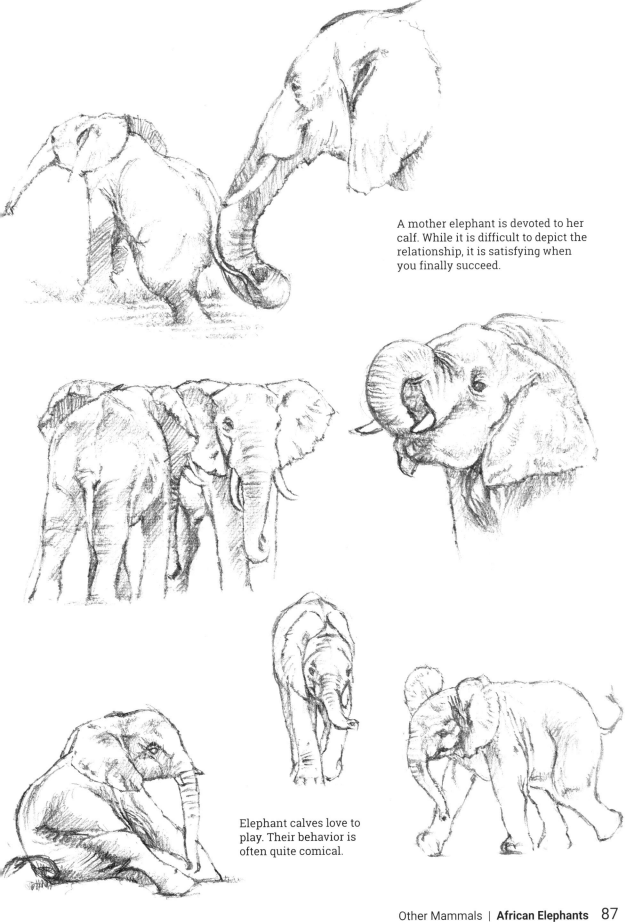

A mother elephant is devoted to her calf. While it is difficult to depict the relationship, it is satisfying when you finally succeed.

Elephant calves love to play. Their behavior is often quite comical.

Giraffes

Family: Giraffidae; Genus: *Giraffa*
Native to Sub-Saharan Africa, giraffes, the tallest animals on earth, have an average height of 15–20 feet (4.5–6 m). Their tongues, which may be 20 inches (50 cm) long, are used to pluck leaves from tall trees.

Giraffes have gentle eyes. Both males and females have a pair of horn-like bone protrusions on their heads. Some have a hump in the middle of their foreheads.

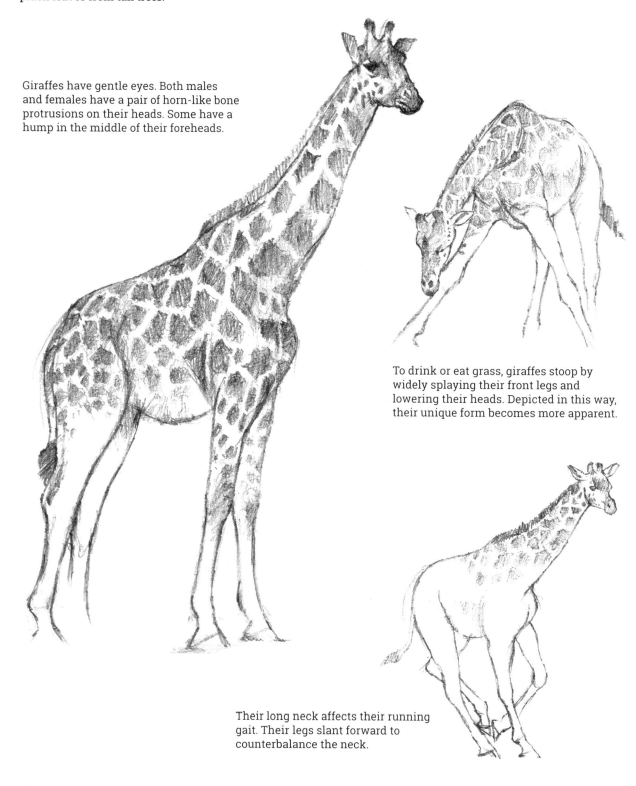

To drink or eat grass, giraffes stoop by widely splaying their front legs and lowering their heads. Depicted in this way, their unique form becomes more apparent.

Their long neck affects their running gait. Their legs slant forward to counterbalance the neck.

Hippopotamus

Family: Hippopotamidae; Genus: *Hippopotamus*

Another Sub-Saharan species, hippos have thick hides. Unable to adequately regulate their body temperature when it is hot, they take to the water.

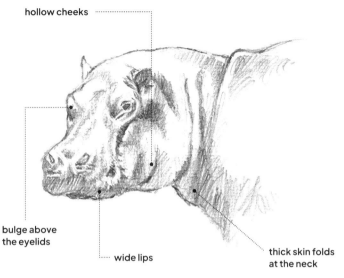

hollow cheeks

bulge above
the eyelids

wide lips

thick skin folds
at the neck

Hippo calf

Related to pigs, hippos have huge bodies supported by short, thick legs. You need to take into account the proportions of the head, torso and limbs.

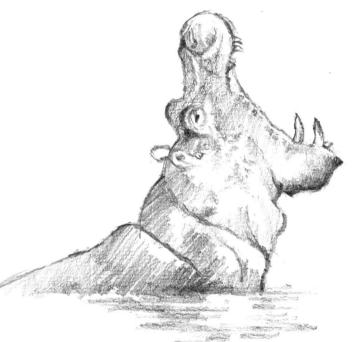

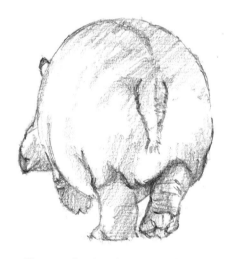

I still remember hearing a schoolgirl at the zoo say how the rear end of a hippo was like a sweet *ohagi* rice ball. From behind, the outline is ovoid.

Hippos skip lightly on their feet under water. When a hippo is almost fully submerged, its eyes, ears and nose can remain above the surface.

Rhinoceros

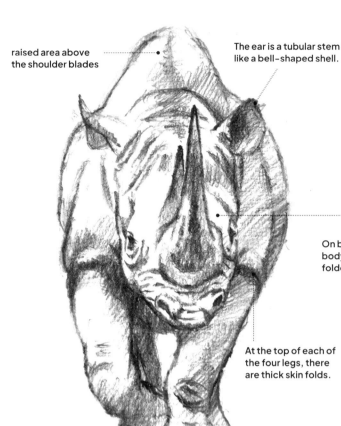

raised area above the shoulder blades

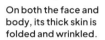
The ear is a tubular stem like a bell-shaped shell.

Black Rhinoceros

Family: Rhinocerotidae; Genus: *Diceros*
Found in Sub-Saharan Africa, the rhino's gray or grayish-brown thick skin may be dusted by soil. Its head and ears are small. Its two horns line up one behind the other.

On both the face and body, its thick skin is folded and wrinkled.

At the top of each of the four legs, there are thick skin folds.

Black rhino calf

The calf has no horn yet, but look at the prominent ears.

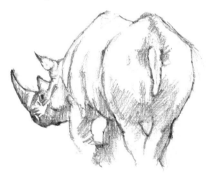

Because the horn is used in traditional Chinese medicine, poaching remains a threat. Give prominence to the rhino's proud horn.

TRY IT! Draw a black rhino's face from an angle.

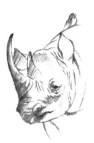

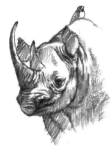

❶ Outline the face in a slightly angled oval. Sketch in the horns and ears.

❷ The angle lets you show the two horns. Carefully observe and draw the skin wrinkles and shadows on the face.

❸ Exploit the whiteness of the paper with powerful contrasting black lines. The bird on the back adds interest.

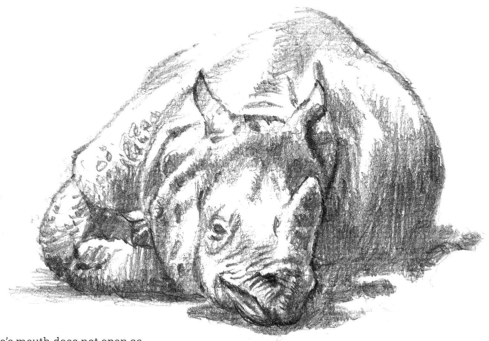

A rhino's mouth does not open as wide as a hippo's. The hippo also has four toes, rhinos only three.

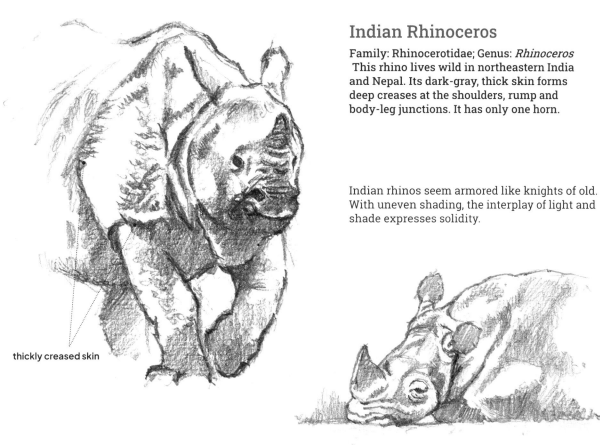

thickly creased skin

Indian Rhinoceros

Family: Rhinocerotidae; Genus: *Rhinoceros*
This rhino lives wild in northeastern India and Nepal. Its dark-gray, thick skin forms deep creases at the shoulders, rump and body-leg junctions. It has only one horn.

Indian rhinos seem armored like knights of old. With uneven shading, the interplay of light and shade expresses solidity.

Bears

Family: Ursidae; Genus: *Ursus*
Present in the Americas, Eurasia, Indonesia, Japan and the Arctic, the largest species of bear is the polar bear. Their excellent sense of smell may be seven times more sensitive than a dog's.

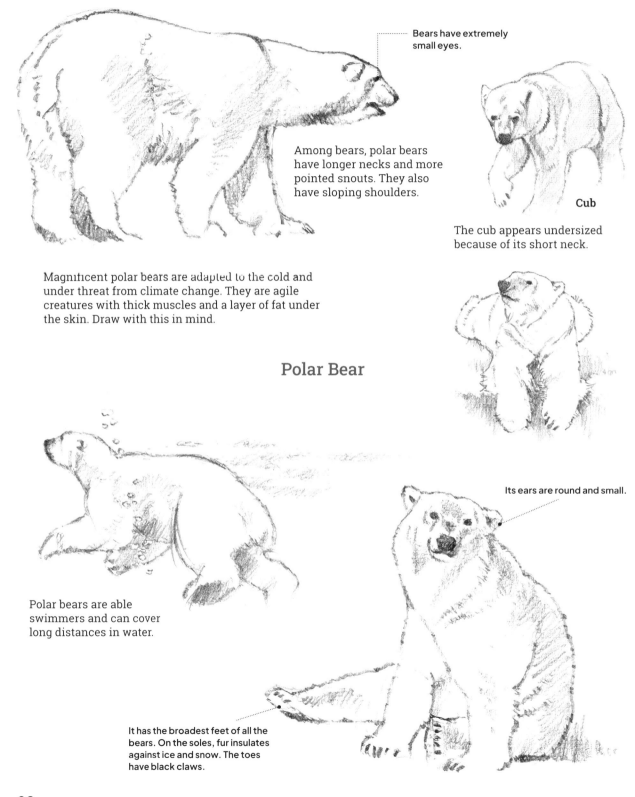

Bears have extremely small eyes.

Among bears, polar bears have longer necks and more pointed snouts. They also have sloping shoulders.

Cub

The cub appears undersized because of its short neck.

Magnificent polar bears are adapted to the cold and under threat from climate change. They are agile creatures with thick muscles and a layer of fat under the skin. Draw with this in mind.

Polar Bear

Polar bears are able swimmers and can cover long distances in water.

Its ears are round and small.

It has the broadest feet of all the bears. On the soles, fur insulates against ice and snow. The toes have black claws.

Brown Bear

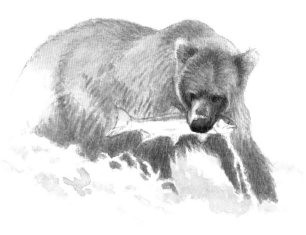

small ears, protruding snout

The face of the brown bear is wider than the polar bear's. The hump around its shoulders is also larger.

(See page 156)

The heads of cubs are large for their body size. Can you make yours as appealing as a plush toy?

As a model for teddy bears, bear cubs are much loved in Western countries.

Cub

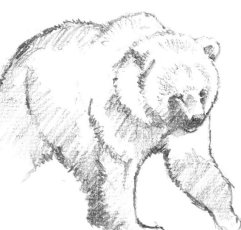

The bear's legs are thick. Long, sharp claws emerge from the toes.

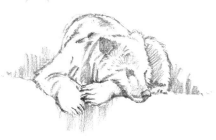

 TRY IT! ## Draw a brown bear from the front.

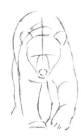

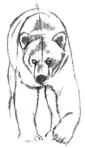

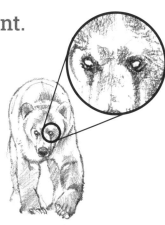

❶ Draw a rounded inverted triangle for the face outline. Fit the body into an oval and sketch the legs. You need to balance the head and limbs with the bulky body.

❷ Draw the eyes, nose and ears, and then add lines to indicate the length of the coat hair.

❸ Shade to express the muscular body under the coat. Leave the paper blank to highlight the eyes. All-white eyes make the bear look more menacing.

Pandas and Badgers

Giant Panda

Family: Ursidae; Genus: *Ailuropoda*
The giant panda inhabits bamboo forests in China. The fur in the black-and-white coat of adult pandas is quite stiff. The paws have evolved to easily grasp bamboo.

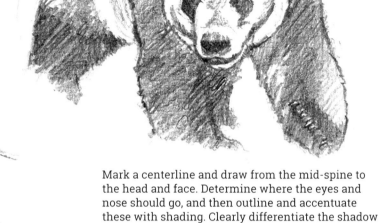

Mark a centerline and draw from the mid-spine to the head and face. Determine where the eyes and nose should go, and then outline and accentuate these with shading. Clearly differentiate the shadow shading and the black areas.

Pandas have five digits on each paw. Each forepaw has an extra thumb-like extension on one digit (sesamoid bone) for gripping bamboo.

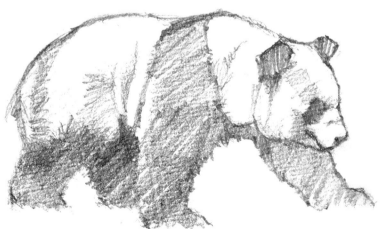

Panda cubs are very playful. They look like animated plush toys. Can you capture their frolicking?

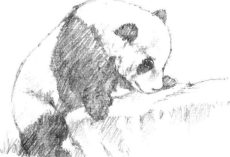

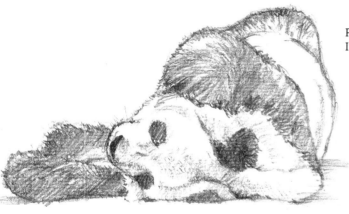

Pandas sleep sixteen hours a day.
It is easy to draw them snoozing.

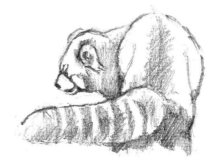

Red Panda

Family: Ursidae; Genus: *Ailuropoda*
They are distributed throughout
China, Nepal, Bhutan and northern
Myanmar. Their diet consists of
bamboo, bamboo shoots, insects,
birds' eggs and fruit.

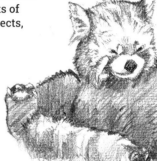

Like their panda cousins, red
pandas mainly eat bamboo grass.
Capture their petite appeal.

Sometimes they furrow their eyebrows.

Japanese Badger

Family: Mustelidae; Genus: *Meles*
Except for Hokkaidō, in Japan badgers inhabit
managed village woodland on mountain slopes.
They feed their stocky bodies with rodents, frogs,
fruit, nuts and crops.

**Badger at Tama
Zoological Park**

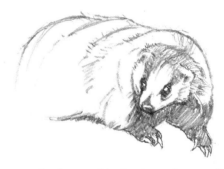

Note the flattened body, sharp claws and the
distinctive black vertical stripes aligned with
each eye. The belly and limbs are also black.

Raccoons

Family: Procyonidae; Genus: *Procyon*
Indigenous to the US and Canada, raccoons are established as an invasive species in Japan and Europe. Their masked face and ringed tail are distinctive features.

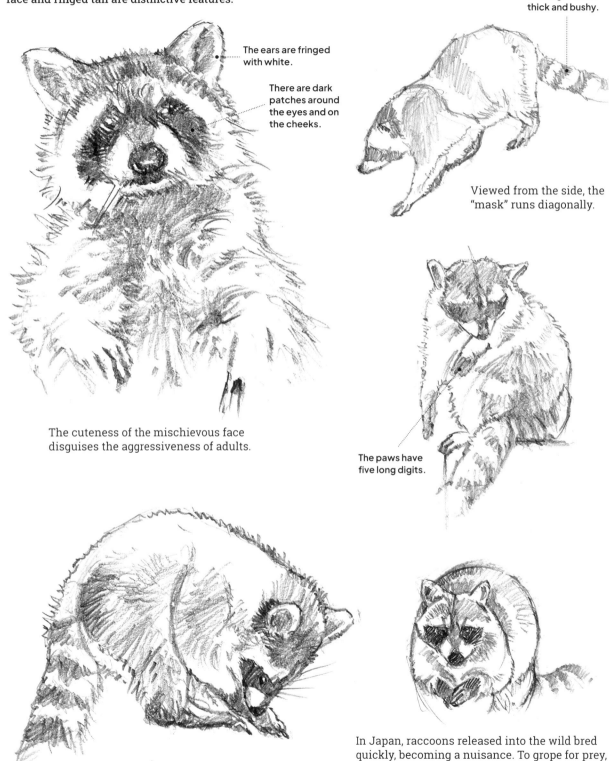

The ears are fringed with white.

There are dark patches around the eyes and on the cheeks.

The ringed tail is thick and bushy.

Viewed from the side, the "mask" runs diagonally.

The paws have five long digits.

The cuteness of the mischievous face disguises the aggressiveness of adults.

In Japan, raccoons released into the wild bred quickly, becoming a nuisance. To grope for prey, raccoons may plunge their forepaws into water. It looks as if they are washing their hands.

Capybaras

Family: Caviidae; Genus: *Hydrochoerus*

Capybaras are found mainly in the Amazon River basin. Their hair is as stiff as the bristles on a scrubbing brush. They spend the daytime underwater.

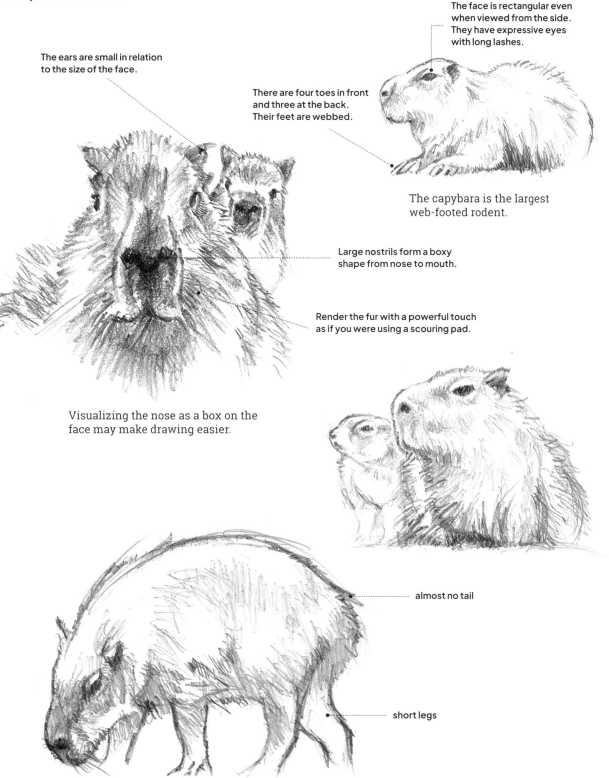

The face is rectangular even when viewed from the side. They have expressive eyes with long lashes.

The ears are small in relation to the size of the face.

There are four toes in front and three at the back. Their feet are webbed.

The capybara is the largest web-footed rodent.

Large nostrils form a boxy shape from nose to mouth.

Render the fur with a powerful touch as if you were using a scouring pad.

Visualizing the nose as a box on the face may make drawing easier.

almost no tail

short legs

Kangaroos

Family: Macropodidae; Genus: *Macropus*
These marsupials have been present in Australia for 65 million years. Their hopping method of locomotion does not allow them to go backward.

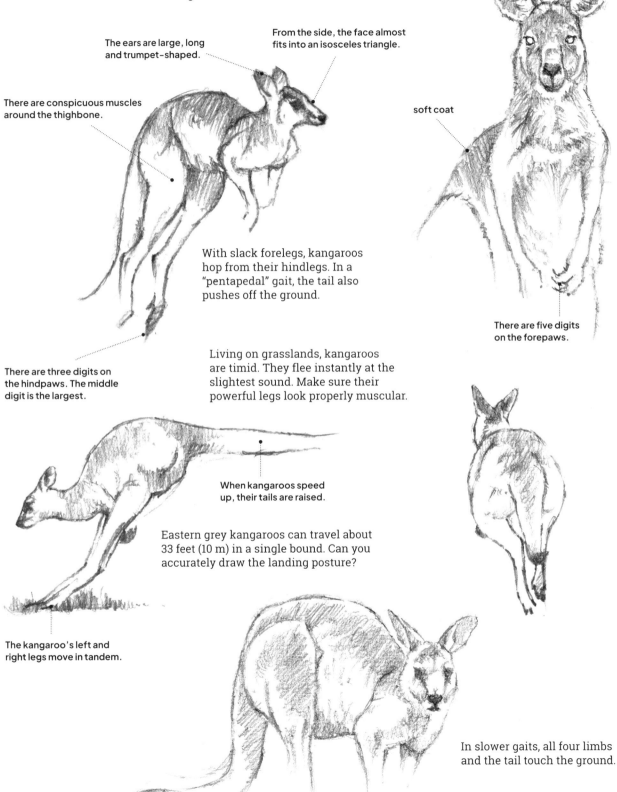

The ears are large, long and trumpet-shaped.

From the side, the face almost fits into an isosceles triangle.

There are conspicuous muscles around the thighbone.

soft coat

With slack forelegs, kangaroos hop from their hindlegs. In a "pentapedal" gait, the tail also pushes off the ground.

There are five digits on the forepaws.

There are three digits on the hindpaws. The middle digit is the largest.

Living on grasslands, kangaroos are timid. They flee instantly at the slightest sound. Make sure their powerful legs look properly muscular.

When kangaroos speed up, their tails are raised.

Eastern grey kangaroos can travel about 33 feet (10 m) in a single bound. Can you accurately draw the landing posture?

The kangaroo's left and right legs move in tandem.

In slower gaits, all four limbs and the tail touch the ground.

Koalas

Family: Phascolarctidae; Genus: *Phascolarctos*

Koalas live in Australia where they feed almost exclusively on eucalyptus leaves. Their body hairs are thick and stiff. There have no tail, as this was lost over the course of their evolution.

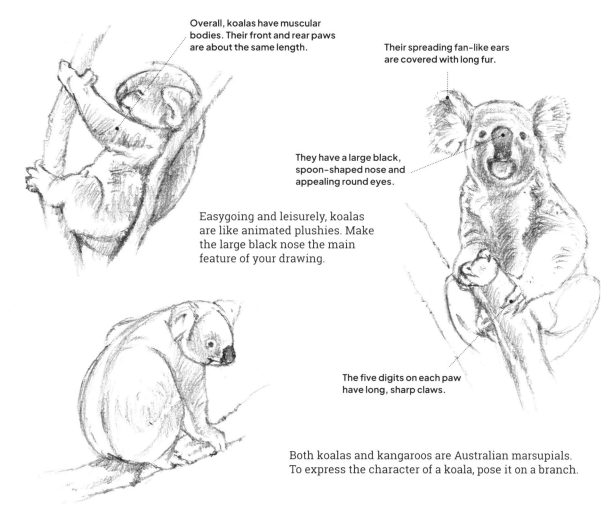

Overall, koalas have muscular bodies. Their front and rear paws are about the same length.

Their spreading fan-like ears are covered with long fur.

They have a large black, spoon-shaped nose and appealing round eyes.

Easygoing and leisurely, koalas are like animated plushies. Make the large black nose the main feature of your drawing.

The five digits on each paw have long, sharp claws.

Both koalas and kangaroos are Australian marsupials. To express the character of a koala, pose it on a branch.

TRY IT! ## Draw a koala in profile.

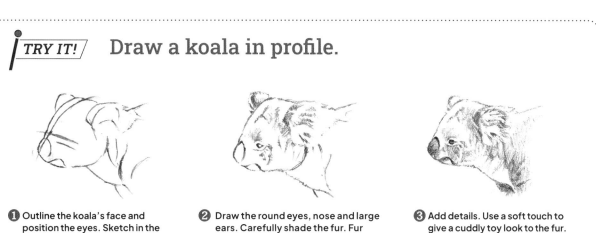

1 Outline the koala's face and position the eyes. Sketch in the large round nose and set the ears.

2 Draw the round eyes, nose and large ears. Carefully shade the fur. Fur length varies according to habitat.

3 Add details. Use a soft touch to give a cuddly toy look to the fur.

Squirrels, Chipmunks and Mice

Siberian Chipmunk

Family: Sciuridae; Genus: *Eutamias*
Distributed across northern Asia and Japan, the small Siberian chipmunk has diminutive ears. Its distinctive feature is an array of five dark stripes along its back.

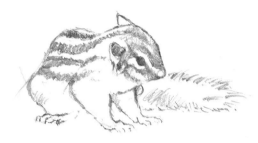

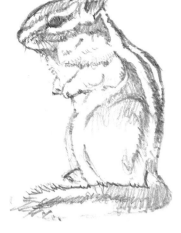

A great drawing subject, chipmunks are cute from any angle. They add interest to larger images.

(See page 160)

The black stripes are well defined and easy to draw.

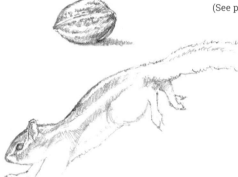

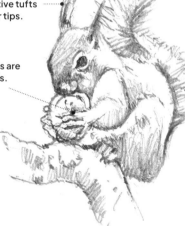

In winter, distinctive tufts appear on the ear tips.

Its dexterous front paws are almost like human hands.

Japanese Squirrel

Family: Sciuridae; Genus: *Eutamias*
Living in Japan, they feed on seeds and berries. The belly is white, but the back fur is red-brown in summer and gray-brown in winter. They have some white fur around the eyes.

▌ TRY IT! ▌ Draw a chipmunk from the side.

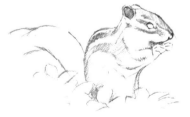

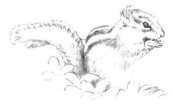

❶ Sketch an almond-shaped face and a roughly arching tail. Viewed from the side, the ratio of tail to body is large.

❷ Draw the mouth and ears. Draw the stripes, paying attention to the flow of the fur.

❸ Detail the stripes, small ears and small paws. The eyes should be black, but leave blank paper to create highlights.

(See coloring sample on page 148)

Harvest Mouse

Family: Muridae; Genus: *Micromys*
Distributed across northern Eurasia and Japan, Japan's smallest rodent is active all day in winter but is generally nocturnal in summer.

The nest of this tiny red-brown mouse resembles a small bird's nest. Make the small creature come to life by rendering the fur and putting a highlight in its eyes.

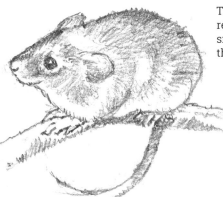

Its eyes and ears are large in relation to its face. The long, furless prehensile tail can grasp branches.

This mouse has distinctive large round eyes.

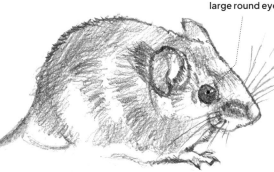

Short orange-brown fur covers the body, but the toes and tail are furless.

Large Japanese Field Mouse

Family: Muridae; Genus: *Apodemus*
Natives of Japan, these mice dig burrows underground and are nocturnally active mainly on the surface. When feeding, they hold seeds, rhizomes and insects with their forepaws.

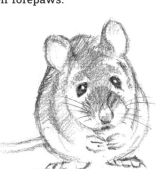

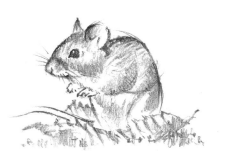

Prairie Dogs, Otters, Flying Squirrels and Sables

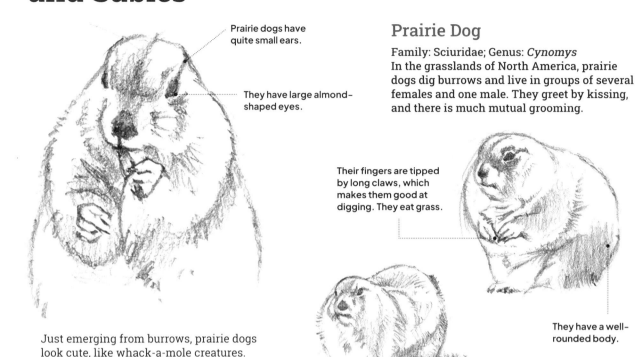

Prairie dogs have quite small ears.

They have large almond–shaped eyes.

Prairie Dog

Family: Sciuridae; Genus: *Cynomys*
In the grasslands of North America, prairie dogs dig burrows and live in groups of several females and one male. They greet by kissing, and there is much mutual grooming.

Their fingers are tipped by long claws, which makes them good at digging. They eat grass.

They have a well–rounded body.

Just emerging from burrows, prairie dogs look cute, like whack-a-mole creatures. While drawing, think of how they differ from squirrels and mice.

Small-clawed Otter

Family: Mustelidae; Genus: *Aonyx*
Ranging from India to Indonesia and southern China, these otters have webbed feet that enable them to live in rivers, swamps and wetlands, where they eat shellfish, fish, reptiles, etc.

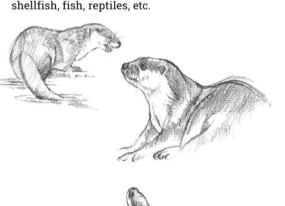

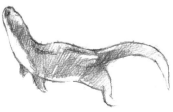

Japanese Sable

Family: Mustelidae; genus: *Martes*
Native to Hokkaidō, Japan, sables are active day and night throughout the year. They are very wary and sometimes stand on two legs to look around.

A face suddenly emerging from beneath the snow.

Their overall body color is light brown, but their limbs and tail are tipped with black. Their round eyes and black button noses make them cute to draw.

Siberian Flying Squirrel

Family: *Sciuridae*; Genus: *Pteromys*
Prevalent in Hokkaidō, Japan, this flying squirrel is brown in summer and pale gray brown or white in winter. The back fur provides camouflage. They dwell in the canopy and depend on trees for food, shelter and mobility.

They glide by spreading "parachutes" of fur-covered skin. To express their nature, draw them in flight.

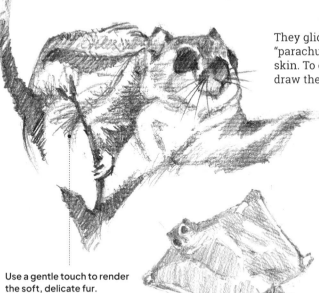

Use a gentle touch to render the soft, delicate fur.

Stoat

Family: Mustelidae; Genus: *Mustela*
Distributed across Europe, central and northern Asia and North America, stoats have relatively long hindlegs that provide surprising leaping ability. As the weather warms, the back fur turns brown. In winter, the coat turns completely white.

Summer fur is a beautiful brown. In winter, the whole coat turns white.

Northern Pika

Family: Ochotonidae; Genus: *Ochotona*
Distributed across the Eurasian continent and in central and eastern Hokkaidō, Japan, their small ears protrude only slightly (0.8 in/2 cm). They grow new fur twice a year.

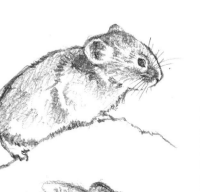

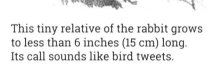

This tiny relative of the rabbit grows to less than 6 inches (15 cm) long. Its call sounds like bird tweets.

They have an almond-shaped face, rounded ears, and a very short (0.2 in/5 mm) tail.

Rabbits

Family: *Leporidae*

The long ears of rabbits are very distinctive. Their silky fur, which covers the whole body, varies greatly in length and coloration. Wild rabbits and hares are skittish creatures that lead the stressful lives of prey animals.

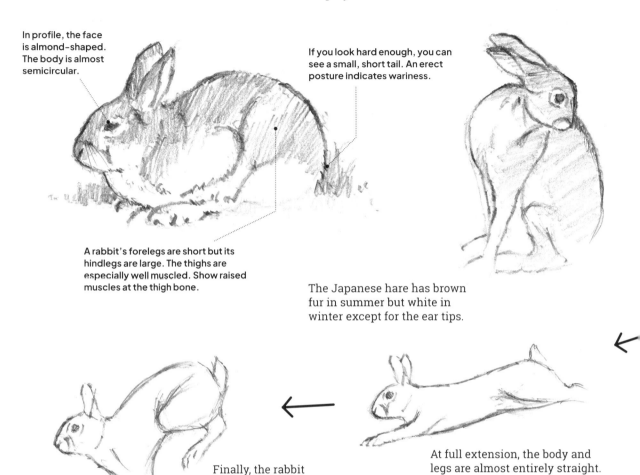

In profile, the face is almond-shaped. The body is almost semicircular.

If you look hard enough, you can see a small, short tail. An erect posture indicates wariness.

A rabbit's forelegs are short but its hindlegs are large. The thighs are especially well muscled. Show raised muscles at the thigh bone.

The Japanese hare has brown fur in summer but white in winter except for the ear tips.

At full extension, the body and legs are almost entirely straight.

Finally, the rabbit lands front feet first.

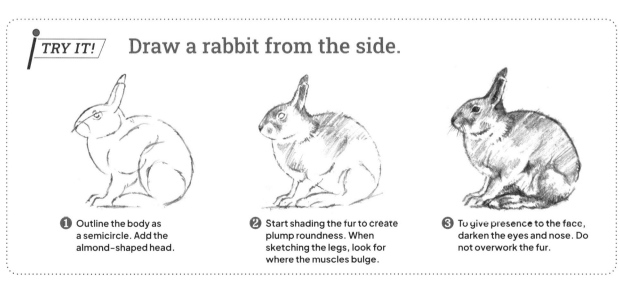

TRIT IT! ## Draw a rabbit from the side.

❶ Outline the body as a semicircle. Add the almond-shaped head.

❷ Start shading the fur to create plump roundness. When sketching the legs, look for where the muscles bulge.

❸ To give presence to the face, darken the eyes and nose. Do not overwork the fur.

104 **Part One:** Basic Sketching Techniques

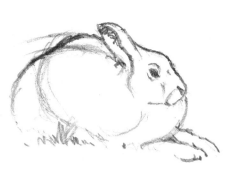

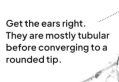

Get the ears right. They are mostly tubular before converging to a rounded tip.

From the front, you can see the narrow forehead and the width of the cheeks.

Their eyes, which are high on the sides of their face, give them nearly 350-degree vision. To pick up sounds, their ears move independently like antennae.

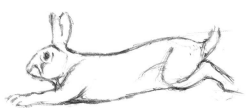

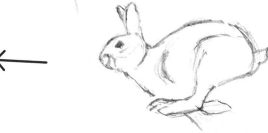

Mid-bound, the fore and rear legs begin to extend.

When leaping, the rabbit's forelegs fold backward and hindlegs hinge forward.

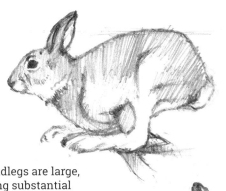

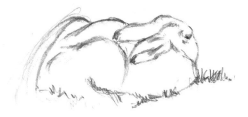

Their hindlegs are large, containing substantial thigh muscles.

Even when sleeping, their eyes remain half-open in order to spot predators.

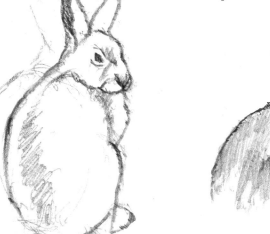

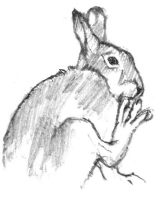

If you watch rabbits, you will see captivating poses and expressions. Can you draw one of these moments?

Primates

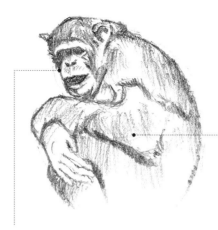

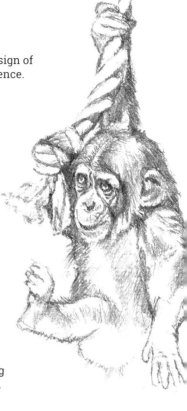

The use of tools is a sign of chimpanzee intelligence.

Chimps have short legs and long hands. Their hands are similar to those of humans, but the thumbs are shorter.

Chimps have a protruding forehead and deep-set eyes. A relatively large mouth bulges from under the nostrils. The hairless face shows many fine wrinkles.

Chimpanzee

Family: Hominidae; Genus: *Chimpanzee*
Indigenous to West and central Africa, chimps have black fur and hairless dark or pale faces. Omnivores, they sometimes use tools to get at food.

I go to zoos to observe and sketch chimps. The endearing expressions and poses of young chimps make me want to draw.

Japanese Macaque

Family: Cercopithecidae; Genus: *Macaca*
Indigenous to northern Honshū, Japan, no other primate lives so far north. Their thicker hair is an adaptation to the cold climate.

/TRY IT!/ ## Draw a chimpanzee.

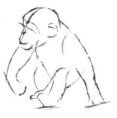

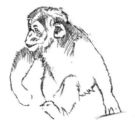

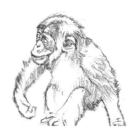

❶ Capture the overall picture as you outline the chimp: an oval face, the body and arms in a triangle; the right hand and left leg shown out in front.

❷ Draw the fur on the arms and head. The fur length is apparent from how much the hairs stick out from the outline.

❸ Add shading to finish. Avoid overshading. The dark tones have little gradation.

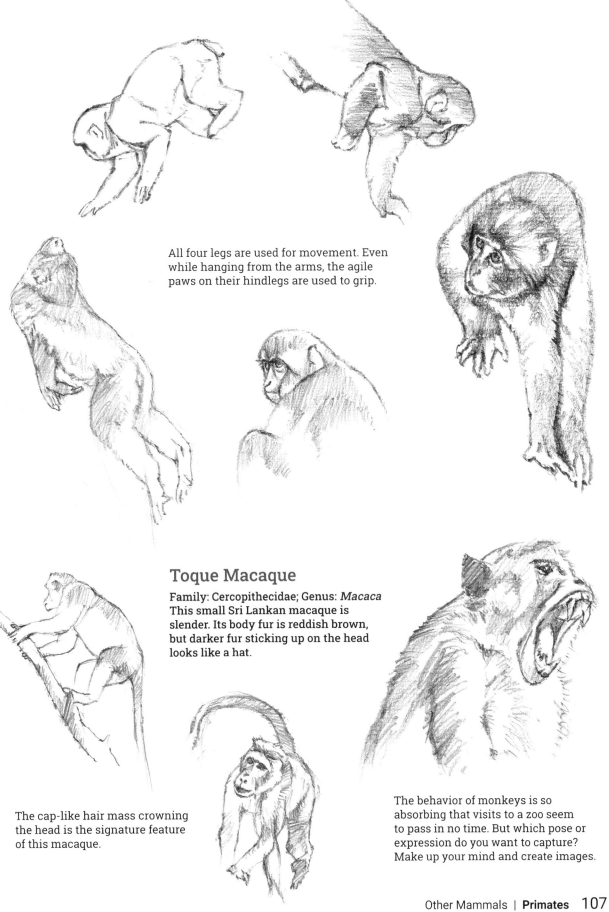

All four legs are used for movement. Even while hanging from the arms, the agile paws on their hindlegs are used to grip.

Toque Macaque

Family: Cercopithecidae; Genus: *Macaca*
This small Sri Lankan macaque is slender. Its body fur is reddish brown, but darker fur sticking up on the head looks like a hat.

The cap-like hair mass crowning the head is the signature feature of this macaque.

The behavior of monkeys is so absorbing that visits to a zoo seem to pass in no time. But which pose or expression do you want to capture? Make up your mind and create images.

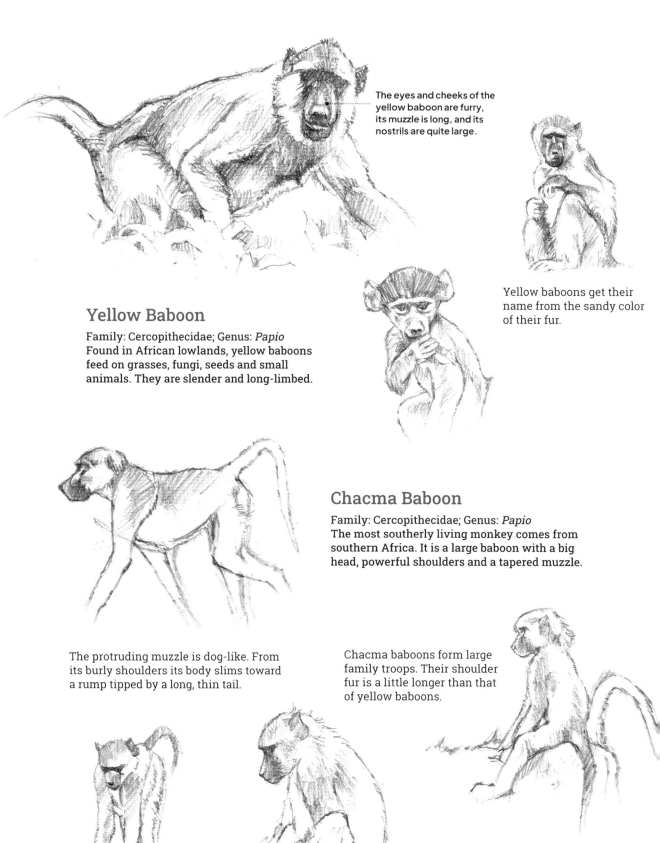

The eyes and cheeks of the yellow baboon are furry, its muzzle is long, and its nostrils are quite large.

Yellow baboons get their name from the sandy color of their fur.

Yellow Baboon

Family: Cercopithecidae; Genus: *Papio*
Found in African lowlands, yellow baboons feed on grasses, fungi, seeds and small animals. They are slender and long-limbed.

Chacma Baboon

Family: Cercopithecidae; Genus: *Papio*
The most southerly living monkey comes from southern Africa. It is a large baboon with a big head, powerful shoulders and a tapered muzzle.

The protruding muzzle is dog-like. From its burly shoulders its body slims toward a rump tipped by a long, thin tail.

Chacma baboons form large family troops. Their shoulder fur is a little longer than that of yellow baboons.

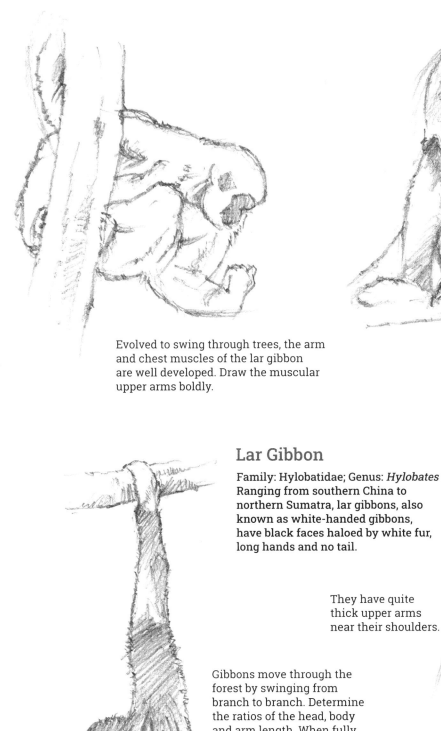

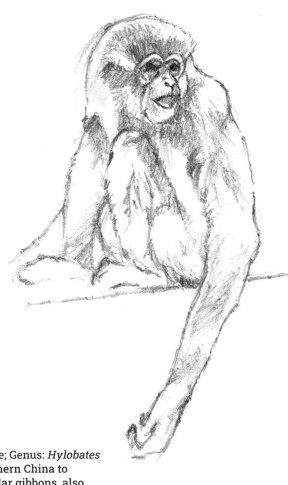

Evolved to swing through trees, the arm and chest muscles of the lar gibbon are well developed. Draw the muscular upper arms boldly.

Lar Gibbon

Family: Hylobatidae; Genus: *Hylobates*
Ranging from southern China to northern Sumatra, lar gibbons, also known as white-handed gibbons, have black faces haloed by white fur, long hands and no tail.

They have quite thick upper arms near their shoulders.

Gibbons move through the forest by swinging from branch to branch. Determine the ratios of the head, body and arm length. When fully extended, their arms are 1.5 times longer than their body.

Mantled Guereza

Family: Cercopithecidae; Genus: *Colobus*
These tropical rainforest dwellers of central and eastern Africa have fringes of long white fur cascading down their sides, and white fur around the face. Living in trees, they eat leaves.

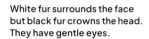

White fur surrounds the face but black fur crowns the head. They have gentle eyes.

The strong contrasts make the mantled guereza fun to draw. Use graceful lines to portray the long silky fur.

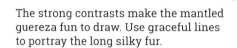

A mantle of long white fur hangs from mid-shoulder and along the back.

There is long, silky white fur from around the middle of the tail.

Black-and-white Ruffed Lemur

Family: Lemuridae; Genus: *Varecia*
This largest member of the lemur family lives in eastern Madagascar. It is named for the white fur that forms a collar around its face.

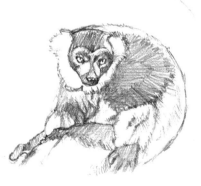

The white hair fringing the face forms a ruff. The dramatic contrast between the ruff and the face makes drawing this lemur fun.

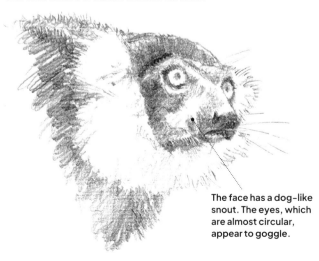

The face has a dog-like snout. The eyes, which are almost circular, appear to goggle.

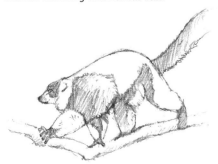

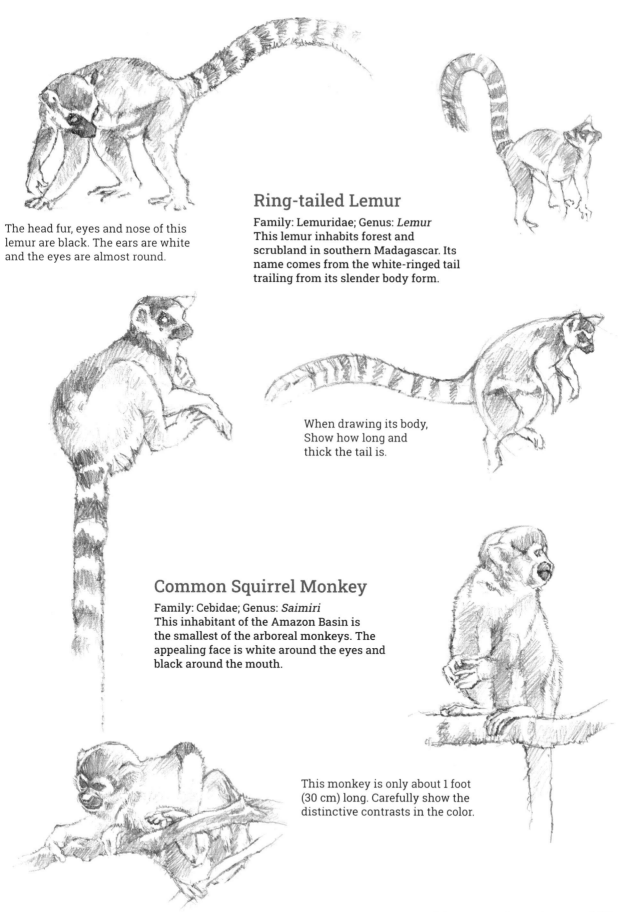

The head fur, eyes and nose of this lemur are black. The ears are white and the eyes are almost round.

Ring-tailed Lemur

Family: Lemuridae; Genus: *Lemur*
This lemur inhabits forest and scrubland in southern Madagascar. Its name comes from the white-ringed tail trailing from its slender body form.

When drawing its body, Show how long and thick the tail is.

Common Squirrel Monkey

Family: Cebidae; Genus: *Saimiri*
This inhabitant of the Amazon Basin is the smallest of the arboreal monkeys. The appealing face is white around the eyes and black around the mouth.

This monkey is only about 1 foot (30 cm) long. Carefully show the distinctive contrasts in the color.

Mandrill

Family: Cercopithecidae;
Genus: *Mandrillus*
The distinctive coloring of the male mandrill's face—a long red nose ridge, blue-grooved cheeks and yellow whiskers—help them stand out in dark tropical rainforests, where they live on fruit and seeds.

Golden Snub-nosed Monkey

Family: Cercopithecidae;
Genus: *Rhinopithecus*
Living mainly in Sichuan, China, the fur on the back of this monkey is long. Around its face and on the chest and limbs, the fur is orange. While it mainly feeds on leaves, it also eats seeds and insects.

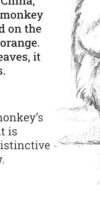

The fur surrounding the monkey's eyes give the impression it is wearing spectacles. The distinctive face is fascinating to draw.

The coloring of the mandrill's powerful face intimidates rivals. Can you use black pencil shading well enough to hint at the color differences?

Orangutan

Family: Hominidae; Genus: *Pongo*
Wild orangutans live in Sumatra and Borneo. Usually solitary, they can sometimes be seen in pairs or in parent-child groups. Their main diet is fruit although they also eat insects and small animals.

long fur

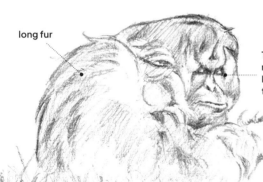

The eyes of an orangutan are recessed and its gaze is sharp. Its mouth projects forward from the tip of the nose.

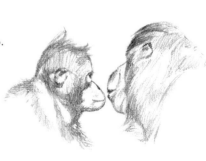

Orangutans are highly intelligent apes. Their fleeting expressions and gestures often appear human. They are an exciting subject to draw.

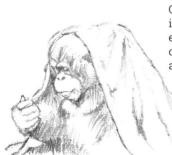

Infants have a short, sparse coat. Their eyes are innocent and cute. Can you capture their toddler charm?

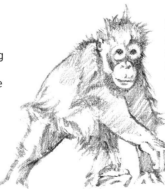

Gorillas

Family: Hominidae; Genus: *Gorilla*

In the equatorial rainforests of Africa, gorillas mainly feed on vegetation as well as fruit and termites. Active during the day, each evening they make a new bed. Their body color is predominantly black or dark grayish brown.

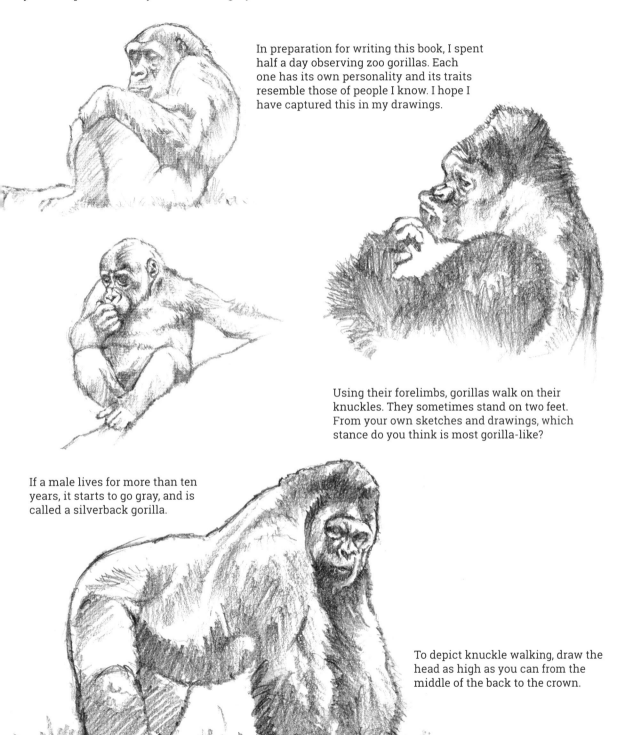

In preparation for writing this book, I spent half a day observing zoo gorillas. Each one has its own personality and its traits resemble those of people I know. I hope I have captured this in my drawings.

Using their forelimbs, gorillas walk on their knuckles. They sometimes stand on two feet. From your own sketches and drawings, which stance do you think is most gorilla-like?

If a male lives for more than ten years, it starts to go gray, and is called a silverback gorilla.

To depict knuckle walking, draw the head as high as you can from the middle of the back to the crown.

How to Draw Mammals

While the skeletons of vertebrates, including mammals, are basically similar, the number, size, thickness, length, curvature and position vary.

Draw with the skeleton in mind: Key Points

1 | Mammals have a skull, spinal column (backbone), thorax (space housing lungs, enclosed by thoracic spine, ribs and breastbone), forelimbs (pectoral girdle, upper leg/arm, lower leg/forearm, foot/hand/paw) and hindlimbs (pelvis, thigh, lower leg, foot). Compare the location of these in different animals.

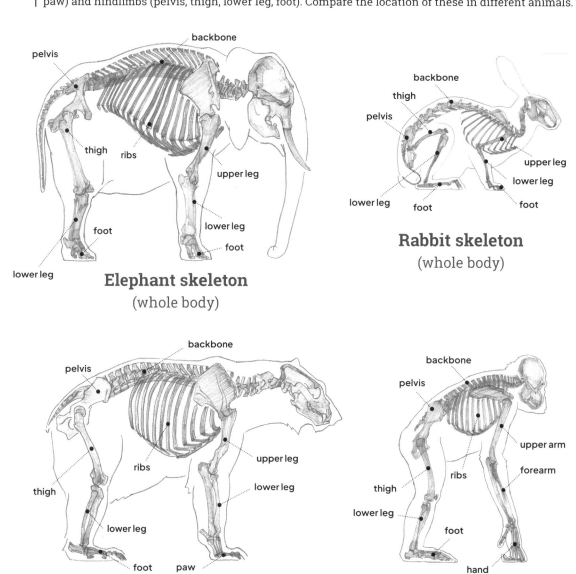

Elephant skeleton
(whole body)

Rabbit skeleton
(whole body)

Bear skeleton
(whole body)

Chimpanzee skeleton
(whole body)

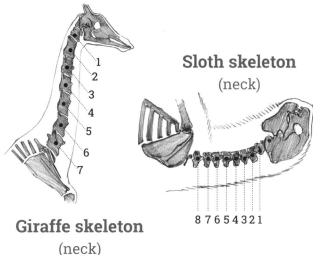

2 The mammal neck generally has 7 bones (cervical vertebrae). Exceptions are the sloth (8) and the dugong (6). More bones do not make the sloth neck longer, but increases its range of motion. A sloth can turn its face directly down while hanging from a branch. It is like a person being able to turn their head around to see behind.

Sloth skeleton
(neck)

Giraffe skeleton
(neck)

(*Source*: J. Z. Young, *The Life of Vertebrates*, 2nd ed., Clarendon Press, Oxford, 1969.)

Mammalian gaits

Mammals usually move over the ground in one of three ways. A plantigrade gait involves walking on the sole and heel. This is used by gorillas, bears, pandas and humans, as it is more stable for standing upright. Cats, dogs, pigs and elephants all walk tiptoe with a digitigrade gait. In an unguligrade gait, hoofed animals such as horses, cows, deer and goats contact the ground only with their toenails.

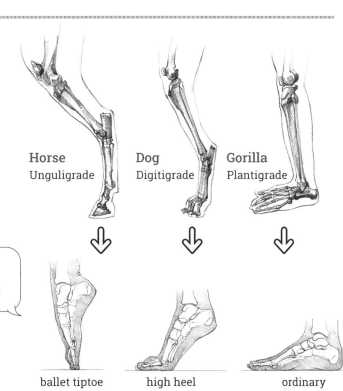

Horse
Unguligrade

Dog
Digitigrade

Gorilla
Plantigrade

Human equivalents

ballet tiptoe high heel ordinary

(*Source*: R. Spanner (ed.), *Spalteholz–Spanner Handatlas der Anatomie des Menschen*, 17th ed., Scheltema & Holkema, Amsterdam, 1971)

Whales

Drawing Fundamentals

Unlike terrestrial mammals, whales are streamlined with fish-like features. Decide the size and location of the mouth, eyes, flippers and fins (flukes).

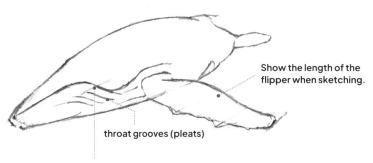

Show the length of the flipper when sketching.

throat grooves (pleats)

Curve the mouth line around the position of the eye.

❶ Sketch the outline

Outline the body roughly in a flattened oval. Draw the mouth line, the wavy throat grooves and the left flipper.

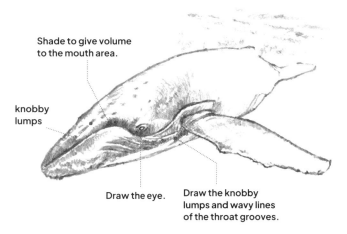

Shade to give volume to the mouth area.

knobby lumps

Draw the eye.

Draw the knobby lumps and wavy lines of the throat grooves.

❷ Create dimensionality

Underwater lighting is dim. If you are not sure how to light this drawing, imagine strong overhead sunlight.

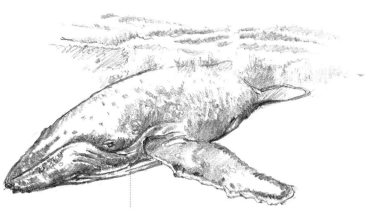

Shade to create dimensionality.

❸ Completion

Show the propulsion of the whale's two fins (flukes) at the rear by drawing some waves and bubbles. To add realism to the whale, finish the skin with realistic textures.

Humpback Whale

Family: Balaenopteridae; Genus: *Megaptera*
This mid-size whale spends the summer in polar seas feeding on krill and plankton. In winter, humpback whales breed in warm equatorial waters.

When whales feed, they scoop up a lot of seawater. The throat grooves (pleats) allow the skin to expand.

Whales exhale and inhale through blowholes.

The front flippers of humpback whales are longer than in other species, sometimes one–third of their body length.

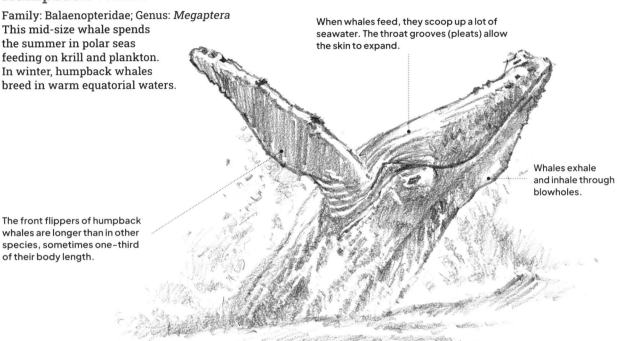

dorsal fin on the back

The upper and lower jaws have knobby lumps.

In Alaska, I saw a humpback whale. The memory of it breaching the surface of the water is still very vivid. Memories like this can add another dimension to your drawing process.

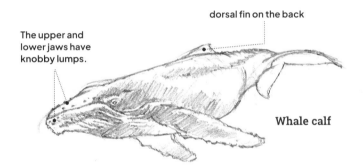

Whale calf

Sperm whale

Family: Physeteridae; Genus: *Physeter*
Sperm whales can grow to a maximum length of 60 feet (18 m). Their protruding foreheads are instantly recognizable. The large head holds the biggest brain of any creature. Widely distributed across the oceans, these whales spend two-thirds of their lives in deep water.

Tail propulsion in fish comes from lateral strokes. Whales and other marine mammals, however, move their fins (flukes) up and down. This kind of basic understanding makes your drawings more believable.

hump–like dorsal fin

small square pectoral fin

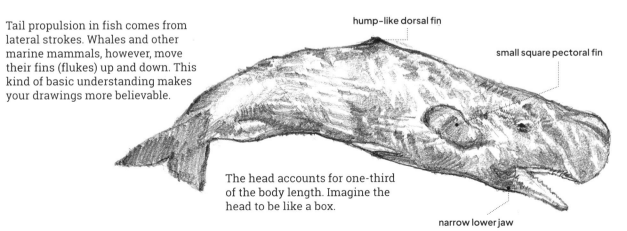

The head accounts for one-third of the body length. Imagine the head to be like a box.

narrow lower jaw

Dolphins and Seals

Bottlenose Dolphin

Family: Delphinidae; Genus: *Tursiop*
Dolphins live offshore in tropical to temperate waters all over the world. The bottlenose dolphin is the best-known species. Fast swimmers, they are also excellent jumpers.

A wide mouth protrudes from a long, slender body. A boomerang-shaped dorsal fin is located nearly halfway along the back.

It has been shown that dolphins have high IQs.

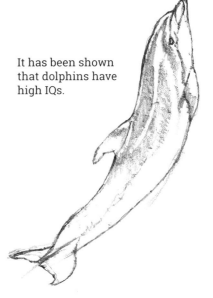

Dolphins generate forward thrust by moving their tail flukes up and down. Pectoral fins help them steer. Five vestigial toe bones indicate that these fins evolved from forelimbs.

Dolphin blowholes are on the forehead. They breathe with lungs.

Understand how the body has adapted to moving through water, and make sure to draw all the lines smoothly.

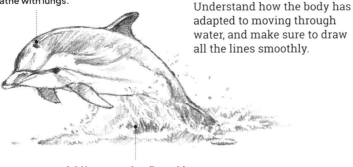

Add impact and realism with splashes and waves created on the surface of the water when the subject breaches.

The killer whale (orca) is white above the eyes, under the chin and along the belly.

wide, round pectoral fins

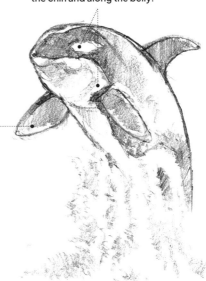

Killer Whale (Orca)

Family: Delphinidae; Genus: *Orcinus*
Largest of the dolphin family, the killer whale or orca is found throughout the world living in family groups, making it the world's most widely distributed mammal. Orcas are recognizable by their distinctive black-and-white patterned body.

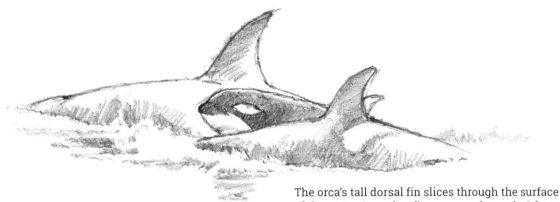

The orca's tall dorsal fin slices through the surface of the water. In males, fins can reach nearly 6 feet (1.8 m). Female orca's fins are shorter and more curved. Simply depicting dorsal fins cutting through the surface can result in a striking drawing.

Spotted Seal

Family: Phocidae; Genus: *Phoca*
Distributed in coastal waters all the way from Alaska to the Yellow Sea between China and Korea, spotted seals are born with whitish fur, but after 2–3 weeks the pups become gray with black blotches.

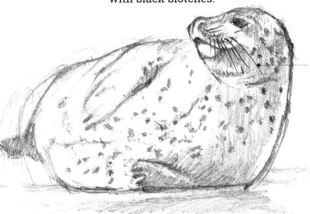

The many nerves packed in seal whiskers, known as *vibrissae*, allow them to detect fish.

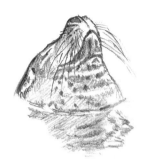

Sketching is easier if you picture a circular head on an oval body.

Harbor Seal

Family: Phocidae; Genus: *Phoca*
Found in all temperate and Arctic coastal waters in the northern hemisphere, harbor seals have fur dotted with rings, either dark on light or vice versa. They inhabit rocky shores.

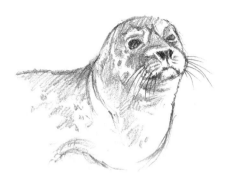

Each seal has a unique pattern of rings.

Can you depict the clumsiness of seals using flippers to move on their bellies?

When seals come ashore, movement becomes difficult. Express the plump form that's well-padded with blubber.

How to Draw Marine Animals

Here, you can find relevant information about animals that live in water.
You can also compare how life on land or in water has affected body forms.

Draw with the skeleton in mind: Key Points

Aquatic mammals and fish are free-swimming creatures with skeletons. During evolution, aquatic mammals migrated from the land to the water. The pectoral fins of dolphins and whales evolved from arms but the hindlimbs were completely lost. Seals and walruses have flippers that evolved from limbs. When you go to an aquarium, closely observe how aquatic creatures move.

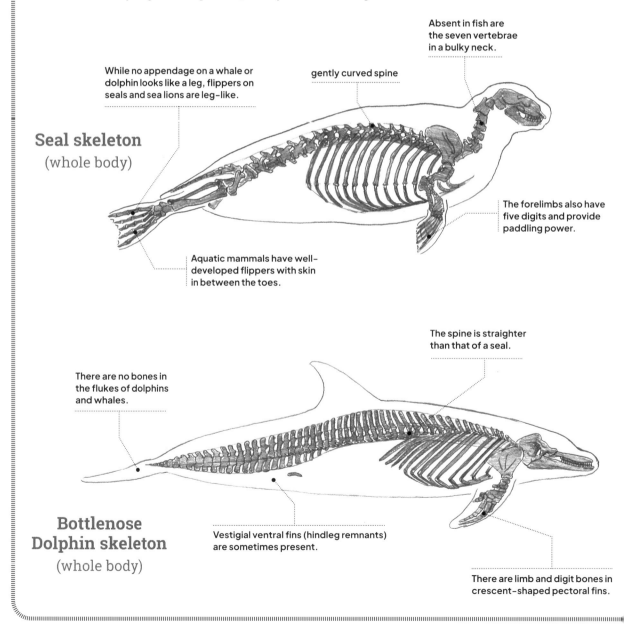

Absent in fish are the seven vertebrae in a bulky neck.

gently curved spine

While no appendage on a whale or dolphin looks like a leg, flippers on seals and sea lions are leg-like.

Seal skeleton
(whole body)

The forelimbs also have five digits and provide paddling power.

Aquatic mammals have well-developed flippers with skin in between the toes.

The spine is straighter than that of a seal.

There are no bones in the flukes of dolphins and whales.

Bottlenose Dolphin skeleton
(whole body)

Vestigial ventral fins (hindleg remnants) are sometimes present.

There are limb and digit bones in crescent-shaped pectoral fins.

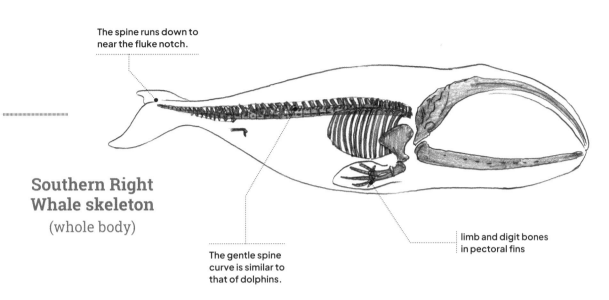

The spine runs down to near the fluke notch.

Southern Right Whale skeleton
(whole body)

The gentle spine curve is similar to that of dolphins.

limb and digit bones in pectoral fins

Aquatic mammals and fish: Comparison

We can understand both forms better by comparing them. One clear difference is the number and forms of fins. Fish, aquatic from the beginning, evolved fins to maintain balance, steer and move through water. They have more fins than aquatic mammals. To move, most fish waggle their tail fins left and right. In contrast, aquatic mammals mostly propel themselves by moving their flukes up and down.

Arrangement of marine mammal flukes and fish fins

Tail propulsion: horizontal vs. vertical

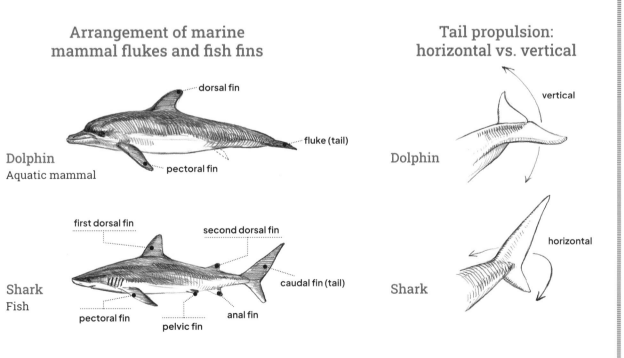

dorsal fin

fluke (tail)

Dolphin
Aquatic mammal

pectoral fin

first dorsal fin

second dorsal fin

caudal fin (tail)

Shark
Fish

pectoral fin

pelvic fin

anal fin

vertical

Dolphin

horizontal

Shark

Lizards and Crocodiles

Lizards are the most numerous of reptiles, comprising more than 4,000 species. They live mainly in the tropics.

Green Iguana

Family: Iguanidae; Genus: *Iguana*
Iguanas live in tropical rainforests in South and Central America and the Galapagos Islands where they feed on plants and seaweed. The nose-to-tail-tip length varies from 8 inches to 6½ feet (20 cm–2 m).

row of spines from neck to tail

raised scales all over body

five digits on each of four limbs

Chinese water dragons have a shorter snout and larger eyes than iguanas. The mane-like spines are also longer.

Chinese Water Dragon

Family: Agamidae; Genus: *Iguana*
Found in southern China, Thailand and Vietnam, this omnivorous lizard has a bluish green body and tail 2–3 feet (60–90 cm) long. It feeds on insects, small animals and fruit.

Look beyond the beautiful green color and capture the varied mosaic texture of the skin.

Komodo Dragon

Family: Varanidae; Genus: *Varanus*
Present on the Komodo Islands and parts of Flores, komodos weigh up to 220 pounds (100 kg) and grow to about 10 feet (3 m). As carnivores, they have a superb sense of smell and stamina. They can also be ferocious.

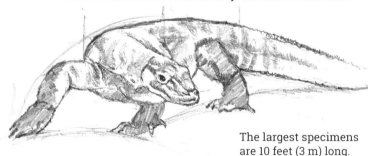

The largest specimens are 10 feet (3 m) long.

Hard keratinized scales cover the whole body.

There are about 80 teeth in the upper and lower jaws.

There are webbed toes on each of the four feet.

Crocodilians

Crocodilian is a general term for crocodiles and other reptiles that mainly live in water. There are three families: crocodiles, alligators and gharials. They have long snouts and long, boxy, tapering tails. They are found in fresh water and coastal seas throughout and near the tropics.

Frogs and Toads

Japanese Common Toad

Family: Bufonidae; Genus: *Bufo*

Indigenous to Hokkaidō and much of Honshū in Japan, common toads are usually about 5 inches (12 cm) from snout to vent. In common with other toads, They are covered in "warts."

Frog heads are generally triangular with eyes that protrude upward. Their bodies are round. Most species have no ribs. Some frogs live only on land or in trees, but most also live in water.

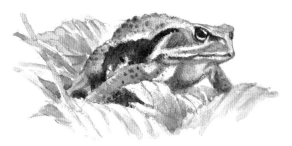

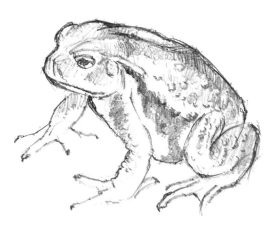

Seen from the front, frogs have large eyes. I find them cute. In this picture, I expressed my feelings.

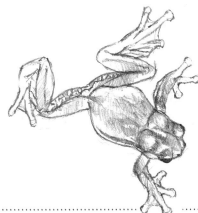

Japanese Tree Frog

Family: Hylidae; Genus: *Dryophytes*

Distributed in Japan, the Korean Peninsula and eastern China, this frog has a snout-to-vent length up to $1\frac{4}{5}$ inches (4.5 cm). Mottling on the back contains chromatophores, enabling it to change coloration.

| TRY IT! | ## Draw a Japanese tree frog from above.

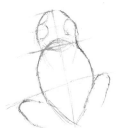

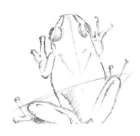

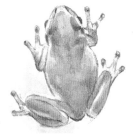

1 Roughly outline the face as a semicircle and the body as an oval. Place the eyes on the face and legs on the body. From above, it is easy to visualize the face–body balance.

2 Draw the eyes, mouth and feet. Include shadows and lines that suggest three-dimensionality. Ensure the left and right legs are not symmetrical.

3 Color to finish. Exploit the whiteness of the paper to create an overall muted sheen. Vary the shading with an overlay of yellowy green.

Sparrows

Drawing Fundamentals

Once you have decided on the form, from head to tail feathers, consider the movement of birds, how the feathers overlap and the flow of plumage.

❶ **Sketch the body form.**

❷ **Sketch the face and wings.**

❸ **Add detailing.**

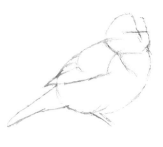 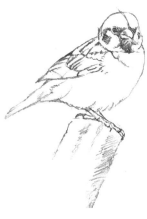 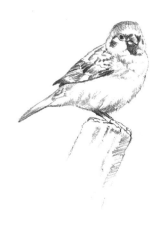

Outline the head, body and tail feathers. Draw an eyeline, centerline and wing. Get the balance right.

Draw the beak, eyes and wings, and add touches of shading. If your bird is not depicted in motion, show where it is perched.

Draw the wing pattern and the ruffled breast feathers. As you shade, consider the darkest areas and the areas closest to white.

(See coloring sample on page 150)

TRY IT! ## Draw the wings of an oriental turtle dove.

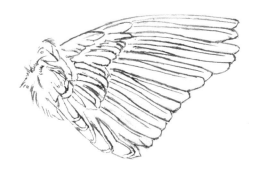 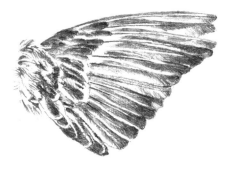

❶ Visualize the wing structure (see page 135). Imagine the wing bones and how they articulate, and notice how the feathers overlap.

❷ While shading, pay close attention to the subtle pattern of each feather.

(See coloring sample on page 18)

Family: Passeridae; Genus: *Passer*
Old World sparrows range across Eurasia, from Portugal to
Japan. They eat anything from seeds and bugs to breadcrumbs
and food scraps.

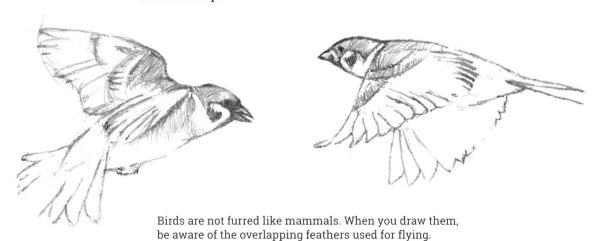

Birds are not furred like mammals. When you draw them,
be aware of the overlapping feathers used for flying.

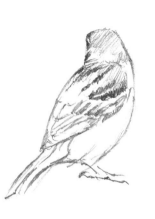

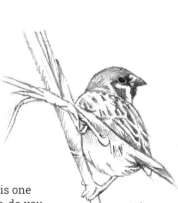

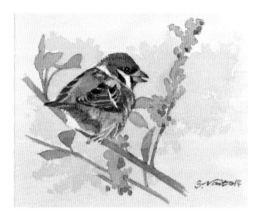

Even though the sparrow is one
of the most common birds, do you
know the color of its head? Close
observation will provide the answer.

When sparrows perch,
how are their feet posed?

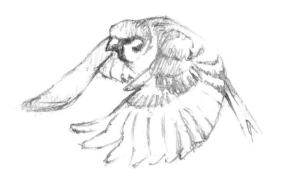

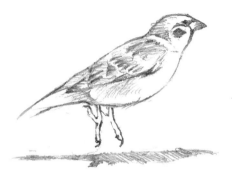

Tails are necessary for take off,
landing and steering.

Look carefully at this hopping sparrow
to see how the feet are held.

Hawks and Eagles

Northern Goshawk

Family: Accipitridae; Genus: *Accipiter*

Northern Goshawks are found over most of the temperate Northern Hemisphere. Their backs are blue-gray. From neck to legs, the white front is marked by irregular, narrow wavy bars. Goshawks can fly level at 50 mph (80 kph), but in a dive can reach 80 mph (130 kph).

TRY IT!

Draw a northern goshawk in flight.

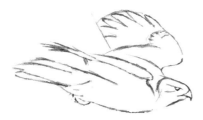

1 Behind the face, sketch the wings and tail feathers. Position the eyes and beak. This angle means the right wing is facing side on. It is not easy to draw the shape.

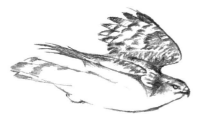

2 Note the balance of the left and right wings and how the feathers differ from those on the head and tail.

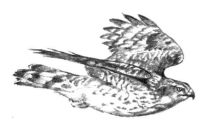

3 The sharp eyes and beak are focal points, but the wing structure also has to be convincing.

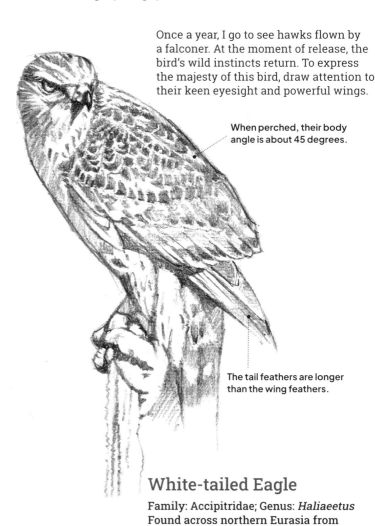

Once a year, I go to see hawks flown by a falconer. At the moment of release, the bird's wild instincts return. To express the majesty of this bird, draw attention to their keen eyesight and powerful wings.

When perched, their body angle is about 45 degrees.

The tail feathers are longer than the wing feathers.

White-tailed Eagle

Family: Accipitridae; Genus: *Haliaeetus*

Found across northern Eurasia from Denmark to Japan, this eagle is named for its white tail feathers although it is mostly brown. It hunts fish, birds and mammals.

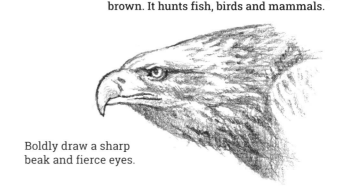

Boldly draw a sharp beak and fierce eyes.

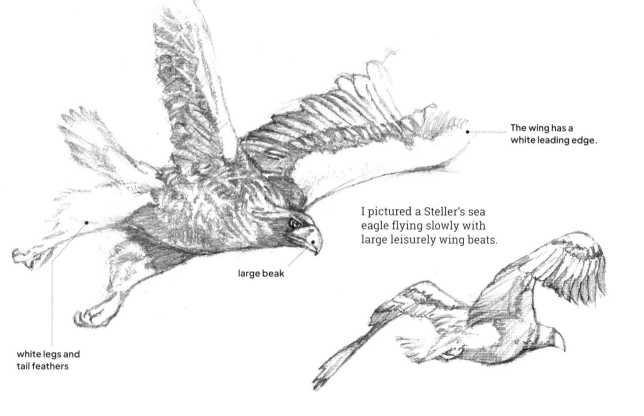

The wing has a
white leading edge.

I pictured a Steller's sea
eagle flying slowly with
large leisurely wing beats.

large beak

white legs and
tail feathers

Steller's Sea Eagle

Family: Accipitridae; Genus: *Haliaeetus*
Indigenous to northeast Asia, this eagle winters in Japan
and is the largest eagle found there. Its wingspan may
exceed 8 feet (2.4 m). It feeds mainly on fish.

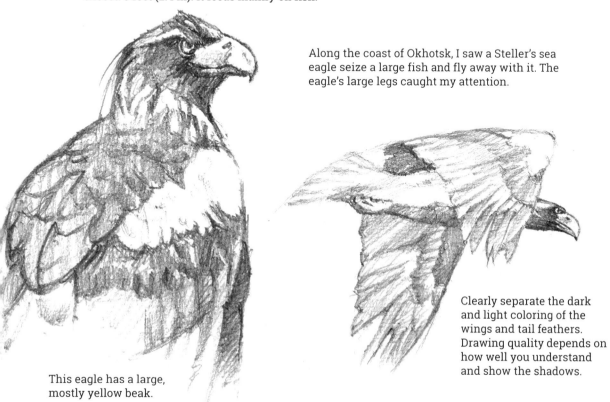

Along the coast of Okhotsk, I saw a Steller's sea
eagle seize a large fish and fly away with it. The
eagle's large legs caught my attention.

Clearly separate the dark
and light coloring of the
wings and tail feathers.
Drawing quality depends on
how well you understand
and show the shadows.

This eagle has a large,
mostly yellow beak.

Owls, Macaws and Crows

Ural Owl

Family: Strigidae; Genus: *Papio*
The Ural owl lives across temperate northern Eurasia from Japan to Scandinavia. A formidable hunter, it has sensitive eyes and hearing, and a neck that rotates 180 degrees.

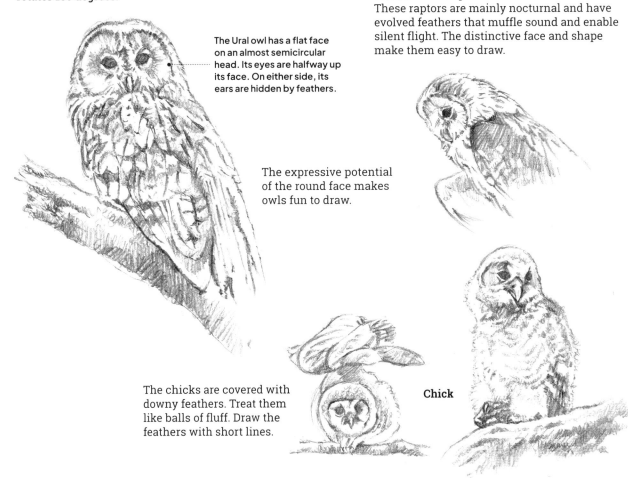

The Ural owl has a flat face on an almost semicircular head. Its eyes are halfway up its face. On either side, its ears are hidden by feathers.

More than 200 species of owl live worldwide. These raptors are mainly nocturnal and have evolved feathers that muffle sound and enable silent flight. The distinctive face and shape make them easy to draw.

The expressive potential of the round face makes owls fun to draw.

The chicks are covered with downy feathers. Treat them like balls of fluff. Draw the feathers with short lines.

Chick

Distinctive tufts of feathers give this owl a horned appearance.

Indian Eagle Owl

Eurasian Eagle-owl

Family: Strigidae; Genus: *Bubo*
The Eurasian eagle-owl, the largest of all eagle owls, lives across temperate Eurasia from Western Europe to Japan. Its wingspan may extend to over 6 feet (1.8 m).

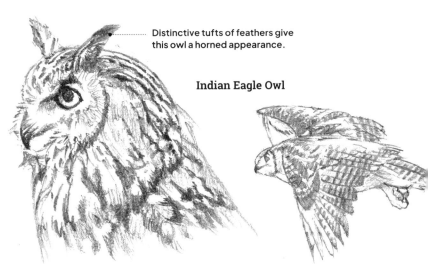

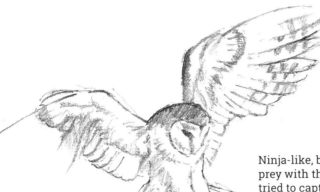

Barn Owl

Family: Tytonidae; Genus: *Tyto*
One of the most widely distributed of all birds, barn owls live everywhere except in polar and desert regions. They have long feathers, short angular tails and heart-shaped white faces.

Ninja-like, barn owls swoop on prey with their feet forward. I tried to capture that moment.

Scarlet Macaw

Family: Psittacidae; Genus: *Ara*
The scarlet macaw is distributed from Central America to Brazil. Its feathers are mainly a deep red, but there are flashes of blue and yellow on the wings and on the long tail that accounts for more than half its overall length.

Blue-and-yellow Macaw

Family: Psittacidae; Genus: *Ara*
Indigenous to southern Central America and Bolivia, this macaw is one of the largest parrots. It is brightly colored, with a yellow front and blue wings and tail. It has a loud call and is a good mimic.

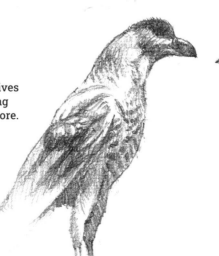

Its large beak can crack hard nut kernels. The tilted head expresses a typical macaw characteristic.

Large-billed Crow

Family: Corvidae; Genus: *Corvus*
Named for its curved, thick beak, this crow lives in East and Southeast Asia. It has a protruding forehead, and is a mostly carnivorous omnivore.

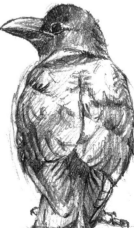

An indescribably beautiful effect can occur when light strikes the black plumage of crows. Using only the graphite in your pencil, can you express something of this beauty?

Doves and Pigeons

Family: Columbidae; Genus: *Columba*
Indigenous to the Mediterranean hinterland, pigeons
have spread throughout the world.

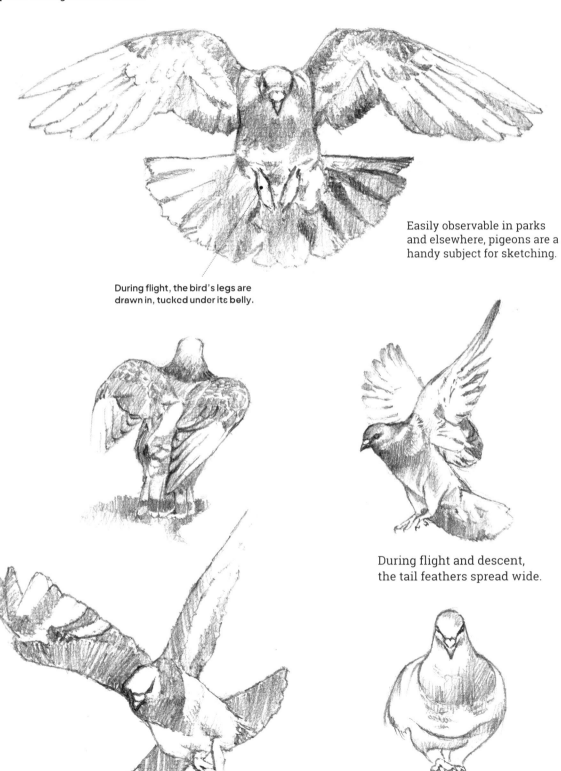

During flight, the bird's legs are
drawn in, tucked under its belly.

Easily observable in parks
and elsewhere, pigeons are a
handy subject for sketching.

During flight and descent,
the tail feathers spread wide.

Cranes

On four continents, the exceptions being Antarctica and South America, there are fifteen crane species in four genera.

Cranes tend to stretch their necks and legs straight out. They fly with slowly flapping wings.

Red-crowned Crane

Family: Gruidae; Genus: *Grus*
Distributed from southeastern Russia and northeast China to Korea and Japan, these cranes have a white body and black neck and tail feathers. Their bald forehead has red skin. Being omnivorous, they feed on fish, crustaceans, mollusks, amphibians, water plants, acorns, rice, etc. They feed in deeper water than other cranes.

Crane courtship displays are full of beauty and grace. Can you capture the essence of this dance?

The wings are black from below the eyes to the neck and back. Red skin is exposed on the crown. The image of the bird is of strong colors accentuating its white body.

Grey-crowned Crane

Family: Gruidae; Genus: *Balearica*
Indigenous to southern Africa, this crane is noted for a fan of stiff golden feathers on its crown. It has velvety feathers on its forehead and a furry-looking gray neck adorned with gorgeous long plumes.

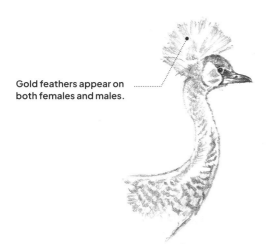

Gold feathers appear on both females and males.

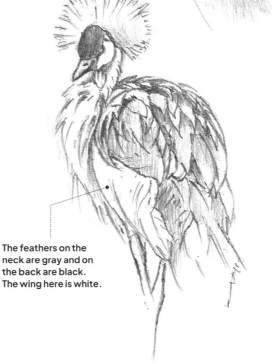

The feathers on the neck are gray and on the back are black. The wing here is white.

Penguins and Ducks

Humboldt Penguin

Family: Spheniscidae; Genus: *Spheniscus*
Found on coasts of north and central Chile
and Peru, Humboldt penguins are slow on
the ground but swim at high speed and
dive to catch squid, shrimp and krill.

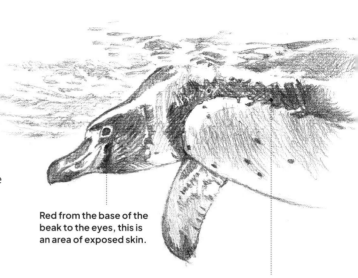

Lit from above, they are
submerged, but there may be
light reflected from below.

**Red from the base of the
beak to the eyes, this is
an area of exposed skin.**

**Humboldt penguins have a
thick black line around the
arch of the breast.**

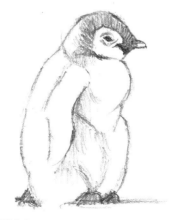

In aquariums, you can look
up at them swimming.

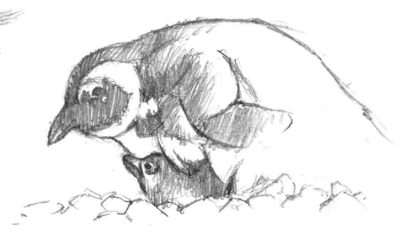

Emperor Penguin

Family: Spheniscidae; Genus: *Aptenodytes*
This bird, the largest of all penguins, lives in Antarctica.
They spend summers at sea. In autumn, waddles of
penguins migrate over ice to sites where they form
colonies, lay eggs and raise chicks.

Chick
These are about four heads tall.
Make the body bulges cute.

King Penguin

Family: Spheniscidae; Genus: *Aptenodytes*
Found on small islands around Antarctica, the king penguin, the second largest of all penguins, has a striking orange coloration on the head and throat. They eat fish, squid and crustaceans.

Wing-like flippers propel penguins through the water. The flippers and the overall body form of each species are distinctive.

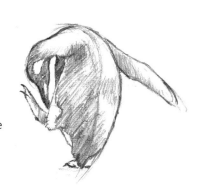

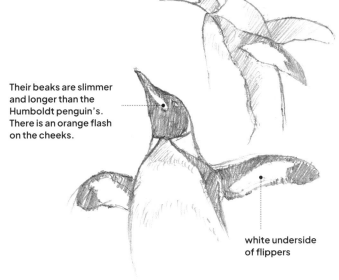

Their beaks are slimmer and longer than the Humboldt penguin's. There is an orange flash on the cheeks.

white underside of flippers

A black back, a pure white belly and a distinctive orange-to-yellow gradation from throat to breast characterize the king penguin.

Eastern Spot-billed Duck

Family: Anatidae; Genus: *Anas*
Mostly permanent residents in China, Japan and the Korean Peninsula, this duck lives on rivers, lakes and marshes, and feeds on grass, berries and aquatic snails.

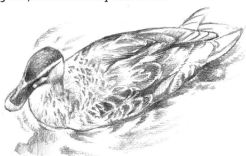

Duckling

Male and female Eastern spot-billed ducks have similar coloration. Their ducklings hatch every year next to a pond in a nearby park. Adults and juveniles are perfect for observing and drawing. Next, let us spread our wings and describe the appearance of flight.

TRY IT!

Draw a duckling.

❶ Viewed from a somewhat oblique angle, the form is a large ellipse. The head length is about one–third of the body.

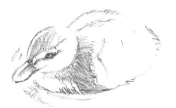

❷ The juvenile patterning is layered with short lines. It is lit from behind.

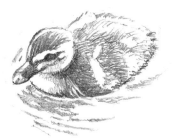

❸ Add dark lines and shading on the head and beak to define the face. Rippling water makes the context clear.

How to Draw Birds

Birds evolved very differently from mammals. Here, you can find out about body forms and wing structure.

Draw with the skeleton in mind: Key Points

1 Bird bodies are covered with functional and decorative feathers. Hard keratin forms their beaks. They have many more cervical vertebrae (neck bones) and more flexible necks than mammals. Large birds tend to have relatively smaller heads. Birds perched on branches hold their bodies almost perpendicular. Their tail tips usually come below foot level. Flying species have a well-developed breastbone called a keel. Flightless birds do not have keels.

The head of this large species is proportionally much smaller than its body.

Ostrich skeleton
(whole body)

Numerous neck bones allow birds to remain still and turn their heads backward.

Goose skeleton
(whole body)

keel

keel

Bird bodies are held perpendicular from toe to crown when perching.

Eagle skeleton
(whole body)

Tail feathers end lower than feet when perching.

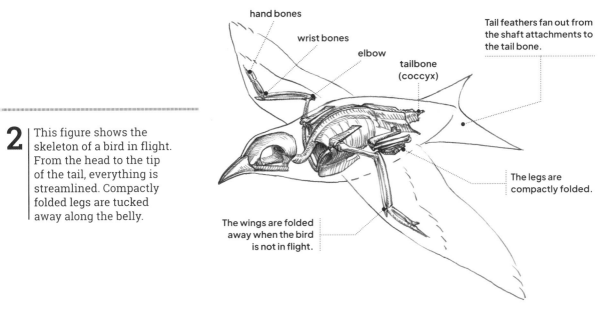

2 | This figure shows the skeleton of a bird in flight. From the head to the tip of the tail, everything is streamlined. Compactly folded legs are tucked away along the belly.

hand bones

wrist bones

elbow

tailbone (coccyx)

Tail feathers fan out from the shaft attachments to the tail bone.

The legs are compactly folded.

The wings are folded away when the bird is not in flight.

Types and names of feathers

The purpose of wing feathers depends on their location. Feathers are named for their different functions. "Coverts" means a set of feathers, which literally "cover other feathers."

From above

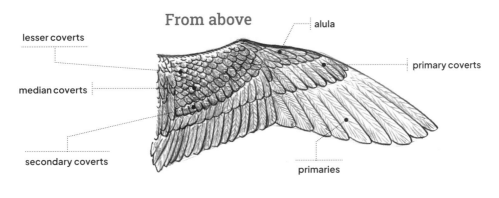

lesser coverts

alula

median coverts

primary coverts

secondary coverts

primaries

From below

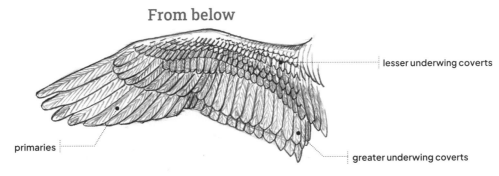

lesser underwing coverts

primaries

greater underwing coverts

(*Source: Structure and Life of Birds III: Wings and Flight* (in Japanese), Abiko City Museum of Birds, 1998)

How to Draw Imaginary Animals
Draw with the skeleton in mind: Key Points

Animals are often imagined as chimeras, that is, combinations of actual creatures. For example, the sphinx has a human head and a lion's body, and angels have human bodies with bird wings. Dragons typically have lizard or crocodilian heads, dinosaur bodies and bat wings. Inconsistencies in the skeletal joint structure cannot be resolved by art anatomy. When creating a fantastical creature, do not worry about internal structure. Play with external forms.

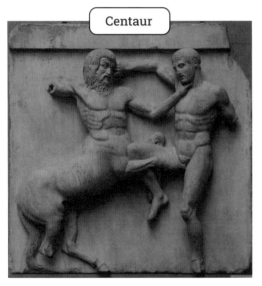

Centaur

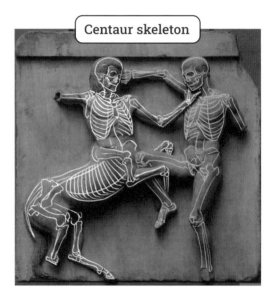

Centaur skeleton

To form a centaur, a horse chest and forelimbs join at a man's waist. This relief marble is from the British Museum collection of Metopes of the Parthenon (ca. 446 BCE). (Photo and illustration: author)

Imaginary animals in other art works

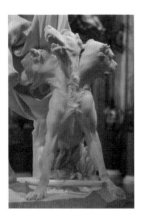

Gian Lorenzo Bernini Bernini's marble statue includes a three-headed Cerebus (1622, Borghese Gallery). (Photo: author)

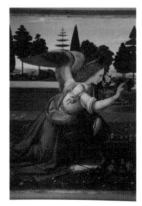

Leonardo da Vinci Annunciation (ca. 1472–75, tempera, Uffizi Gallery) Pointed wings of waterfowl feathers spring from a human back. (Photo: author)

Coloring Your Drawings

Useful Art Materials and Tools

The great thing about drawing is that you can easily start with paper and pencil. Here, you can find out about things I find most useful for coloring.

Sketchbook

You can draw on random paper but I find a sketchbook is the easiest and most convenient way to draw. If you plan to use watercolor, thicker paper is better. Try different papers to find the one that best suits your style and touch.

Drawing Board

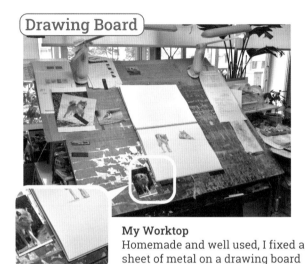

My Worktop

Homemade and well used, I fixed a sheet of metal on a drawing board and pasted paper on it. The metal lets me use magnets to hold photos and sketchbooks in place while I work.

Lens and compasses

I use compasses to gauge the proportions of subjects. I need a magnifying glass to see fine detail when drawing from photos.

Pencils

I like Mitsubishi uni pencils in 2H, H, HB and B. F gets the most use.

Handy water bottle

A plastic condiment squeeze bottle makes it easy to distribute water into palette wells.

Fixative

I use this to prevent smudging of pencil drawings.

Pencil Sharpening Board

I put offcuts of illustration board (yellow circle) next to my pencils. I rub sharpened pencil tips to blunt them and rub round tips to make them sharper. Cardboard also works.

Watercolors

I prefer Windsor & Newton transparent watercolor paints.

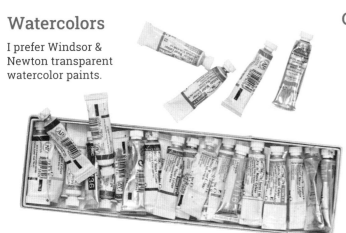

Colored pencils

Makers include Holbein and Charisma Color. I prefer oil-based pencils.

Palette and brushes

For watercolor, try both round and flat watercolor brushes. They are inexpensive and easy to use.

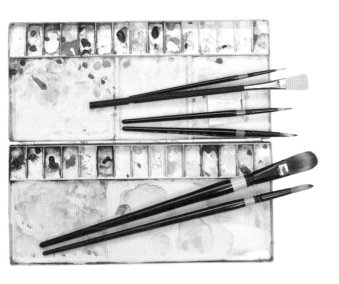

Grouping your pencils

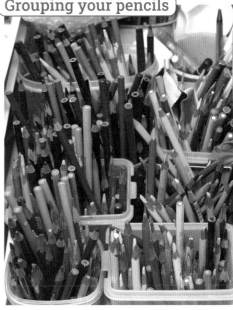

To find what you want at a glance, keep colored pencils grouped in color sets.

Paper towels

I use these to absorb moisture from brushes and to wipe off paint from the palette.

Idea

When you no longer need a mixed color on the palette, wipe off only that area with a moistened paper towel.

Acrylic paint and paper palettes

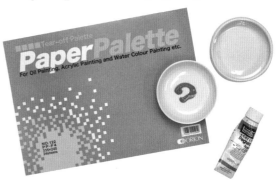

I use Liquitex acrylic paints with small ceramic plates or paper palettes to simplify cleaning.

Visual Materials and Objects

If you want to depict the fine details of a subject, take photos. If you have the opportunity to purchase taxidermy, other specimens and even bird feathers, they can serve as good resources for observing details.

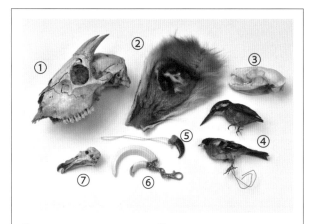

① Antelope or goat skull ② Skinned red fox face ③ Masked palm civet skull ④ Small stuffed birds ⑤ Brown bear claw ⑥ Wild boar tusk ⑦ Seabird skull, possibly a petrel. Some time ago, I bought stuffed birds from a taxidermist.

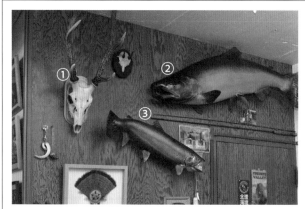

① Japanese deer skull ② King salmon caught in Alaska ③ Steelhead trout caught in Canada.

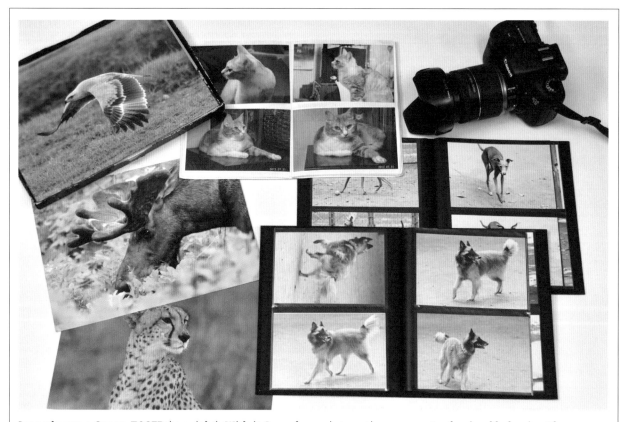

I mostly use a Canon EOS7D (top right). With it, I can freeze interesting moments of animal behavior. The cheetah photo (bottom left) was sent to me by a wildlife photographer.

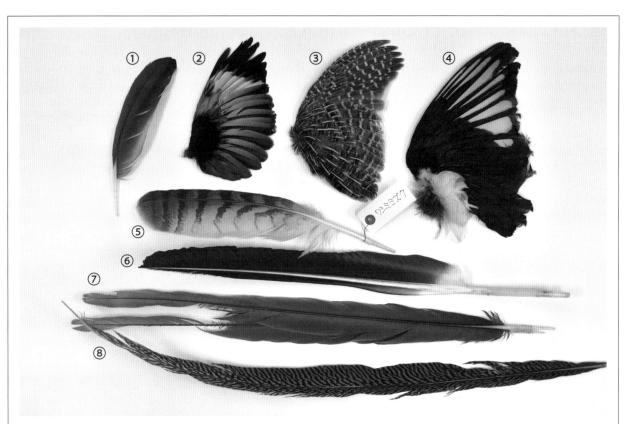

① Scarlet macaw feather ② White-throated kingfisher wing ③ Japanese quail wing ④ Eurasian magpie wing ⑤ Eurasian eagle-owl feather ⑥ White-tailed eagle primary feather ⑦ Blue-and-yellow macaw tail feather ⑧ Green pheasant tail feather. I bought these from fishing tackle shops or got them during trips abroad.

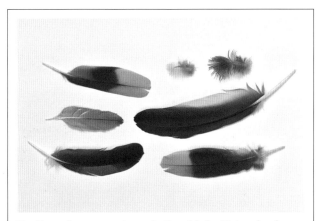

Feathers from parrots and other birds. Natural colors and textures stimulate artistic interest.

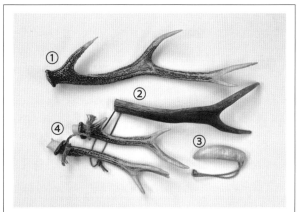

① Japanese deer antler ② Reindeer antler ③ Sperm whale tooth ④ Japanese deer antlers. When you travel, items like these can be found in souvenir shops.

Coloring Basics

Try adding color to your drawings. Even a light touch of watercolor greatly increases realism.

Sample 1: Watercolor **Cat**

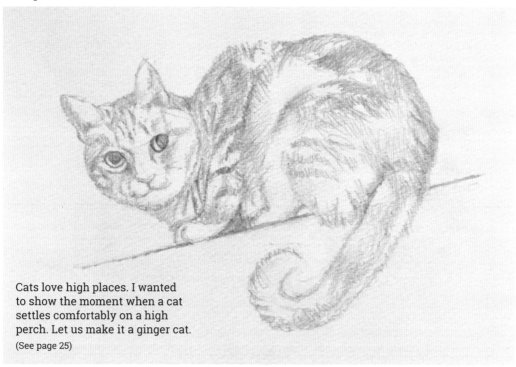

Cats love high places. I wanted to show the moment when a cat settles comfortably on a high perch. Let us make it a ginger cat.
(See page 25)

Start with the lightest color.

Dry paper does not initially absorb paint well. Before painting, moisten all over with water, then dry lightly with a hair dryer. Start painting thinly with a mix of pink, light brown and light gray.

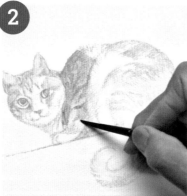

Paint in layers.

Paint the fur starting with pale brown. Then add darker shades of brown. Monitoring the balance, gradually increase the color saturation.

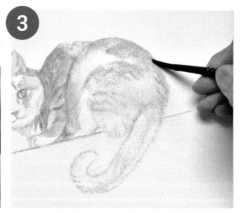

Consider the whole coloration.

Do not paint too darkly where light is reflected. Leave such highlights and white fur unpainted.

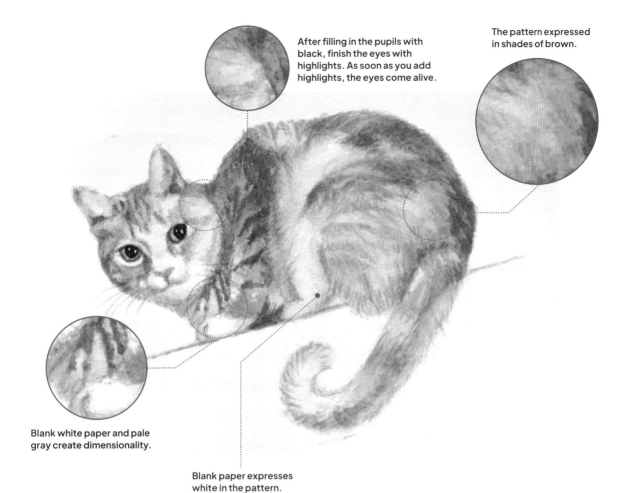

After filling in the pupils with black, finish the eyes with highlights. As soon as you add highlights, the eyes come alive.

The pattern expressed in shades of brown.

Blank white paper and pale gray create dimensionality.

Blank paper expresses white in the pattern.

4

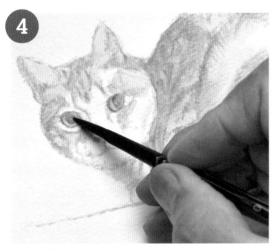

Paint the eyes.
After coloring the irises, blacken the pupils. A strong black enhances expression in the eyes.

5

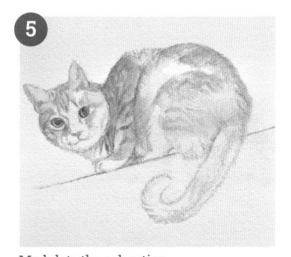

Modulate the coloration.
Once pale colors have been added on top of sketched lines and shading, add darker colors to inject more life.

Sample 2: Watercolor
Dog

The coloring of a Shiba Inu is similar to the wild fox. Erect ears enhance their clever look. When drawing them, you understand the features that make the breed a world favorite.

(See page 63)

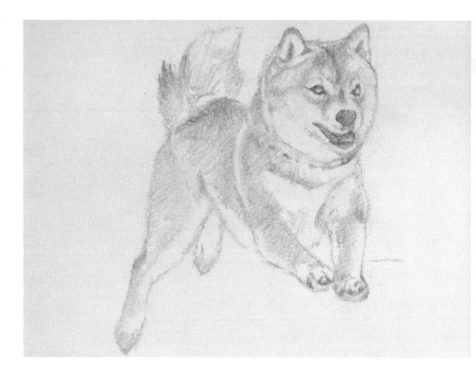

Moisten with water.

As dry paper does not initially absorb paint well, moisten the paper all over with water before starting to draw.

Dry lightly.

Lightly dry with a hair dryer but leave the surface damp.

Start with light colors.

Create a mix of pink, light brown and light gray and lightly apply as a base to areas that will be overpainted.

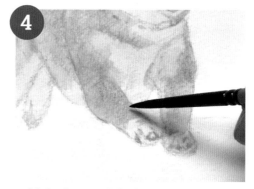

Add darker and darker tones.

Leave blank paper to show white, as at the paws. Elsewhere, gradually go from light to the darkest coloring.

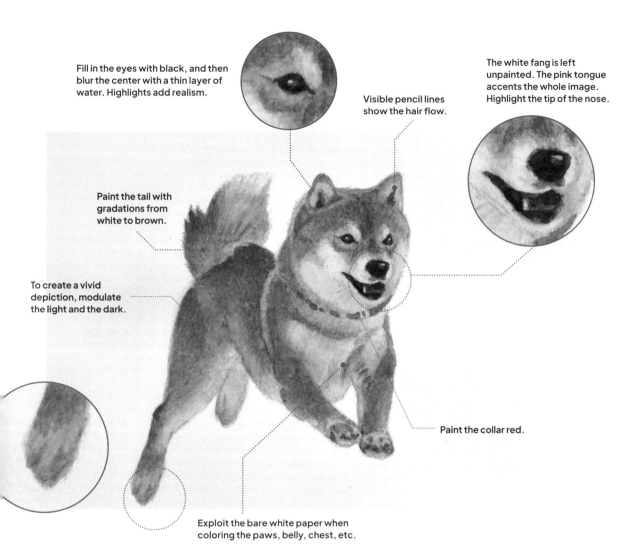

Fill in the eyes with black, and then blur the center with a thin layer of water. Highlights add realism.

Visible pencil lines show the hair flow.

The white fang is left unpainted. The pink tongue accents the whole image. Highlight the tip of the nose.

Paint the tail with gradations from white to brown.

To create a vivid depiction, modulate the light and the dark.

Paint the collar red.

Exploit the bare white paper when coloring the paws, belly, chest, etc.

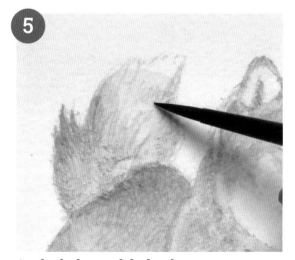

5

Apply darker and darker layers.
Checking changes in the shade, paint the tail mostly light brown. The body is similarly painted in layers to increase intensity where necessary.

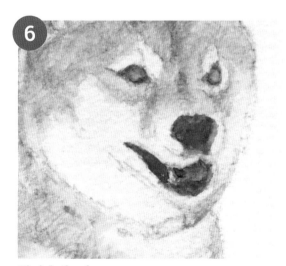

6

Finish the face.
After applying the pale base to colored parts of the face, paint the nose, mouth and eyes. Now you can see how to color other key areas.

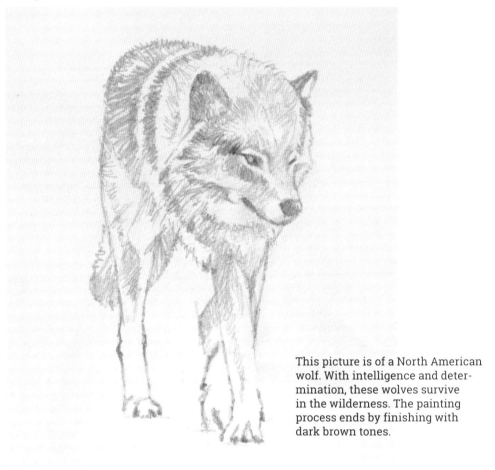

This picture is of a North American wolf. With intelligence and determination, these wolves survive in the wilderness. The painting process ends by finishing with dark brown tones.

Moisten the paper.

Lightly apply water to the entire surface and let it dry until just a little damp.

Paint the light colors first.

Using a mix of light gray and light brown, paint the non-white areas. If you paint darker colors first, correction is difficult.

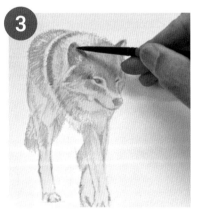

Paint the ears.

Darker colors are added as a finishing touch. First color in light colors and gradually add darker tones.

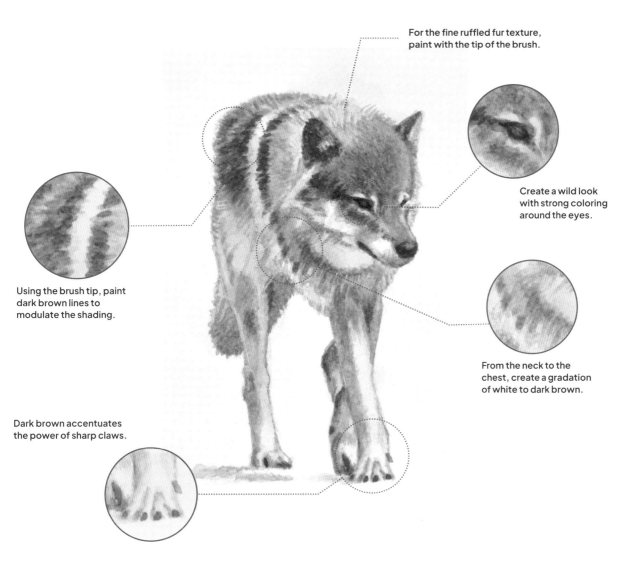

For the fine ruffled fur texture, paint with the tip of the brush.

Create a wild look with strong coloring around the eyes.

Using the brush tip, paint dark brown lines to modulate the shading.

From the neck to the chest, create a gradation of white to dark brown.

Dark brown accentuates the power of sharp claws.

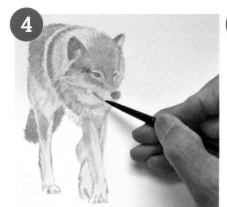

4

Add light brown.

Use light browns for the forehead, body and eyes. Use both light brown and dark brown to create contrast, which will help to create shadows.

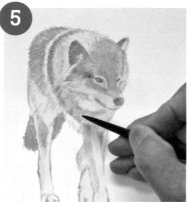

5

Add brown tints on the body.

Apply light browns to the tail, chest, legs, etc. Contrast by detailing browns on the face more than on the body.

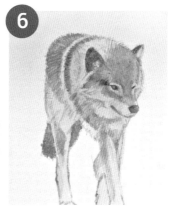

6

Finish with darker tones.

After coloring the body with lighter colors, finish with dark brown.

Chipmunk

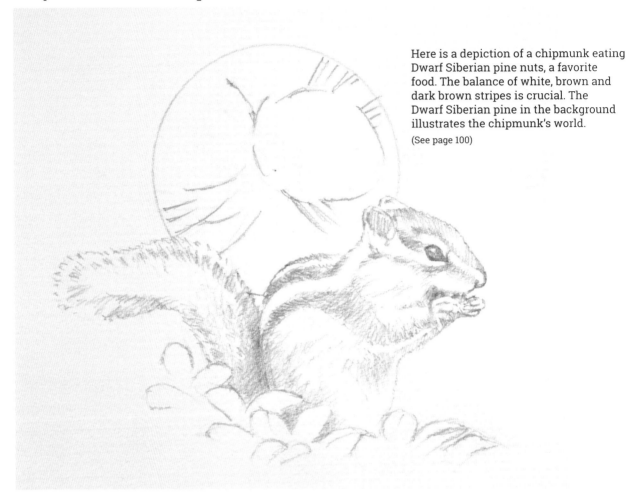

Here is a depiction of a chipmunk eating Dwarf Siberian pine nuts, a favorite food. The balance of white, brown and dark brown stripes is crucial. The Dwarf Siberian pine in the background illustrates the chipmunk's world.

(See page 100)

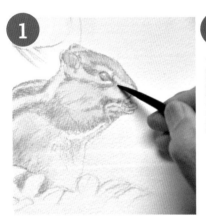

Start with paler tints.
First lightly apply water to the paper surface and let it dry till slightly damp. Mix pink, light gray and yellow, and apply as a base to the areas to be colored.

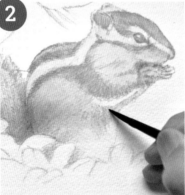

Add shading.
After applying light brown, touch up the shaded areas with light gray. The shading is becoming more defined.

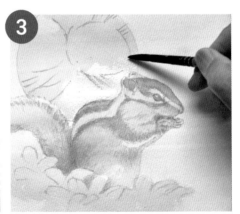

Apply a thin wash to the background.
While the painted chipmunk is drying, add a light green base to the background area.

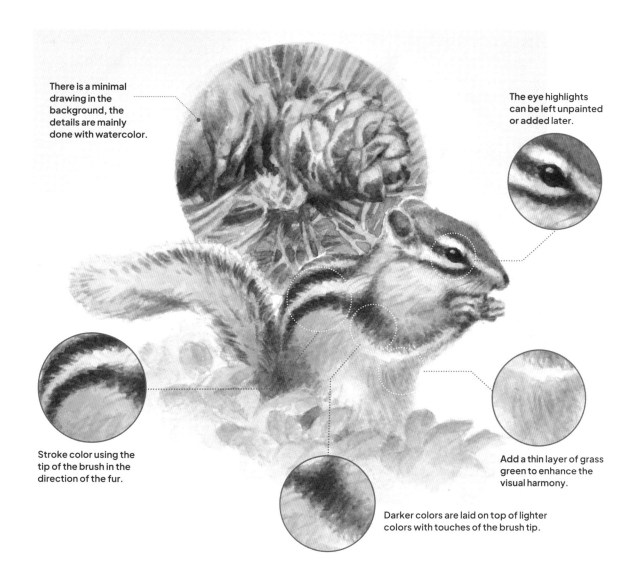

There is a minimal drawing in the background, the details are mainly done with watercolor.

The eye highlights can be left unpainted or added later.

Stroke color using the tip of the brush in the direction of the fur.

Darker colors are laid on top of lighter colors with touches of the brush tip.

Add a thin layer of grass green to enhance the visual harmony.

Add darker touches to the background.

For an effective color bleed, add darker touches before the base color dries.

Paint the stripes.

Resume coloring the chipmunk. Paint dark brown striping.

Paint the eyes.

Finish by painting the darkest parts, such as the eyes. It is important to leave clearly visible white highlights.

Sample 5: Watercolor **Sparrow**

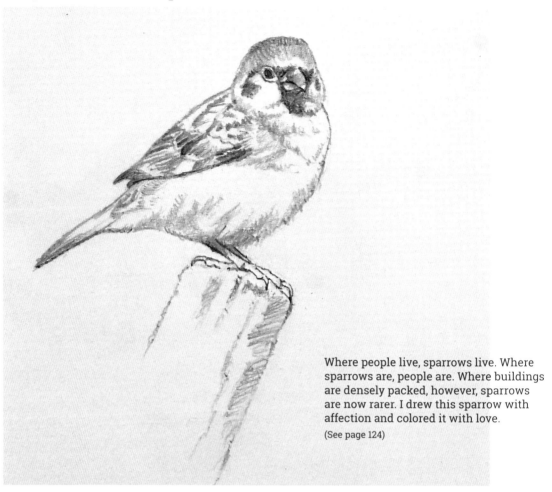

Where people live, sparrows live. Where sparrows are, people are. Where buildings are densely packed, however, sparrows are now rarer. I drew this sparrow with affection and colored it with love.

(See page 124)

Moisten with water.
Apply water to the entire surface, then dry lightly with a hair dryer. When the paper is slightly damp, paint goes on better.

Paint the head and under the beak.
Mix light gray and light pinkish colors. Use this pale color as a base for all the colored areas. Paint under the beak and from the head downward.

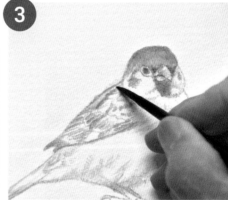

Paint the wings with the base color.
Before adding any other colors, paint the light brown base color on the wings.

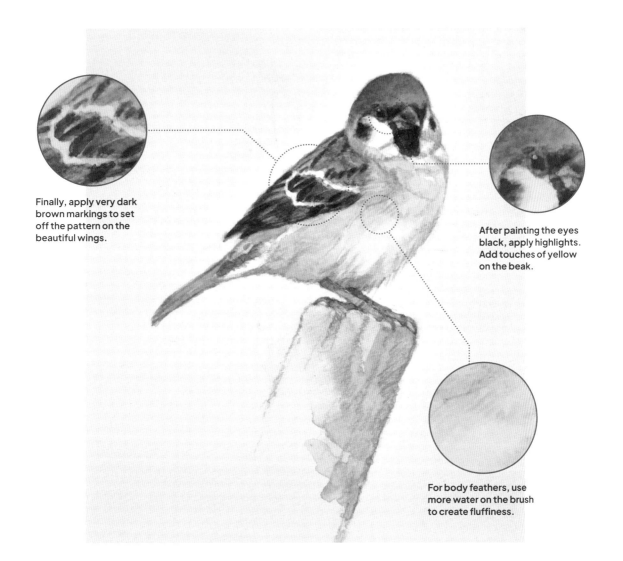

Finally, apply very dark brown markings to set off the pattern on the beautiful wings.

After painting the eyes black, apply highlights. Add touches of yellow on the beak.

For body feathers, use more water on the brush to create fluffiness.

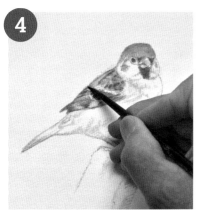

Add light brown.

Create a light brown color and continue painting the wings. The light source is from upper left. To show brightness, use more diluted paint.

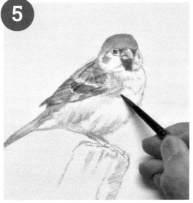

Add shadows.

Thin the base color with more water and touch up the shadows to give the body volume.

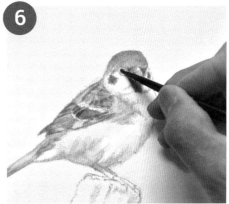

Finish with the face.

Paint the beak, cheeks and eyes. Apply dark face coloring to achieve a striking look.

How to Repair "Oh No!" Moments

Pencil lines can be easily erased. Paint cannot. Mistakes, however, can be fixed in watercolor painting, so stay calm.

Paint has gone across the line!

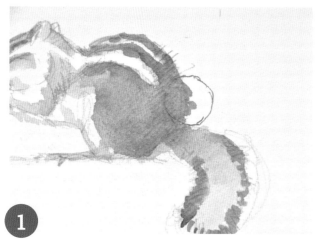

1 Your hand slipped. You accidentally painted beyond the line.

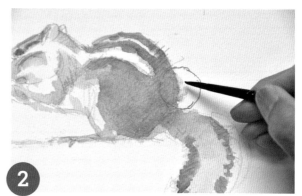

2 Load the brush with water. Use rinsing brush strokes on the offending area.

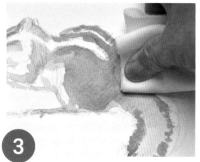

3 Pat with a paper towel.

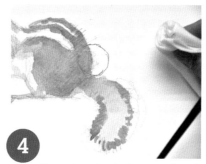

4 See, a lot of paint is gone already.

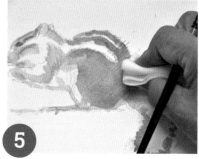

5 Repeat rinse and pat. As necessary, rinse with the brush, pat with the towel.

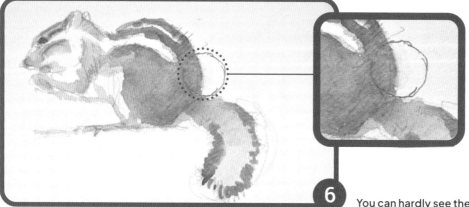

6 You can hardly see the mistake.

The area came out too dark!

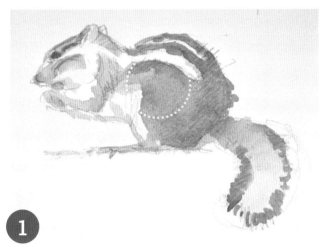

1 You made an area too dark that should be lighter.

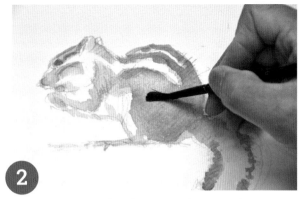

2 Load the brush with water and moisten the dark area.

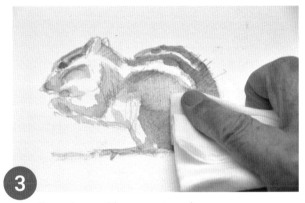

3 Press down with a paper towel.

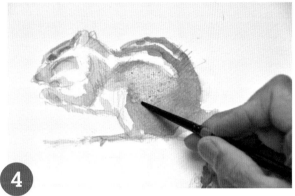

4 Touch up with a lighter color.

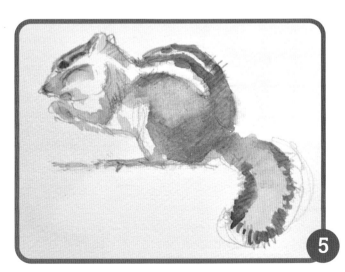

5 The color problem is solved.

Sample 6: Soft Finish **Panda**

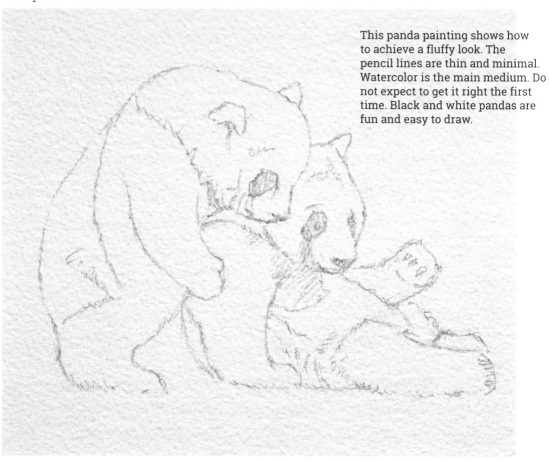

This panda painting shows how to achieve a fluffy look. The pencil lines are thin and minimal. Watercolor is the main medium. Do not expect to get it right the first time. Black and white pandas are fun and easy to draw.

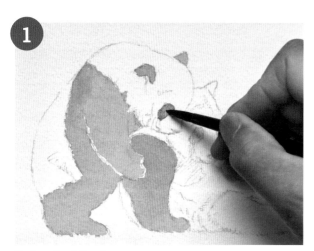

1

Paint the black areas.

Paint thinly with a mix of black and purple. Black alone is too strong for the overall image. To avoid unevenness, apply all at once before anywhere in the patch of color dries.

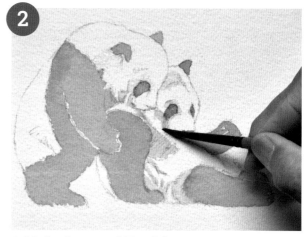

2

Add shadows and blotching.

Using light brown or light gray, add shadows or blotches to the white fur. It evokes a sense of playing outdoors.

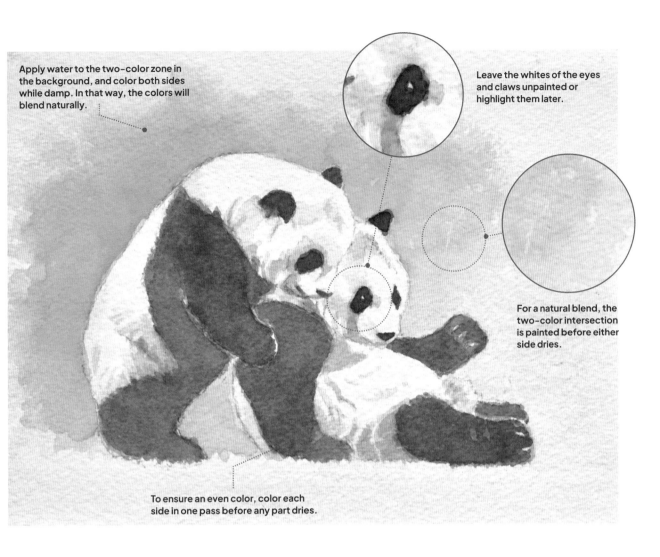

Apply water to the two-color zone in the background, and color both sides while damp. In that way, the colors will blend naturally.

Leave the whites of the eyes and claws unpainted or highlight them later.

For a natural blend, the two-color intersection is painted before either side dries.

To ensure an even color, color each side in one pass before any part dries.

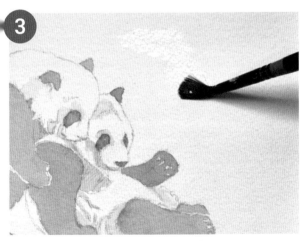

Apply water to the background.
Moisten the paper so that the colors blend.

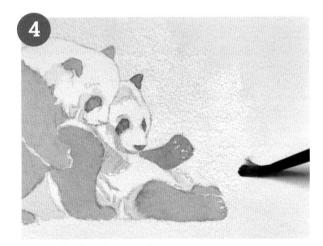

Paint the background.
Paint the left side of the background using a light pink and red (rose madder) mix, and the right with a mix of cadmium yellow and lemon yellow.

Sample 7: Colored Pencil Contrast **Bear**

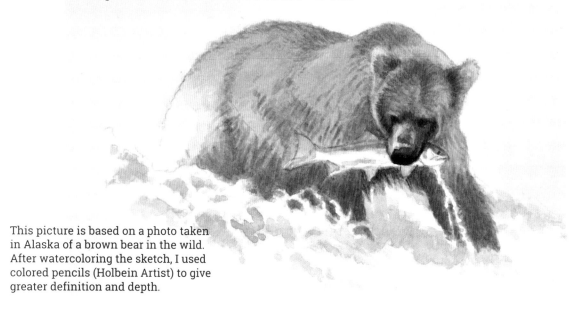

This picture is based on a photo taken in Alaska of a brown bear in the wild. After watercoloring the sketch, I used colored pencils (Holbein Artist) to give greater definition and depth.

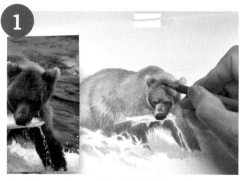

Add touches of light brick and dark brown.

Once the watercolors are completely dry, add touches of light brick and dark brown colored pencil to the head and ears. This shading adds volume.

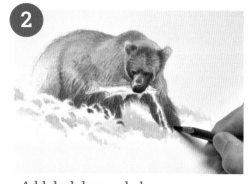

Add dark brown below.

Light is coming from the upper left. Show this with dark brown colored pencil shading.

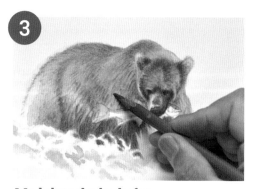

Modulate the body fur.

To suggest contour layering of the fur, add brick red and dark brown touches on the body.

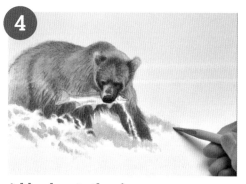

Add colors to the river.

Color some river water emerald green. Add other cold blues and greens. Make the river come alive.

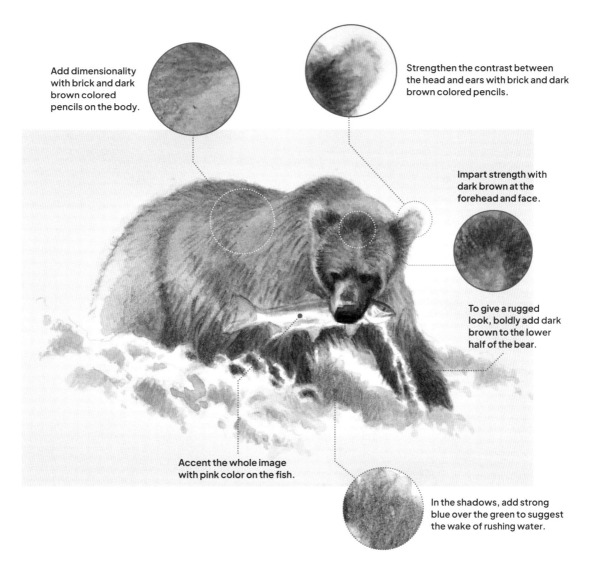

Add dimensionality with brick and dark brown colored pencils on the body.

Strengthen the contrast between the head and ears with brick and dark brown colored pencils.

Impart strength with dark brown at the forehead and face.

To give a rugged look, boldly add dark brown to the lower half of the bear.

Accent the whole image with pink color on the fish.

In the shadows, add strong blue over the green to suggest the wake of rushing water.

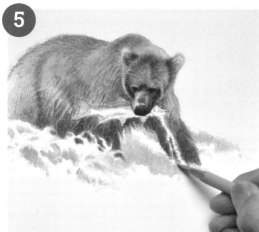

5 Layer the river coloring.

Express water depth and the play of light with greens and blues on the emerald water.

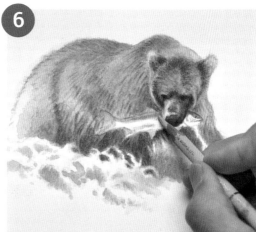

6 Add pink to the fish.

Add pink to the back of the fish. This touch draws the eye to the middle of the picture.

Sample 8: Acrylic Paint **Wolf**

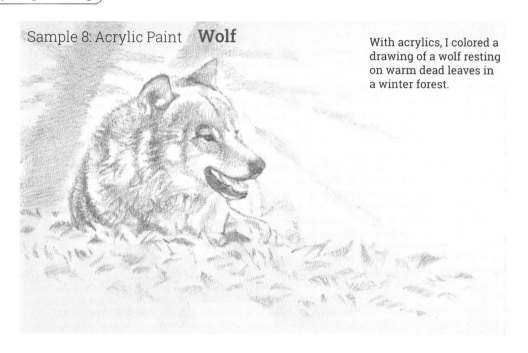

With acrylics, I colored a drawing of a wolf resting on warm dead leaves in a winter forest.

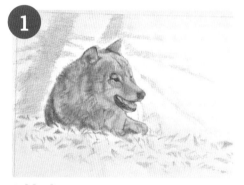

Add a base.
Mix a base color with red, brown, gray, white and yellow, and apply a thin layer to where the fur is to be colored.

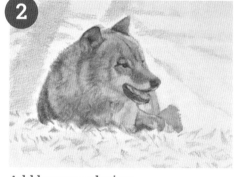

Add brown coloring.
Add brown touches to contrast the shadows with highlights.

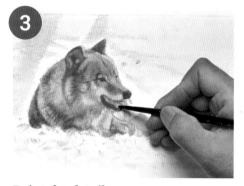

Paint the details.
After finishing the fur with more dark brown, add color to the eyes, nose, mouth and other areas.

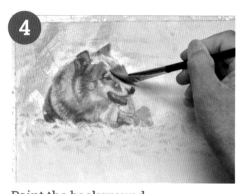

Paint the background.
After adhering masking tape along four sides of the paper, apply a light base color. Overlap this color on the wolf and blend it in.

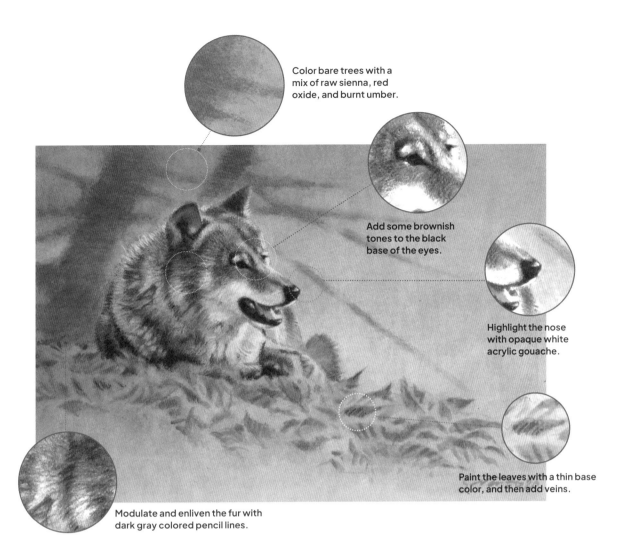

Color bare trees with a mix of raw sienna, red oxide, and burnt umber.

Add some brownish tones to the black base of the eyes.

Highlight the nose with opaque white acrylic gouache.

Paint the leaves with a thin base color, and then add veins.

Modulate and enliven the fur with dark gray colored pencil lines.

5

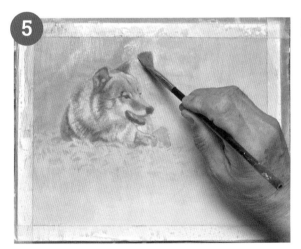

Add grading to the background.

Apply a thin layer of the base color on the background, graded from brown to yellow.

6

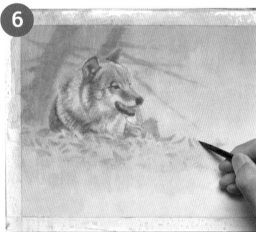

Add dead leaves and trees.

Paint dead leaves and trees in dark brown tones that match the overall gradation.

Selected Works by Sadao Naitō

I have created many animal paintings.
I hope you find inspiration in this selection.

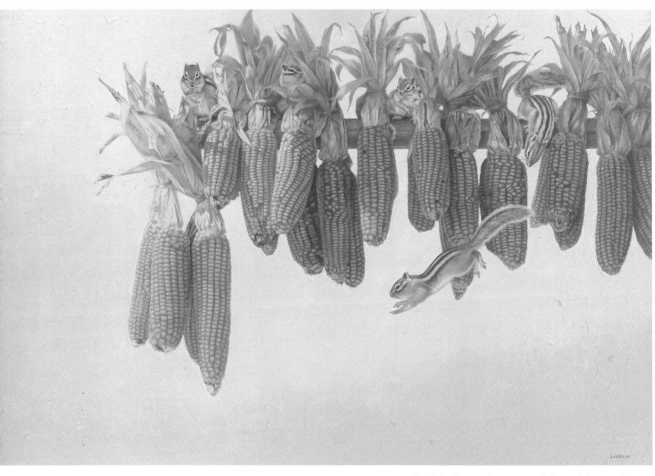

▲ In this dynamic composition, chipmunks are
raiding ears of corn intended for livestock.

Five Friends. Subject: chipmunks and corn.
Acrylic & gouache (38″ × 25″/97 × 64 cm)

▶ Farmers used to set fire to dried grass on the banks
of watercourses and paddy fields. In a flash, kestrels would
swoop down on insects that sprang from hiding.

Bank Fire. Subject: Common kestrel.
Acrylic & gouache (24″ × 31″/60 × 78 cm).

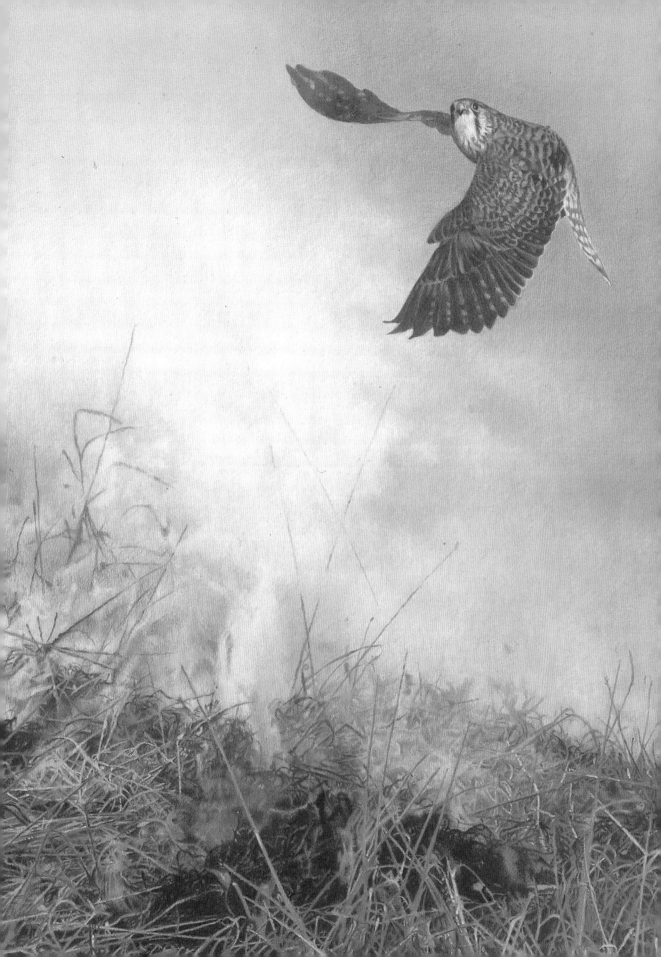

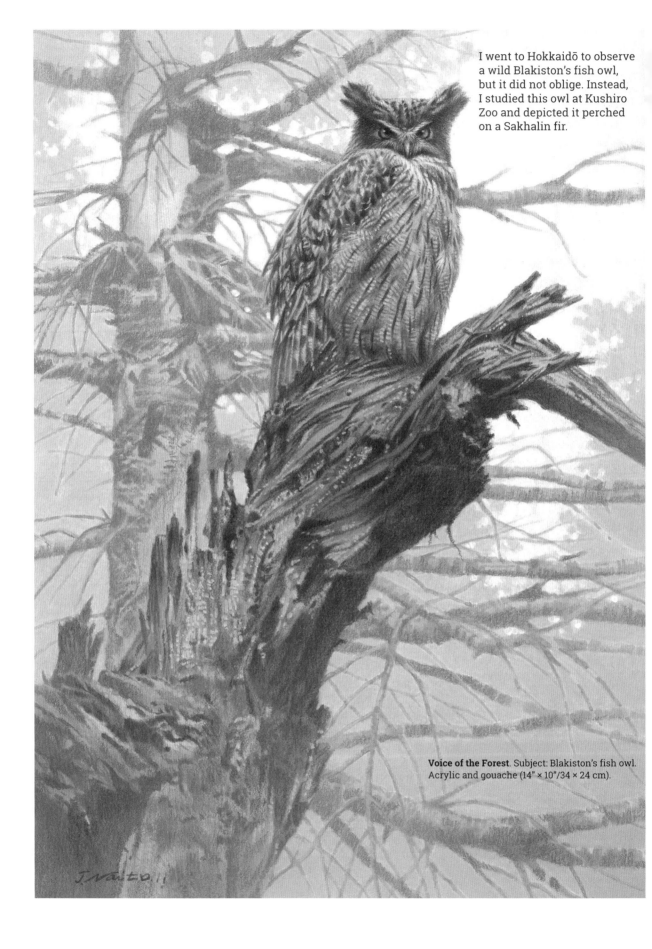

I went to Hokkaidō to observe a wild Blakiston's fish owl, but it did not oblige. Instead, I studied this owl at Kushiro Zoo and depicted it perched on a Sakhalin fir.

Voice of the Forest. Subject: Blakiston's fish owl. Acrylic and gouache (14" × 10"/34 × 24 cm).

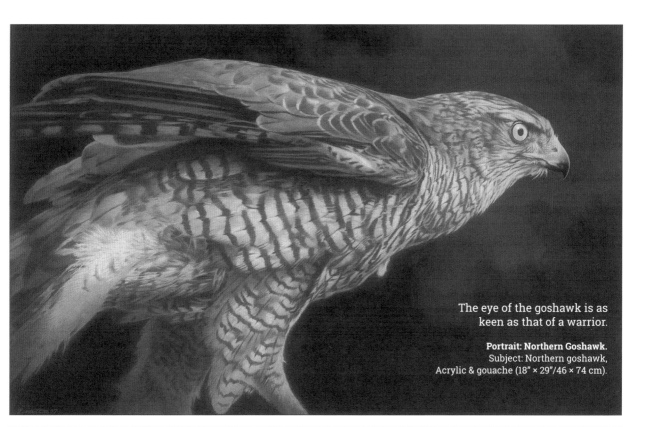

The eye of the goshawk is as keen as that of a warrior.

Portrait: Northern Goshawk.
Subject: Northern goshawk,
Acrylic & gouache (18″ × 29″/46 × 74 cm).

Here, I wanted to show life in the wild. I depicted a common snipe quietly at home in the reeds.

Common Snipe.
Acrylic & gouache (21″ × 29″/52 × 73 cm).

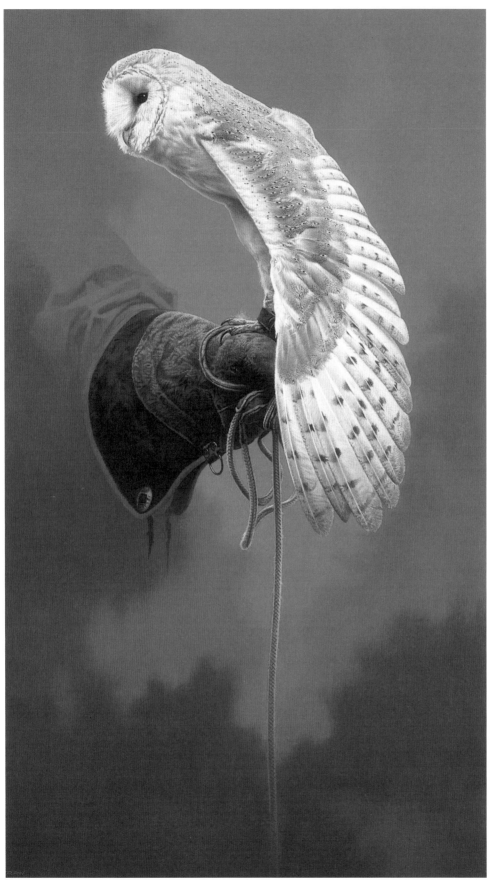

A barn owl seems at ease with its female handler. The scene fired my imagination and I painted it.

Trust. Subject: Barn owl. Acrylic & gouache (39″ × 22″/98 × 56 cm).

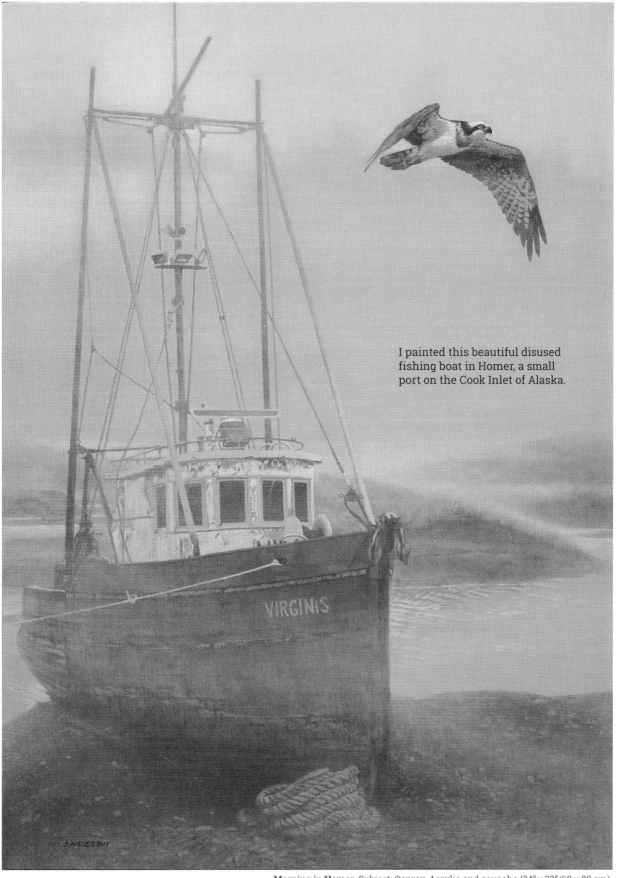

I painted this beautiful disused fishing boat in Homer, a small port on the Cook Inlet of Alaska.

VIRGINIS

Morning in Homer. Subject: Osprey. Acrylic and gouache (24" × 32"/60 × 80 cm).

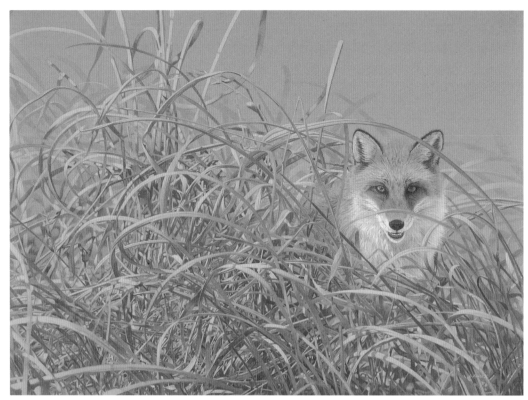

I will never forget a fox I once saw on the journey back from a long fishing trip. Illuminated by headlights, its face floated in the dark.

Silent Gaze. Subject: Fox, Acrylic & gouache (22″ × 30″/55 × 75 cm).

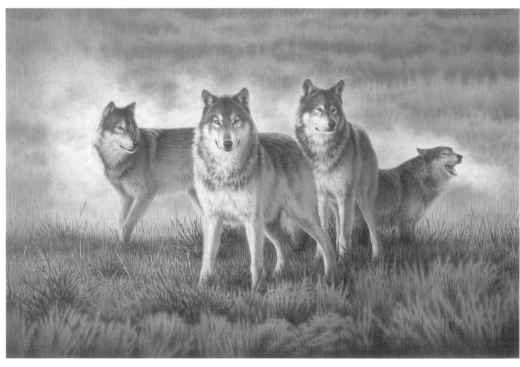

With fear and awe, some Native Americans accepted spiritual unity with the wolf.

Blue Legend. Subject: Timber wolf. Acrylic & gouache (21″ × 32″/54 × 81 cm).

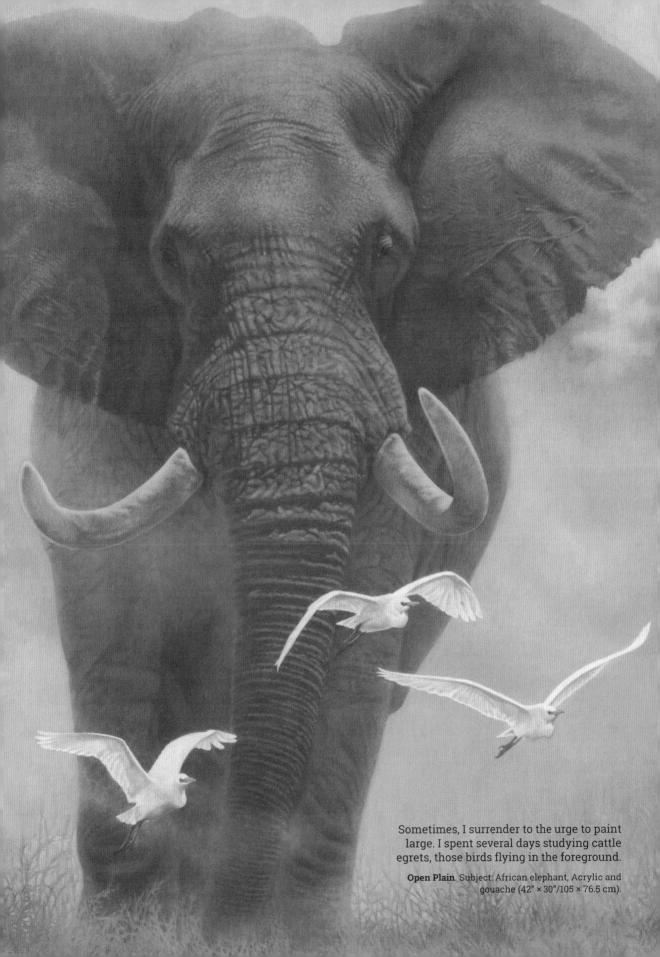

Sometimes, I surrender to the urge to paint large. I spent several days studying cattle egrets, those birds flying in the foreground.

Open Plain. Subject: African elephant, Acrylic and gouache (42" × 30"/105 × 76.5 cm).

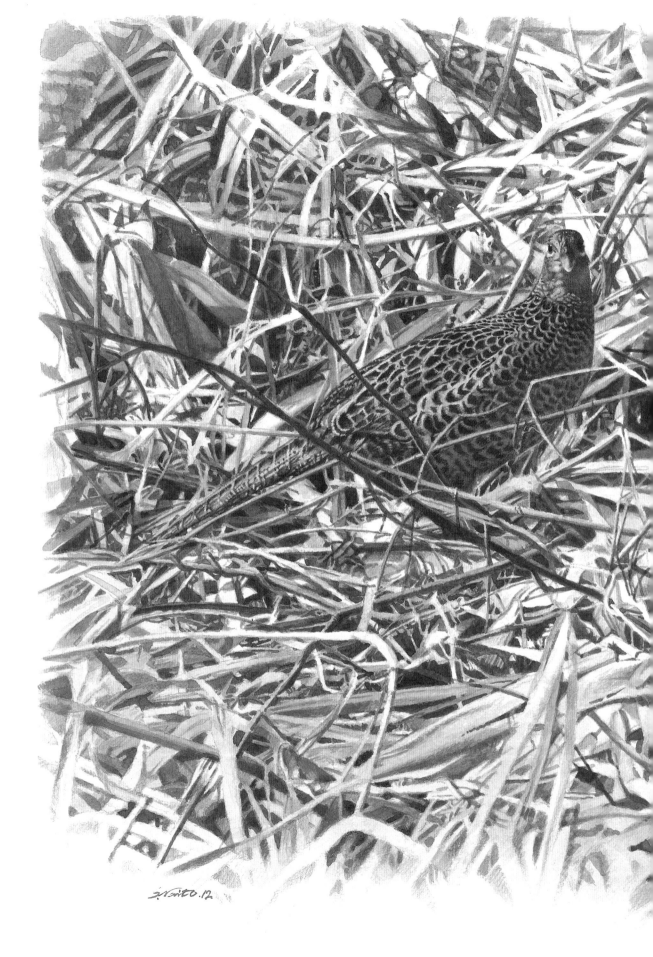

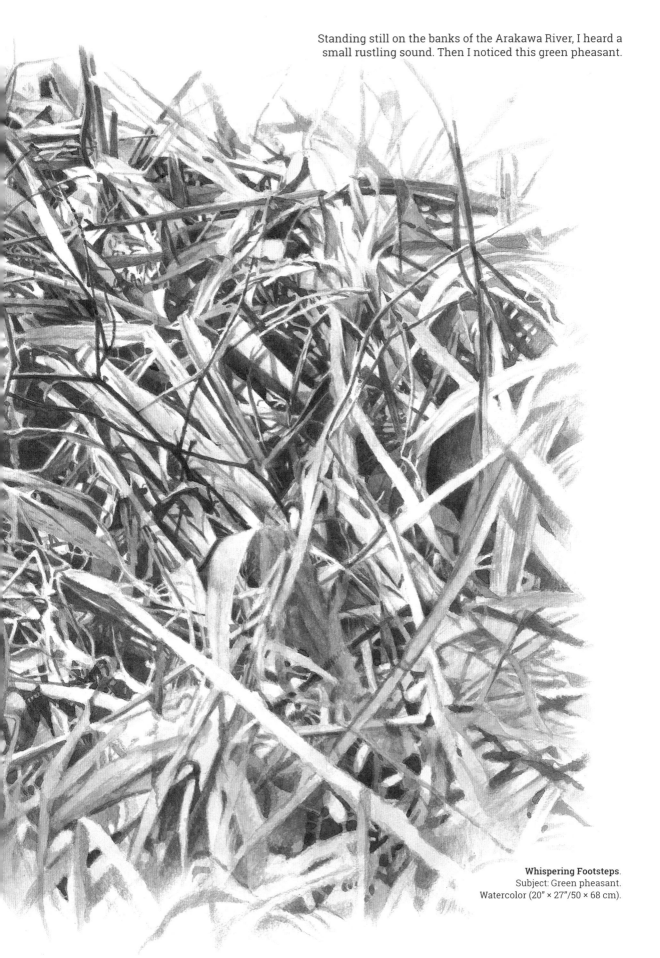

Standing still on the banks of the Arakawa River, I heard a small rustling sound. Then I noticed this green pheasant.

Whispering Footsteps.
Subject: Green pheasant.
Watercolor (20" × 27"/50 × 68 cm).

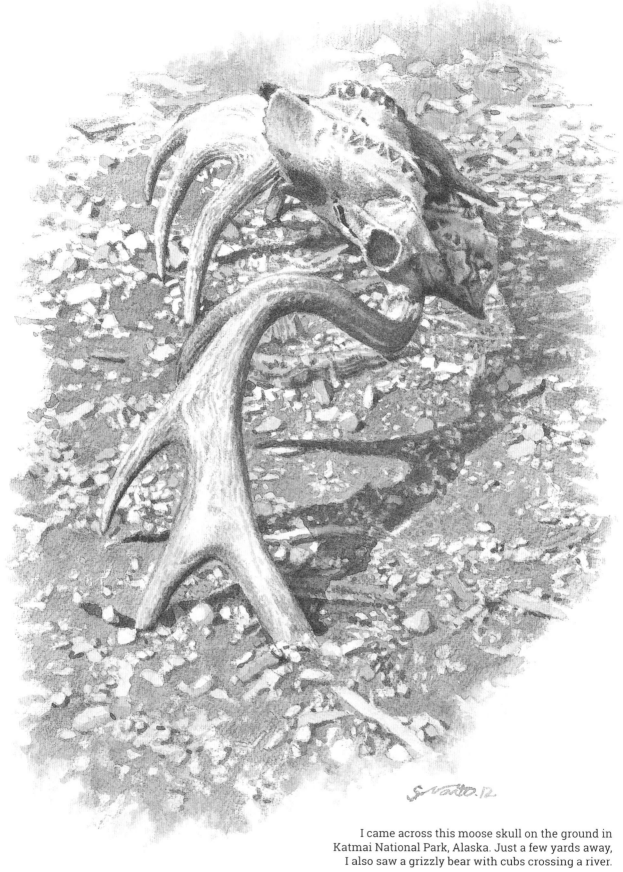

I came across this moose skull on the ground in
Katmai National Park, Alaska. Just a few yards away,
I also saw a grizzly bear with cubs crossing a river.

Moose Skull. Subject: Alaskan moose. Watercolor (10" × 8"/24 × 19 cm)

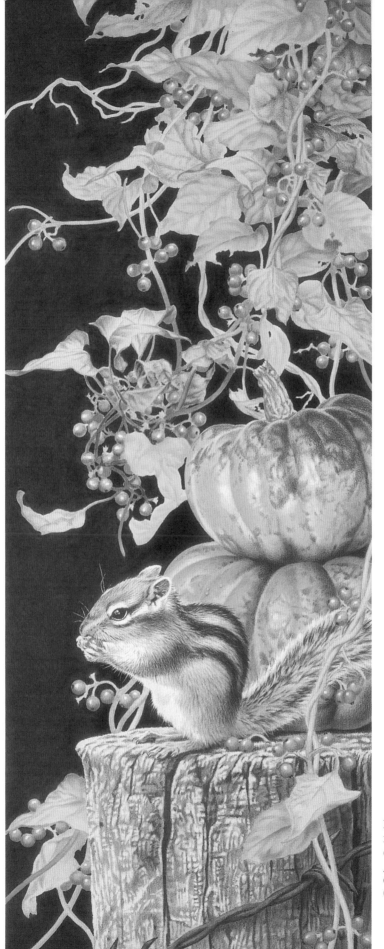

Placing a squash in a room brings home the changing season.

Autumn Gifts. Subject: Chipmunk. Acrylic & gouache (28" × 10"/72 × 26 cm)

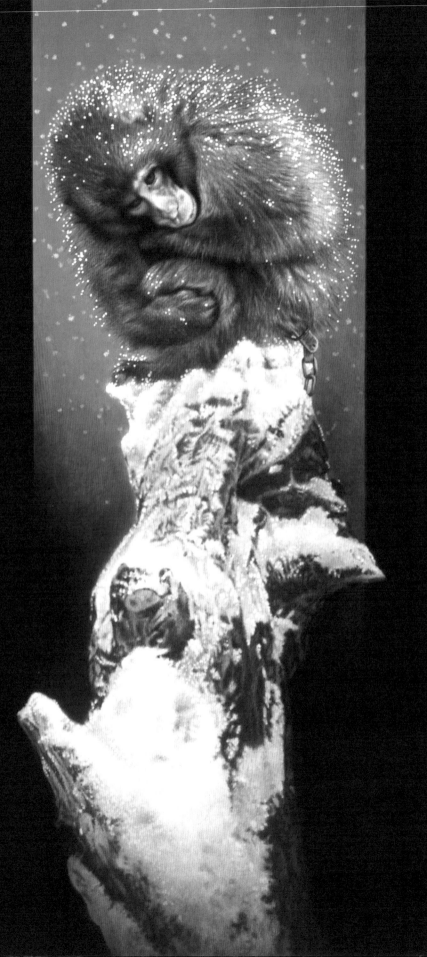

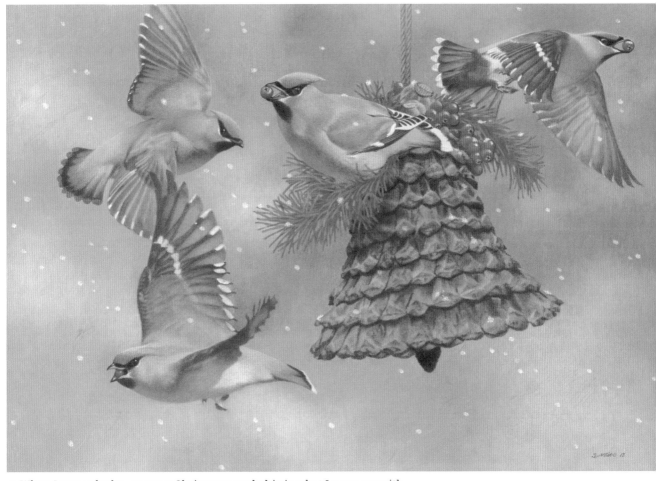

▲ When I was asked to create a Christmas card, this is what I came up with.

Christmas Bell and Waxwings. Subject: Waxwing. Acrylic & gouache (17" × 25"/43 × 63 cm).

◄ When I saw a Japanese macaque chained up in a private menagerie, its sad expression was seared into my memory.

Untitled. Subject: Japanese macaque, Acrylic and gouache (28" × 20"/70 × 50 cm).

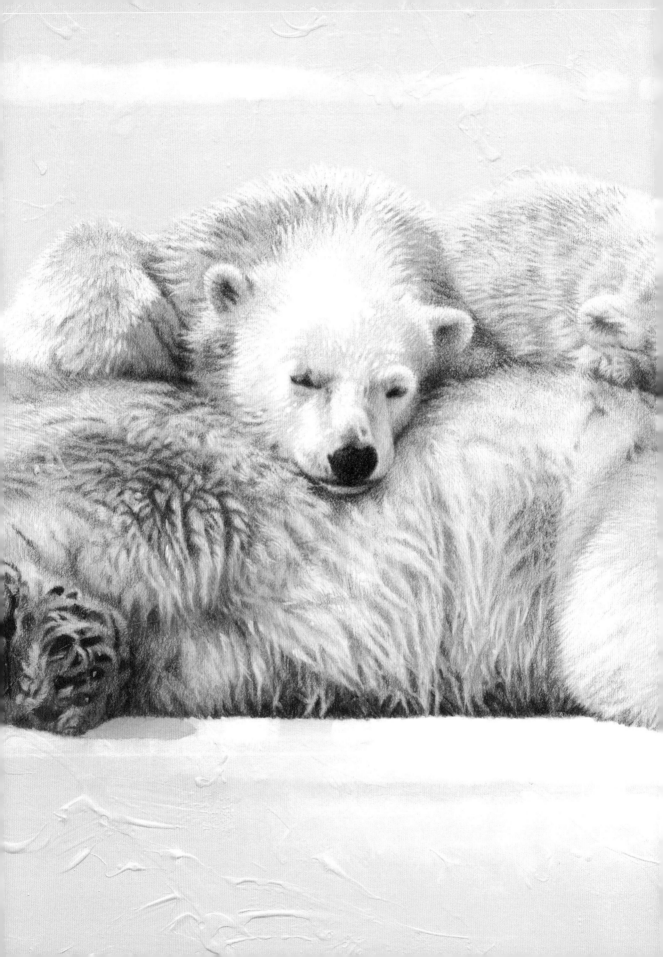

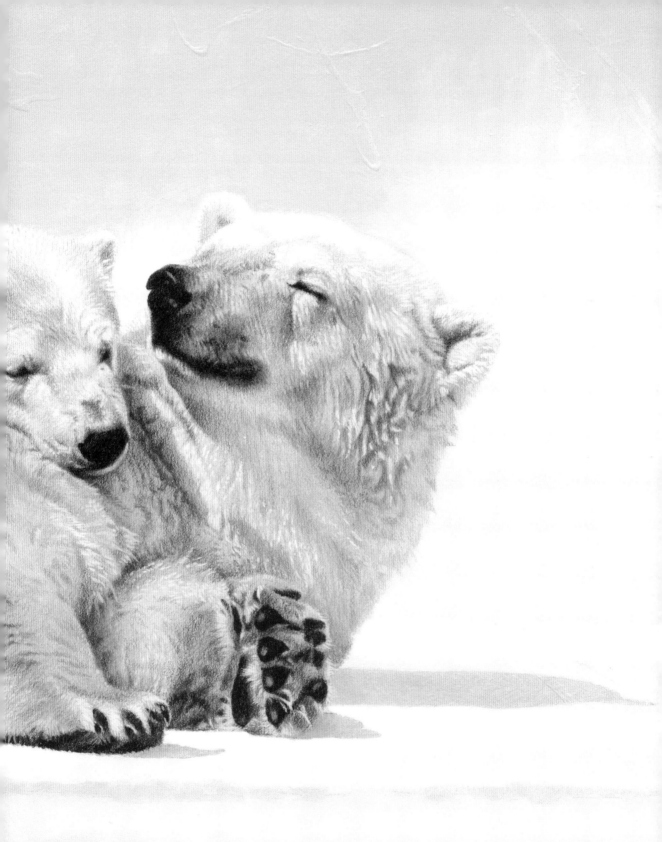

I painted this in 2011, the year of the Tōhoku earthquake and tsunami. It was soothing to watch a polar bear and cubs at Sapporo Maruyama Zoo.

Bonding. Subject: Polar bear. Acrylic & gouache (18″ × 25″/46 × 64 cm).

Sadao Naitō

Born in Tokyo in 1947, he graduated from the Tokyo Designer Gakuin College. He has created illustrations for *Newton* magazine's *Japan Nature Series* calendar as well as for United Airlines *American Nature Series*, and other clients such as JR Central and Suntory Holdings. He has also provided numerous illustrations for picture books, children's books, science publications and textbooks. In 1992, he received an Artist's Prize for a picture published in Kodansha's annual *Illustration in Japan*, and was awarded the Yamashina Institute of Ornithology Director General's Award in the *First Japan Bird Festival Wildlife Art Exhibition*. Other prizes include a Merit Award at the 2015 Members Exhibition of the Society of Animal Artists. In 2007, to commemorate its 100th anniversary, children's book publisher Froebel-Kan published *Sadao Naito: Animals, an anthology of his paintings*. In 2020 in Tokyo, he held a joint exhibition, *The Sedona*, with American artist Steve Hallmark. He continues to be a leading painter of detailed animal subjects. A member of WWF (World Wildlife Fund) Japan and the Wild Bird Society of Japan, he is also a member the Society of Animal Artists (USA), and serves as an advisor to the Japan Wildlife Art Society.

Kōta Katō Special Feature: pages 56–57, 72–73, 114–15, 120–21, 134–36

Born in Tokyo in 1981, he has a Ph.D. in Fine Arts. After completing a degree course in garment creation at the Bunka Fashion College in 2002, he entered the Design Department at Tokyo University of the Arts. After graduating in 2008, he remained at the same university to complete graduate studies in the Aesthetics and Art History Department at the Graduate School of Fine Arts, and at the Artistic Anatomy Laboratory. He is currently an Assistant Professor at the Department of Anatomy and Life Structure, Juntendo University, and lectures part-time at the Artistic Anatomy Laboratory, Tokyo University of the Arts. He co-authored *Introduction to Greek Art History* (Sangensha, 2017), and reillustrated and translated into Japanese the text of *Ellenberger's Animal Anatomy* (Born Digital, 2020).

Books to Span the East and West

Tuttle Publishing was founded in 1832 in the small New England town of Rutland, Vermont [USA]. Our core values remain as strong today as they were then—to publish best-in-class books which bring people together one page at a time. In 1948, we established a publishing outpost in Japan—and Tuttle is now a leader in publishing English-language books about the arts, languages and cultures of Asia. The world has become a much smaller place today and Asia's economic and cultural influence has grown. Yet the need for meaningful dialogue and information about this diverse region has never been greater. Over the past seven decades, Tuttle has published thousands of books on subjects ranging from martial arts and paper crafts to language learning and literature— and our talented authors, illustrators, designers and photographers have won many prestigious awards. We welcome you to explore the wealth of information available on Asia at **www.tuttlepublishing.com**.

Published by Tuttle Publishing, an imprint of Periplus Editions (HK) Ltd.

www.tuttlepublishing.com

ISBN 978-4-8053-1735-8

DOBUTSU WO EGAKO
Copyright © Sadao Naito, Kota Kato, GENKOSHA Co., Ltd. 2020
English translation rights arranged with GENKOSHA Co., Ltd. through Japan UNI Agency, Inc., Tokyo

English Translation © 2023 Periplus Editions (HK) Ltd
Translated from Japanese by David Eunice

Printed in China 2306EP
27 26 25 24 23 10 9 8 7 6 5 4 3 2 1

TUTTLE PUBLISHING® is a registered trademark of Tuttle Publishing, a division of Periplus Editions (HK) Ltd.

Distributed by:

North America, Latin America & Europe
Tuttle Publishing
364 Innovation Drive, North Clarendon
VT 05759-9436 U.S.A.
Tel: (802) 773-8930
Fax: (802) 773-6993
info@tuttlepublishing.com
www.tuttlepublishing.com

Japan
Tuttle Publishing
Yaekari Building 3rd Floor
5-4-12 Osaki Shinagawa-ku, Tokyo 141 0032
Tel: (81) 3 5437-0171
Fax: (81) 3 5437-0755
sales@tuttle.co.jp
www.tuttle.co.jp

Asia Pacific
Berkeley Books Pte. Ltd.
3 Kallang Sector, #04-01, Singapore 349278
Tel: (65) 6741-2178
Fax: (65) 6741-2179
inquiries@periplus.com.sg
www.tuttlepublishing.com